A SINGULAR ELEGANCE

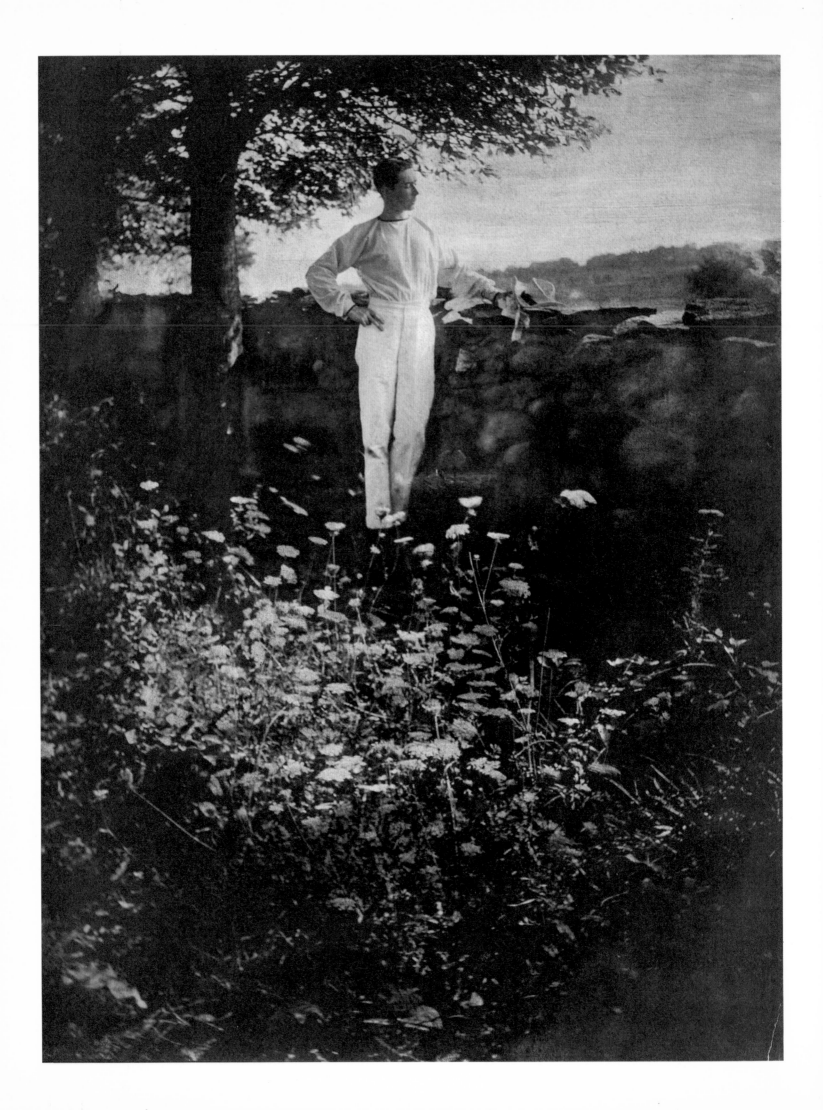

A SINGULAR ELEGANCE

The photographs of

BARON ADOLPH DE MEYER

Dedication by John Szarkowski
Introduction by Willis Hartshorn
Essay by Anne Ehrenkranz

CHRONICLE BOOKS, SAN FRANCISCO

in association with

International Center of Photography, New York

First published in the United States by Chronicle Books, San Francisco.
Published in conjunction with the exhibition
A SINGULAR ELEGANCE: THE PHOTOGRAPHS OF BARON ADOLPH DE MEYER
organized by the International Center of Photography, New York,
on view at ICP Midtown from December 10, 1994 through February 12, 1995.

The exhibition and tour of A SINGULAR ELEGANCE: THE PHOTOGRAPHS OF BARON ADOLPH DE MEYER
are sponsored by *Harper's BAZAAR*. Additional support has been received
from the National Endowment for the Arts, a Federal agency.

Text edited by Diana Stoll
Project coordinator: Paula Curtz
Production manager: Jennie McGregor Bernard
Design assistant: Francesca Richer
Typesetting and composition by Terence Wight
Printed by la cromolito, Milan

LIBRARY OF CONGRESS CATALOGING IN PUBLICATION DATA AVAILABLE

ISBN: 0-8118-0830-0

Chronicle Books, 275 Fifth Street, San Francisco, CA 94103

10 9 8 7 6 5 4 3 2 1

Distributed in Canada by Raincoast Books,
112 East Third Avenue, Vancouver, B.C. V5T 1C8

Right
MRS. HARRY PAYNE WHITNEY (GERTRUDE VANDERBILT WHITNEY)
c. 1912. Collection Mrs. Thomas LeBoutillier, Old Westbury, Long Island, New York.

Previous page
GERTRUDE KÄSEBIER, PORTRAIT OF BARON DE MEYER
1903. Collection The Museum of Modern Art, New York. Gift of Mina Turner.

Page 7
FOUNTAIN OF SATURN, VERSAILLES
Early 1900s. Published in *Camera Work* 40, October, 1912.

Book design by Yolanda Cuomo

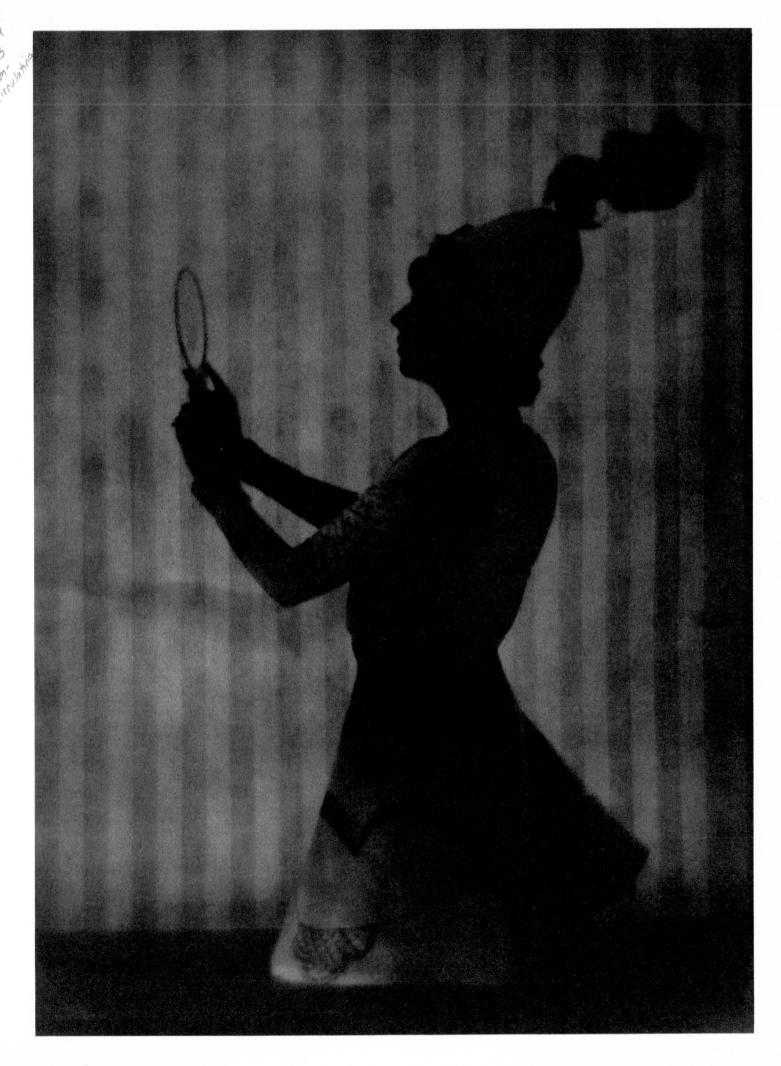

CONTENTS

∽

⌐

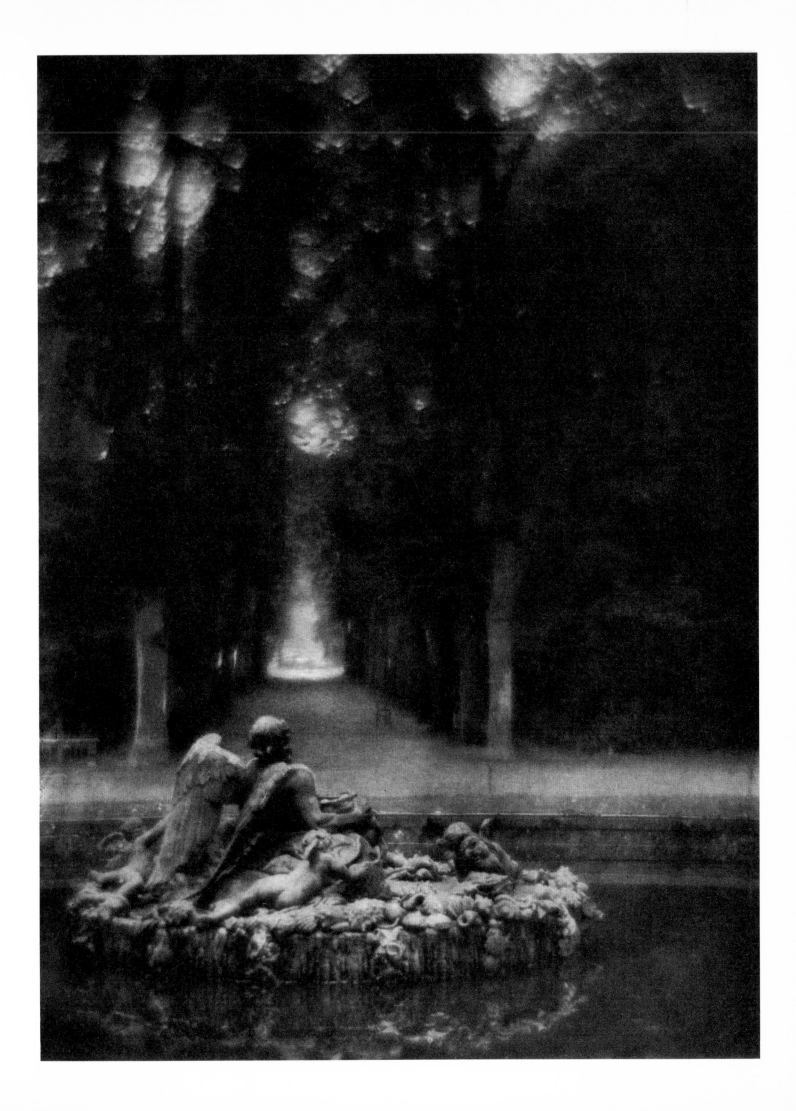

Dedication

BY JOHN SZARKOWSKI

Sam Wagstaff has been widely praised for his taste, but I think the quality at issue is something richer and better than taste. I suspect that Wagstaff would have endorsed Louis Sullivan's jaundiced view of the word taste: Sullivan said that the word meant a little more than nothing and a little less than something. I prefer to praise Wagstaff's knowledge.

Sam Wagstaff had spent half a lifetime in the arts before becoming interested in (passionate about) photography; he was intimately familiar with contemporary art, and also confident not only with older painting and sculpture but with a wide range of decorative arts, and also with those arts that are too seldom seen in museums. Only those who did not know him would be surprised to learn that thirty years ago (when Wagstaff was Chief Curator of the Wadsworth Athenaeum) he was instrumental in mounting an historically important exhibition of the work of the couturier Charles James, while that estimable artist was still alive.

His knowledge of the arts was, in other words, both broad and worldly—worldly in the sense that it had been achieved not only in lecture rooms and seminars but in artists' studios and galleries and antique shops and bookstores and bazaars of various kinds. This is to say that Wagstaff had the perfect education for a successful collector of photographs, first, because he was both fiercely discriminating and wholly democratic: he demanded precision and grace of statement, and welcomed it wherever he found it; second, he knew a good deal about the history of the Western world, and about the artifacts—the bridges, buildings, canon, costumes, ships, etc.— that encapsulate that history, and he was therefore in a good position to recognize a subject of consequence before most others.

It is not surprising that Wagstaff should have recognized the virtue in the work of Baron de Meyer, when the photography world in general saw him only as a minor character in an ephemeral Edwardian operetta. Wagstaff's own mother, Olga Piokowska, is said to have been a fashion artist. Perhaps she knew de Meyer. In any case Wagstaff might have learned at her knee that not even the characters of the most artificial worlds are beyond the reach of art.

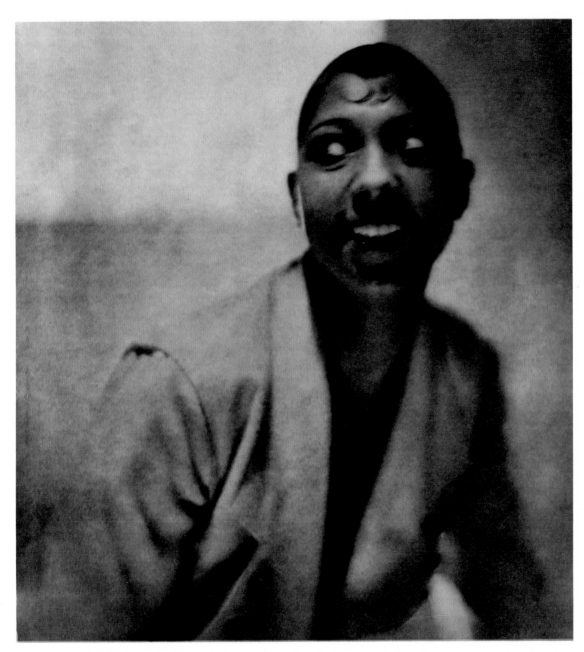

JOSEPHINE BAKER, ca. 1925. Collection The J. Paul Getty Museum, Malibu, California.

Introduction

BY WILLIS HARTSHORN

Baron Adolph de Meyer is often thought of as an aristocratic Edwardian, a gentleman amateur. Accounts tend to obscure his photographic accomplishments, overpowering them with tales of the Baron's extravagance, and of his life among the chic international set.

In London, around the turn of the century, de Meyer's social position and apparent financial independence may have worked to his advantage, but it was the sophisticated beauty of his still lifes and portraits that gave him access to the most advanced photographic circles. A participant of the Linked Ring in England and the Photo-Secession in America, de Meyer interacted with such influential photographers as F. Holland Day, Alvin Langdon Coburn, Gertrude Käsebier, Edward Steichen, and Alfred Stieglitz.

But the amateur Pictorialist phase of de Meyer's photographic career was brought to an end with the approach of the First World War. Forced to flee to America and left without financial resources, de Meyer turned to photography as a means of survival. The results of this necessity would transform fashion photography from a rather mundane documentary mode to one of artistic consequence. Starting in January 1913, de Meyer was omnipresent in the pages of *Vogue* and *Vanity Fair.* In a society hungry for European sophistication, he provided a sense of elegance that captured the imagination of the American woman. De Meyer became the first in a long line of highly paid and well-regarded fashion photographers who would use the power of the photograph to create refined fantasies of feminine beauty.

Throughout the United States and Europe there was a restructuring of the social order in the teens and twenties, which brought entertainers and artists into the society of industrialists and aristocrats. At the same time, the burgeoning fashion and entertainment industries offered vocations that were beginning to be accepted among those of the leisure class who found their economic fortunes changed. The aristocratic notions of class and birthright were being replaced with the newfound concept of celebrity, created in the mass-market magazines and Hollywood. Baron de Meyer was the first to enjoy this celebrity status as a fashion photographer, and went on to turn his talents to interior décor and clothes design, introducing his creations to the public through *Vogue* and *Vanity Fair.*

While de Meyer was an integral part of the development of the modern fashion magazine, he ultimately fell victim to the very medium he had helped to create. After leaving *Vogue* in 1922 to work in Paris for *Harper's Bazar*, de Meyer found his romantic style of photography becoming outmoded. By the late 1920s he was relegated to secondary importance in the magazine's pages as increasing numbers of artists and art directors touted the programs of Modernism, again revolutionizing the look of commercial magazines. De Meyer appropriated certain aspects of the new hard-edged style, but he never convincingly adapted to the developing Modernist agenda. He soon found that maintaining his celebrity status in an ever-changing marketplace was as difficult as retaining the comforts of the upper-class life in a changing social structure. After nearly twenty years, de Meyer left the world of fashion photography in 1932.

Styles in fashion must be constantly reinvented, so that the mechanisms of commerce can continue to be fed on the look of the new. However, in order to appeal to the consumer, mass-market design must lose its aggressive edge and have a sense of familiarity. Art movements—once they have found a certain level of acceptability in society—often provide the new look that fashion perpetually requires. De Meyer brought Pictorialism to the pages of the fashion magazines in 1913. The magazines later left de Meyer's romantic imagery behind for the clean lines of Modernism, and the dreams of Surrealism, although all of these genres had been tamed and lost their currency as aesthetic movements by the time they were used in the service of selling fashion. That de Meyer was able to maintain his influence in such a capricious world, for such a length of time, is in itself a remarkable achievement.

Cecil Beaton, who admired de Meyer, gave a knowing summary of the artist in his book *The Glass of Fashion*: "[De Meyer] succeeded in overcoming the mechanical limitations of the camera . . . and created impressionistic pictures of the ladies of his day that brought to the surface their innate elegance with an uncanny and varied mastery and spirit. His was the triumph of mind over the matter of mechanism. . . . Utilizing ladies in tiaras and silver lamé as his subject matter, he produced Whistlerian impressions of sunlight on water, of dappled light through trees. . . . De Meyer managed to convey his enjoyment of a subject, and he never conveyed too much: he was not afraid of producing an almost empty photograph."

Baron de Meyer worked with great energy and success to establish an artistic vision for photography as the nineteenth century came to a close. Later, he went on to create an image of elegance that virtually defined the standards of fashion in the new century. De Meyer is a model from whom many other fashion photographers follow. To see his accomplishments now, particularly those images that exist only in the ephemeral pages of the fashion magazines, is to appreciate the romantic elegance that was his creation, and to see how his work formed a foundation for later styles of fashion photography.

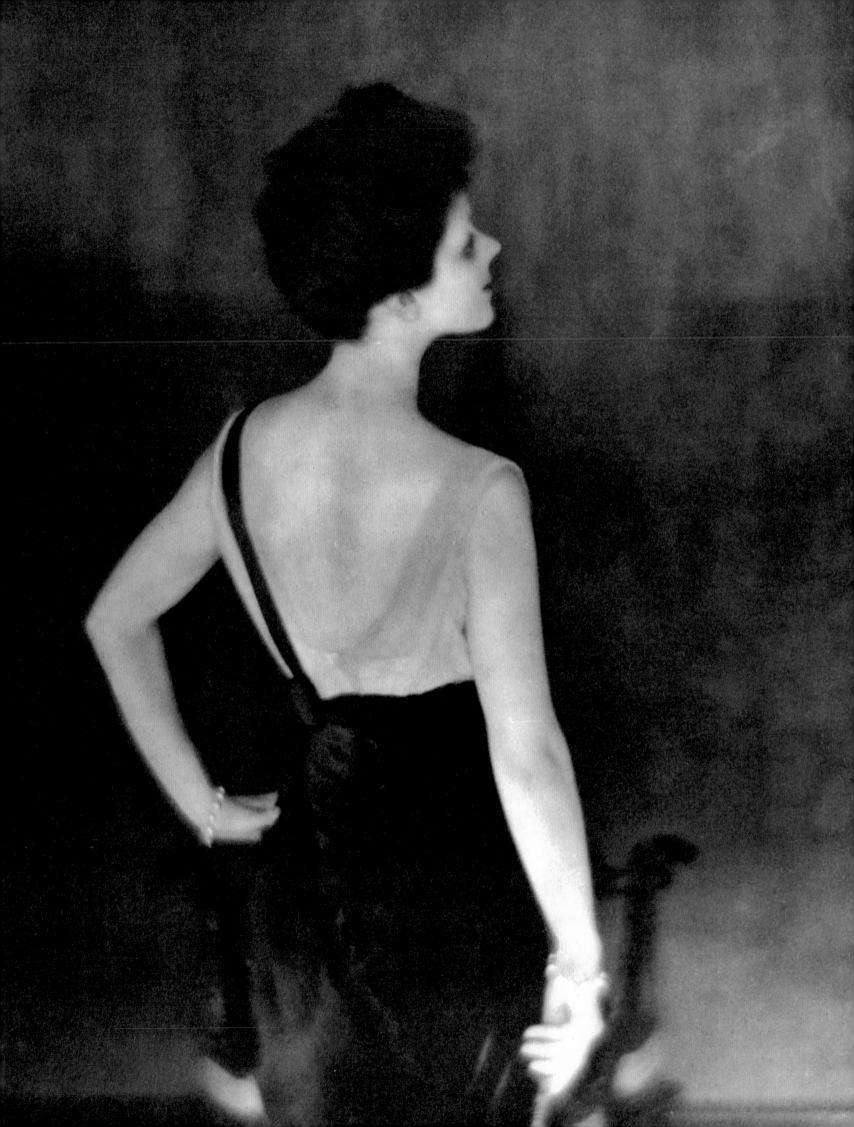

ℐ singular elegance

BY ANNE EHRENKRANZ

"During this frivolous season of uninterrupted costuming, of fancy-dress affairs and festivities of all sorts, my proper place should have been in a glass case, not on a ballroom floor. I wandered through it all as a bit of lacquer, a figure off some screen, . . . as a carved piece of rock crystal, detached from its pedestal."[1] These are the words of a man moving in the context of a glittering Paris society; they were written for the readers of *Harper's Bazar*, in September of 1923.[2] The address *60 rue de Varenne, Paris*, highlighted in italics at the head of the column, indicated that the report originated in the fashion capital of the world, and that it was written and illustrated with photographs by the magazine's celebrated master of taste and style, Baron Adolph de Meyer. During the first quarter of this century, de Meyer's luminous photographs shaped and defined the genre of fashion photography. He possessed a unique vision that combined art and documentation with an intuition that came close to genius. With a brilliant and highly individual style, refined in the photography salons of the century's opening decade, he reported the culture of fashion on the pages of *Vogue, Vanity Fair,* and *Harper's Bazar,* finally reforming the very look and layout of the magazines themselves. The work that remains is the legacy of an artist who changed a photographic genre through his intelligent and deeply creative sensibility.

From a description by the great English fashion photographer Cecil Beaton, and from photographs by de Meyer's friends, the Americans Gertrude Käsebier and Clarence White, we know that the Baron did present himself as an exotic type, a "bit of lacquer, a figure off some screen." In his life, as in his photographs, de Meyer was not concerned with the banalities of reality or fact. Instead, he implemented a way of seeing that transformed the people in front of his camera into fantastical figures, illustrations from picture books, princesses and princes. Moreover, he exuded an empathetic, fluid perception of individual identity, which let his subjects—chiefly social figures and theater people—map out their own personalities and desires on the photographic plates, allowing them to appear as something other than commodities.

Many of de Meyer's original photographic prints have been lost; he himself destroyed negatives and prints before he left Europe for the United States in 1938, in fear of the coming war. (In a letter to Alfred Stieglitz of February 15, 1940, de Meyer reported that he destroyed "all that was superfluous, it seemed to me a burden—all my photographic work especially."[3]) As

RITA DE ACOSTA LYDIG, negative ca. 1913; printed ca. 1940. Collection The J. Paul Getty Museum, Malibu, California. Published in *Harper's Bazar*, March, 1917.

with the work of many photographers, the most interesting way to consider de Meyer's art is through the complete run of his production, not limiting study to a few perfect prints; it is therefore necessary to turn to the pages of publications, both art journals and commercial magazines, to understand fully the depth of his graphic sensibility. Beginning in 1908, with the photogravures published by Stieglitz in *Camera Work* and the autochromes printed in the English magazine *The Studio*, through the years at *Vogue* and *Vanity Fair* from 1913 to 1922, and finally at *Harper's Bazar* until 1932, these publications show both his inventiveness and his astonishing productivity. To appreciate the profound effect of de Meyer's art on the commercial fashion publications, and on the elegant, but uncertain, worlds of society, fashion, and theater, we must look closely at *Vogue, Vanity Fair,* and *Harper's Bazar,* with an understanding that much of the Baron's superb printing has been forever lost to a fairly primitive photomechanical reproduction technique.

AN EPHEMERAL LIFE: A BIOGRAPHY OF FANTASY

De Meyer fabricated most, if not all, of the biographical information about his life; the facts must therefore be surmised obliquely, through scraps and documents, and through the biographies and memoirs of his acquaintances. From accounts of the period, we do know that he was in all likelihood half-Jewish, homosexual, and certainly German. The prejudices and politics of the day forced de Meyer at an early age into an evasive life of fantasy; his legendary air of mystery began self-protectively. It is no wonder that he felt he belonged in a glass case and not on the ballroom floor, for it was an age that saw the public turn viciously on men of his sexual persuasion and ethnic and cultural background.

Even his earliest beginnings are difficult to determine with any certainty. In a rare biographical reminiscence, which appeared in *Vogue* in 1915, de Meyer wrote: "As I was born in Paris, and passed most of my childhood in that city, I still dimly remember hearing of the gaieties and splendors at the Tuilleries during the days of Napoleon III and Eugénie."[4] In an interview of the same year for *Vanity Fair* (the Condé Nast publications accorded de Meyer celebrity status as an international arts personality), he stated that his father was Russian, his mother English, and that while he was born in Paris, he was brought up in Germany.[5] In her memoirs, Edna Woolman Chase (the celebrated editor of *Vogue,* who hired de Meyer in 1913) added to this already questionable outline that de Meyer had a French mother, a German father, and Finnish antecedents.[6] Possibly the most reliable biographical information about de Meyer and his wife, Olga, comes from the memoirs of the French society painter Jacques-Émile Blanche.[7] Blanche's account gives de Meyer a Scottish mother, and describes the photographer as a "very wealthy young man of fashion"—he

was, in the last years of the nineteenth century, a member of the Prince of Wales's social circle. De Meyer was born around 1868; it seems likely that his parents were Adele Watson and Adolphus Meyer, and (although he spent some of his early years in Paris) he was educated in Germany.[8] He changed the spelling and arrangement of his name frequently during the 1890s;[9] exhibition catalogues list him variously as "Adolf" or "Adolph," "Meyer" or "Meyer-Watson" and add or delete a "von"—his identity, even in this initial period, is nebulous at best.

In the 1880s, when de Meyer was coming of age, photography was in a period of great transition, both technological and aesthetic. While art currents—such as Symbolism and Impressionism—were highly influential in much of the photography of the day in Europe, this relatively new medium had not yet been accepted among most critical circles as an art itself. At the same time that de Meyer was in Germany, perhaps just starting to experiment with the camera, the American Alfred Stieglitz was also there, forming what was to be his lifelong mission: to accord photography its proper status as a fine art.

$\sim\!\!\!\curvearrowright\!\!\!\circ$

Stieglitz studied in Berlin from 1881 to 1890.[10] As a central driving force of photography at the turn of the century, Stieglitz came to be an important presence in de Meyer's life, and a determining influence on his photographic way of seeing. Although there is no evidence that de Meyer attended to his studies with the intensity of Stieglitz, the rich photographic experience that was found in Berlin and Vienna was available to both of them. De Meyer was probably intrigued with the new technical developments in photography that mesmerized Stieglitz, developments that made possible unprecedented effects in prints as well as greater production capacities. There were untold potentials in the recently produced gelatin silver chloride emulsions; more accurate lenses were being ground to extremely precise and expressive calibrations; exposure times were greatly reduced, and nuances in lighting, inconceivable a decade earlier, were printed on new varieties of paper. De Meyer, always an aesthete, was also probably encouraged in his interest in photography by the increasingly artistic quality of work shown at the European salons.

In the late 1880s and the 1890s, there was a growing number of exhibitions each year devoted to artistic photography. The shows were organized by circles of highly sophisticated amateur photographers, and were generally well received by the critical public. Often they were held under the auspices of the avant-garde German arts organizations, known as "Secessions" to differentiate them from existing, more conservative groups. The signature that de Meyer came to use on the mats of his photographs (and which he retained on his published work throughout both his amateur and his commercial career) was styled in the lettering used by the Viennese Secessionists

for their posters. This lettering Stieglitz used on the exhibition announcements for his organization, founded in New York in 1902 and dubbed, with an acknowledged debt, the "Photo-Secession."

The emergence of serious amateur photography in Germany was due largely to the efforts of Dr. Herman Wilhelm Vogel of Berlin's Technische Hochschule. Vogel organized the first German association of amateur photographers in Berlin in 1887, and two years later held the famous "Photographic Jubilee Exhibition." Not long after, in the spring of 1891, Vienna's Club der Amateur-Photographien presented the seminal show "Artistic Photography." This latter exhibition set a precedent for future photographic exhibitions, both European and American. Secession groups defined themselves by the setting of new artistic standards that challenged those held by established organizations; they were formed by younger artists who felt that theirs was a purer, more intellectual vision, unaffected by the commercial realities of bourgeois society. Primary among the concerns of these photographers was the creation of parameters for emotive, painterly, and artistic expression—to have the photograph bear the trace of the artist. The jury of artists in Vienna did not accept any commercial photography: no scientific or commissioned work intended primarily for sale, advertisement, or documentation. Only photography that was considered essentially an expression of artistic purpose was exhibited.[11]

The lines were thus drawn between photography that was art and photography that was not. These boundaries, both spiritual and intellectual, dominated Stieglitz's lifework. They haunted de Meyer to the very end of his life: in 1940, he wrote to Stieglitz for assurance that he had not prostituted his talent in committing himself to a career in commercial photography. Stieglitz answered him with compassion: "I have often thought about you and the work you have done. The spirit in which you photographed. The spirit in which I feel you have lived. . . . No, you have not prostituted photography. Any one who may say that or may have said that does not know what he or she is talking about." (Stieglitz Archive, 2/7/40.)

The success of the Viennese Camera Club's exhibition encouraged the formation of other amateur photography groups, which gave rise to a series of exhibitions that the European public attended with interest. (The Linked Ring Brotherhood, founded in 1891 in England, was one of the emergent Secession groups; both Stieglitz and de Meyer became members before the end of the century.) Perhaps the most important triumph for the photographers of Stieglitz's moralistic persuasion was the acceptance, by the turn of the century, of photography into exhibition halls that housed painting and sculpture. Stieglitz devoted his energies in the next decade to seeing that photography was also finally shown and collected by the museums. De Meyer's photographs were included in most of the major international exhibitions. Catalogues kept by Stieglitz show that de Meyer's photographs were seen widely between 1894 and 1912: his prints were at exhibitions in New York, Brussels, London, Berlin, Paris, and Turin.

In 1896 the *Bulletin du Photo-Club de Paris* published a photogravure by de Meyer entitled *Virgin and Child*, made in the preceding year. The photogravure is technically excellent: a carefully controlled tonal piece with fine gradations from deep tones to soft white. The image is particularly remarkable in that—although it is essentially a religious composition, based on art-historical conventions—the shift into photographic technique (which defies its sacred iconography) is handled carefully and with impeccable tact. The models, woman and child, are posed forthrightly and, while Raphaelesque, are not overly saccharine or inappropriately costumed. The placement of this photogravure in the Photo-Club publication, along with the inclusion of de Meyer's photographs in the *Wiener Photographische Blatter* of 1894, are evidence that his work was accepted in informed amateur photographic circles by the middle of the 1890s, and that he had become a respected figure in that milieu.

Throughout de Meyer's career, the artistic work of the 1890s and the paintings of the German Symbolist artists, in particular Gustav Klimt, continued to inform his photography. Klimt's aesthetic is patently reflected, especially in de Meyer's fashion photography. De Meyer must have seen and been deeply impressed by the work of the Austrian painter during his artistically formative years in Germany. There is a trace of Klimt's great portraits of women—the linear style and psychological intuition—that is a steady element in de Meyer's later photographs, particularly when the personalities of certain sitters pushed him past known conventions, as in his portraits of the neurotic Marchesa Luisa Casati, the strong-willed Gertrude Vanderbilt Whitney, the vibrant Josephine Baker, and of course in his astonishing series of images of Vaslav Nijinsky. While it would be unrealistic to assign to de Meyer the same range of intellectual motivation and angst that spurred Klimt to reject the realism of bourgeois Viennese art, de Meyer developed a similar ability to portray the inner turmoil of women reaching for a new freedom and sexuality in an uneasy age. In his pictures of women, de Meyer was able to mirror empathetically the trapped, the anxious, the repressed. He used the salient psychological qualities and linear innovations of Klimt's painting to reveal the latent sensuality and intelligence of these women—the precariousness of their social construct. He created a coalescence of troubled psyches and elegant surfaces within frames of exquisite perfection.

One of the more interesting and productive women of this world became de Meyer's close friend and patron: Constance Gladys, Lady de Grey (fig. 6). She was an intelligent and effective patron of the arts, who became the Marchioness of Ripon, a bastion in a new class of women of great wealth that de Meyer immortalized. Beaton wrote that she was "one of the outstanding fig-

ures in the Edwardian period, . . . responsible for bringing about many changes in the social scene. She was the first to mix guests from many divergent worlds, and by so doing created what was later to be known as the "international set.". . . Numbered among her friends were not only the Prince of Wales and his set, but virtually all of the great Covent Garden singers. With a flair for music and an appreciation of the arts, she was able to introduce artists to the aristocracy and to the royal family. To Coombe, her country house, came a hotchpotch of interesting people whom she mixed with great dash. It was not surprising for Nijinsky to sit next to Queen Alexandra at Sunday luncheon, or for Jean de Reszke to spend the weekend there in company with King Edward."[12]

Lady de Grey's position in London society was emblematic of a change that was taking place generally in the status of women in fin-de-siècle England. The Married Women's Property Acts of 1870, 1874, and 1882 gave women the legal right to manage and enjoy their own financial assets within marriage. By the end of the 1880s, there were a few women with power over great fortunes.[13] With these real, but limited, gains in financial and educational opportunity, Victorian women made slow but steady progress toward increasing their potential for self-sufficiency. In journals, argument over the status of women was often virulent during the nineties. Women gained admittance into educational institutions that had previously refused them. Their emerging independence was, it goes without saying, construed by a largely patriarchal culture as a threat to traditional male dominance of the social structure. The anxiety of the women in de Meyer's photographs is often quite evident in their portraits, which together form a gallery of unforgettable faces spanning his career of over thirty years, during which women shed corsets and shortened skirts, but often still reflected the attitudes of men.

However, the new legal protections gave a few strong individuals among English women (and their American counterparts) the ability to begin a new challenge to society in the last decade of the nineteenth century and in the first decade of the twentieth. In the forefront of their ranks were Lady de Grey and Gertrude Vanderbilt Whitney. And de Meyer, when he photographed them, was sensitive to the new parameters these women were drawing for themselves in areas that had previously been restricted and repressed: intelligence and sexuality.

De Meyer's aesthetic was shaped in the artistic climate of his time and place. When he arrived in London, around 1895, he certainly must have been seduced by James McNeill Whistler's paintings, the great Nocturnes and Harmonies, and the soft and painterly portrait work of the nineties. But the work that was outraging London was that of Aubrey Beardsley. Beardsley died in 1898 at the age of twenty-six; nevertheless his graphic art was extremely influential in England and in Europe, in painting, decorative arts, and theater design. The clarity of his line, his daring expression of psychology and sexuality were revelatory, shocking—even today, his work

remains haunting and strangely modern. Living in London, involved in the arts and attending exhibitions, de Meyer could not have been unaware of Beardsley's brilliant drawings, published in *The Yellow Book* and *The Savoy* magazines. There is a certain affinity to Beardsley's style in de Meyer's later handling of luminous whites and velvety blacks, in his understanding of the dramatic possibilities of startling contrast, in his use of sinuous line, and in the elegant juxtaposition of flattened, abstracted shapes.

De Meyer arrived in London a few years before Beardsley's death, and shortly after the devastating event that ended Beardsley's early success. In February, 1895, during the trial of Oscar Wilde on charges of homosexuality, the press went into a frenzy and erroneously reported that Wilde was carrying an issue of *The Yellow Book* at the time of his arrest. The notice ended the magazine's publication and Beardsley's popularity.[14] This episode of homosexual persecution might well have played some part in de Meyer's decision to marry Olga Caracciolo within a few years' time, but the incident would certainly not have diminished de Meyer's admiration for the genius of Beardsley.

By 1896 de Meyer was formally listed as a member of the London Camera Club. Although by this date he had been residing in London for the greater part of the year, the London Salon catalogue still listed him with the address "8 Parkstrasse, Dresden." The Dresden connection seems to have had some significance for de Meyer; his address there is published in most salon catalogues, and his Germanic ties would drive him from England at the opening of World War I. Whether Dresden was the source of income or title (in all likelihood it was both), de Meyer never made clear; in 1908 he wrote to Stieglitz ambiguously: "If I exhibit with you in Dresden be good enough to name me as A. von Meyer for catalogue purposes, not Baron. I want to be plain A. von Meyer in Dresden, they are reasons of delicacy and tact." (Stieglitz Archive, 12/7/08.) As de Meyer omitted biographical fact of his title with "delicacy and tact," it may be assumed that Dresden was the de Meyer family residence.

More to the point, according to Jacques-Émile Blanche's memoirs, whatever the resources were in Dresden, they permitted de Meyer to enter the most delightful social circles in London (figs. 1, 4), those surrounding the Prince of Wales, the future Edward VII. Blanche describes de Meyer as dallying, if only on the fringes, with a fashionable and culturally mixed contingency that included the wealthy financiers Sir Ernest Cassel, Rufus Isaacs, and the Sasoons. It was a cultivated group, very new to English court circles. But they entertained and financed the Prince of Wales lavishly. Blanche particularly noted in his description of the Prince of Wales's court, along with the inevitable wealth, a new receptivity to talented and entertaining people, and a fondness for art.

In 1896 or 1897—significant dates in de Meyer's life remain fluid—he met and married Olga, a poised, intelligent, and provocative young woman. She had a certain notoriety in her own

Fig. 2.
PALAZZO BALBI-VALIER.
Published in *Vogue*,
February 15, 1916.

Fig. 3. EUGENIA ERREZURIZ,
1905. Collection The J. Paul Getty
Museum, Malibu, California.

Fig. 1. KING EDWARD VII, ca. 1901.
The Royal Archives © Her Majesty
Queen Elizabeth II.

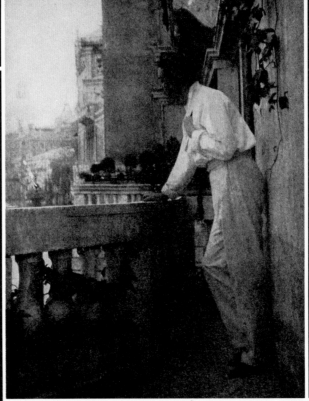

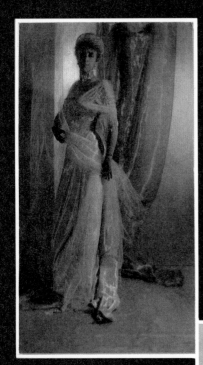

Fig. 4.
QUEEN ALEXANDRA,
ca. 1901. The Royal Archives ©
Her Majesty Queen Elizabeth II.

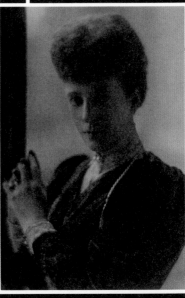

Fig. 6.
CONSTANCE GLADYS,
MARCHIONESS OF RIPON
(LADY DE GREY), ca. 1908.
Collection National
Portrait Gallery, London.

Fig. 5.
FLOWERS IN A VASE,
ca. 1915. Collection
Museum of Art,
Rhode Island
School of Design;
Florence Koehler
Collection, Gift of
Mrs. Henry D. Sharpe.

right: her *décontracté* way of life and questionable parentage raised polite eyebrows. But her elegance and unique sense of style inspired a lifelong devotion from both de Meyer and Blanche. De Meyer's first portraits of her date probably from the late 1890s; they give visual credence to Blanche's literary tribute.

Olga grew up in Dieppe, a fashionable seaside resort in Normandy, a gathering place where writers, artists, composers, and aristocrats mixed easily, freed—as much as they cared to be—from the rigors of court and salon etiquette. Olga's youth was surrounded with social complication. In an apt phrase, the writer Henry James described the French town as "a reduced Florence, every type of character for a novelist seems to gather there . . . that enchanting Olga learnt more at Dieppe than my Maisie knew,"[15] and, indeed, it has been said that Olga was the inspiration for his novel *What Maisie Knew*. Olga's mother, the Duchesse de Caracciolo, remained unmarried, although rarely unaccompanied. The question of who the little girl's father might have been seemed immaterial beside the fact of the very royal presence of the Prince of Wales in her life, a presence made infuriatingly apparent to social mavens by his gift to Olga of the Villa Mystery, in which she and her mother lived. The Prince of Wales was Olga's godfather, and may have been her father: the rumor persisted that she was his illegitimate daughter—and Olga herself seems to have encouraged the notion.

When Blanche first saw Olga, she was certainly a delightful model, with dark auburn hair to her heels, a clear and distinctive profile, and enchanting almond-shaped eyes that became even more piercing and worldly with the passing of time. Years later, *Vogue*'s Edna Woolman Chase, a woman not given to easy accolades, credited Olga with both intelligence and style. Olga sat for many of the artists who vacationed at Dieppe: Walter Sickert, Paul Helleu, and Giovanni Boldini, just as she would model later for de Meyer. It seemed the natural thing for her to do; as a youngster of special beauty, she had an early understanding that her looks and charm were her most valuable dowry. Whistler painted a portrait of Olga in Dieppe, probably in the fall of 1885.[16] *Arrangement in Pink, Red, and Purple* depicts a graceful young girl in a lilac dress, suggestively posed in front of a bright red divan. The portrait is not immediately recognizable as Olga; only the lithe shape of her body and the direct, arresting gaze presage de Meyer's photographs of her from the following decade.

Olga followed in her mother's footsteps, and after relying on several protectors, made an ill-fated early marriage that ended in divorce. After her mother's death, and a short career writing fashion articles for the paper *Gaulois* (owned by one of her mother's admirers), Olga moved to London to be sheltered by friends of the Prince of Wales. By all accounts, she was a young woman possessed of enough style, wit, and grace to succeed. She amused her godfather the Prince—she was interested in the arts and well-informed, and she took good care not to bore him. Edward in

turn saw to it that she was well-dressed, jeweled, and invited to the salons that he frequented. These salons were vital congregations of all the most fashionable and artistic people. De Meyer was an attractive and constant feature of these gatherings. It was at one of those salons, in the final years of the nineteenth century, that Olga and de Meyer met.

In 1898, de Meyer was listed as a member of the Linked Ring photographic society; the London Salon catalogue gave his address as 1 Cadogan Gardens. Whether this handsome red brick house too was a gift of the Prince of Wales is unknown, but Olga and de Meyer lived there together, so we may assume that they married before that date. Their marriage was considered highly successful, and Olga and de Meyer were extremely amicable. They entertained extravagantly, and attended the theater and parties with great regularity. A new mix of artists, actors, and aristocrats was drawn to the de Meyers' home—such heterogeneous company must have come as a welcome relief from the stiff proprieties of bourgeois and court society, where different ilks seldom (if ever) mingled. It seems probable, however, that the couple's passions were fulfilled outside the marital bed: de Meyer was a homosexual, and it was rumored that Olga had both lesbian and heterosexual liaisons. In their circle—a swish new society that mixed wealth, the arts, and adventurous nobility—one did what one did stylishly, and with the proper partner, and kept it out of the public eye.

It was around this time that de Meyer made an early series of photographs of his wife. They reveal a young woman with elfin features, a striking profile, and distinctive elegance. Olga modeled with an easy grace and confidence born of constant admiration. The photographs are charming, if unremarkable; they are primarily interesting for their documentation of technically accomplished, turn-of-the-century, studio photographic portraiture. De Meyer's work from this time is stylistically indebted to the well-known French fashion- and society-photographer Leopold Reutlinger—who kept to the simplest permissible concepts in his work, using customary settings (potted palms, heavily carved chairs, and painted backdrops), and backlighting his models, a new technique that made light radiate from behind the sitter, softening features becomingly.

The Baron was already established among the smart set as a leading portrait photographer, whose radiant images flattered his subjects, without misrepresenting them. He photographed almost everyone of importance, including Edward VII and his family. But de Meyer's work encompassed more than just glamorous documentation: his sensibility stemmed from the serious principles of Pictorialism.

THE LINKED RING BROTHERHOOD AND AMERICAN FRIENDS

Stieglitz's criteria were highly significant to the development and standards of Pictorial photography and to the formalization of de Meyer's aesthetic. In an article published in the American

annual *Photographic Mozaics,* in 1882, he discussed some of the elements that he considered necessary to artistic photography. The piece was titled "A Plea for Art Photography in America." Stieglitz wrote: "In what respects are [Americans'] photographs deficient, more especially when compared with those of our English colleagues? . . . What we lack is that taste and sense for composition and for tone, which is essential in producing a photograph of artistic value—in other words, a picture. . . . Those exquisite atmospheric effects which we admire in the English pictures are rarely, if ever, seen in the pictures of an American. . . . Atmosphere is the medium through which we see all things. In order, therefore, to see them in their true value in a photograph, as we do in Nature, atmosphere must be there."[17] Stieglitz's central notion of producing a "photograph of artistic value," a *picture,* dominated all discussion in the Secession camera clubs at the turn of the century. Stieglitz's words *picture* and *atmosphere* delineated the shared terrain between photography and art.

The Linked Ring Brotherhood was founded in May, 1892, as a Secession group. Following the Viennese example, it was clearly an attempt to separate photographers who were interested in the promotion of a pure aesthetic from those whose concerns were primarily scientific or practical. The members' goal was that of all the European and American Secession organizations: the acceptance by the public of photography as a fine art. Interestingly, the Linked Ring was structured at its inception as an international organization; the photographers believed their mission went beyond national boundaries. Members were referred to as Links. Acceptance to the Linked Ring was considered a great honor, even by Stieglitz, who joined in 1894.

Within the group, differing aesthetic practices coexisted, and opinion varied on the propriety of nonphotographic techniques (including etching and drawing on the glass plate negative) and the use of printing processes (such as gum bichromate) that lent themselves easily to handwork, manipulation, and the addition of colored ink. Virtually all members of the group experimented with the effects of colored and tinted papers, and with different weights of paper, from heavy textured ones to the sheerest Japanese tissues. Banded mats and highly individualized signatures were also part of the effort to make the presentation of a photograph similar to that of a drawing or etching. This new work had parallels with Japanese prints and with current European and American painting—especially Symbolism, Impressionism, and Tonalism. But this fusion of graphic practices on the photographic plate produced new, hybrid possibilities within the flowering discourse of photography itself. The Linked Ring's first salon was organized in November of 1893. The intention was to exhibit both the work of its members and that of outsiders, the sole stipulation being that only work adhering to the highest Pictorial and artistic standards would be shown. The exhibition was hung at London's Dudley Gallery, and it was acclaimed by the reviewing press.

De Meyer joined the brotherhood in the fall of 1898, and remained a member until 1910, when internal disagreements and Stieglitz's resignation effectively ended the Ring's viability. Until that period, most photographers who were concerned with the establishment of artistic standards for photography and with the ideology of the Aesthetic Movement belonged to the Ring, and de Meyer was considered a central figure in the charmed circle.

Broadening his associations within the photographic community, de Meyer became friendly with several of the American photographers gathered around Stieglitz and the Photo-Secession movement. He and Edward Steichen corresponded about matters of organizing exhibitions, and de Meyer visited Steichen in Paris. The Baron developed a close relationship with Gertrude Käsebier. Stieglitz considered Käsebier the leading portraitist of the day, and published six of her photographs in the inaugural issue of *Camera Work* in January 1903. It was not altogether unusual to find women practicing in the field of photography in the late nineteenth century, perhaps because the medium had not yet been granted the status of fine art, and thus was not reserved as a province for academically trained men only. Käsebier managed to combine the highest aesthetic standards in her work with a shrewd business sense. She enjoyed particular success in the politics of the Pictorial movement (she joined the Linked Ring in 1900), and there was a wide demand for her portrait work.

De Meyer makes no specific reference to when or where he met Käsebier, but it is likely that their paths crossed as fellow Links at the photographic salons. He visited her in Newport, Rhode Island, during a trip to America in the summer of 1903, and their friendship is documented by a number of portraits Käsebier made of him that summer, showing him standing in a field, or poetically leaning against a tree, his languid figure dappled by the New England sunlight (p. 2). The studied poses seem rather affected to modern eyes; Käsebier tinged her obvious affection and respect for de Meyer with the sensitive perception that romance suited his persona best. Stylistically, the portraits are closely related to other photographs Käsebier made outdoors during that summer—*The Road to Rome* and *The Sketch*, for example; the contrived poses were not specific to de Meyer.

It was the start of a friendship that de Meyer valued highly, and there was a marked change in his work from that point. He abandoned the Reutlinger-style traditional studio portrait, and devised a new technique that used to great effect the potential of diffused light and tonal gradation—made possible by a skillful combination of his newly acquired Pinkerton-Smith lens, thoughtful backlighting, and even, eventually, gauze stretched over the lens. The Pinkerton-Smith lens played a vital role in the development of the luminous technique that later became synonymous with de Meyer's art. By Beaton's account, the effect of the lens was nothing short of miraculous: it reflected the light of the "aurora borealis"[18] onto de Meyer's glass-plate negative. It also had

the unique properties of differential focusing; the lens made possible both fine definition at the center of a print and gradated softening to the edges. Charles Caffin later described the unique quality of de Meyer's prints in an exhibition review for *Camera Work*: "He discovered . . . what I suppose is known to many photographers, that the very inexactness of a particular uncorrected lens makes it available for rendering certain effects of light and texture; and by bringing his imagination to bear upon these possibilities he has developed results very beautiful in themselves and thoroughly individual to himself."[19]

De Meyer's society portraits and still lifes of around 1906 almost glow with a silvery light, which became associated with his particular vision, but it seems that its inception may have owed a debt to Käsebier's work, especially her 1903 *The Manger*. Five years after the Newport visit, in November of 1908, de Meyer wrote despondently to Stieglitz: "I am sorry you should have fallen out with poor old mother Käsebier, she is getting very old and is failing in health. . . . I am sorry for the old lady, who has done much for photography, and much for me. . . . I shall never forget the obligation I am under to her." (Stieglitz Archive, 11/10/08.) And Käsebier reciprocated with a high regard for de Meyer's work. She owned many still lifes by him, which she lent to exhibitions over the years.

Käsebier and the photographer Frances Benjamin Johnston traveled to Europe together in the summer of 1905, and they stopped to visit de Meyer at the Palazzo Balbi-Valier, the villa on the Grand Canal in Venice that he and Olga regularly rented (fig. 2). In letters written to her mother in August of that year, Johnston described their visit, saying that de Meyer had generously given them free use of his darkroom facilities at the palazzo, and that he and Käsebier greatly admired each other's work. Käsebier's photographs of de Meyer, taken during this visit, show him posed against the columns of the palazzo and, again, highlight his romantic appearance. Johnston wrote to her mother that he appeared a "gorgeous vision in rich deep pink silk blouse and linen trousers."[20] In her monograph on Käsebier, Barbara Michaels suggests dating de Meyer's slightly theatrical profile portrait of Käsebier to this visit in Venice (p. 57). Their similarly idealized photographs of each other reflect their mutual affection and admiration. When Käsebier left Venice for Paris, she took with her a valued letter of introduction to the sculptor Auguste Rodin from de Meyer.

During this period, de Meyer's photographic aesthetic and style were truly taking form, mingling the elements that surrounded him. In addition to Käsebier's practice, and that of the English Links, he responded to the theories of the English artistic Aesthetic Movement. But above all, he was affected by the standards that Stieglitz was setting with the Photo-Secession. With the arrival in London of each issue of *Camera Work*, de Meyer received not only international coverage of the most advanced work in photography, but also the criticism of Charles Caffin, Sadakichi Hartmann, Paul Haviland, and Steichen. In its fifty numbers, published between 1903 and 1917,

Camera Work brought the word of Stieglitz to the serious photographer, and, at least in the first decade of the twentieth century, that word was aesthetic law.

De Meyer developed a friendship with another American photographer, Alvin Langdon Coburn, a young expatriate who lived in London. In 1906, de Meyer wrote to both Steichen and Stieglitz about an exhibition he was organizing with Coburn that would be hung at the New English Art Galleries in the beginning of the following year. De Meyer conceived of the exhibition as a show of "foreign work," to include a number of like-minded photographers, among them F. Holland Day, Robert Demachy, Käsebier, Heinrich Kühn, and Clarence White. De Meyer seems to have felt a real affinity for Coburn, and expressed his affection in letters to Stieglitz, referring to Coburn as "a great dear." (Stieglitz Archive, 12/10/08.)

The young American was an accomplished photographer and an interesting friend for de Meyer to have. He had arrived in London in the summer of 1899. He was a distant cousin of F. Holland Day, who was the only photographer to challenge Stieglitz's position as the organizational genius behind international Pictorial photography. Day put together the "New School of American Photography" exhibition, which was hung in the galleries of the Royal Photographic Society in October of 1900. It was under Day's tutelage that Coburn had begun his photographic career, at the age of seventeen. Coburn was a great success in London—in 1912, George Bernard Shaw wrote that he considered him and Steichen "the two greatest photographers in the world."[21] Encouraged by Day, Coburn was elected to the Photo-Secession in 1902 and to the Linked Ring in 1903—thus, at twenty-one, he was an active member of the two most forward-thinking and artistically conscious photographic groups, and in that company began his friendship with de Meyer. Coburn did a series of highly successful portraits in 1904 (among them one of Shaw), which evidence a fascination with the same mysterious quality of light that de Meyer used. In Coburn's autobiography, he discusses the photographic distinction he strove for in his work: "When I began my career photography was hardly considered as an art, or a photographer an artist. It had its battle to fight and win, but it was to achieve victory by virtue of its own merits— by the unique subtlety of its tonal range and its capacity to explore and exploit the infinite gradations of luminosity, rather than by imitating the technique of the draughtsman."[22] Together, Coburn and de Meyer explored parallel photographic parameters at the beginning of the twentieth century.

The Belgian writer Maurice Maeterlinck was also a probable source of inspiration for both photographers. Day introduced Coburn to Maeterlinck's work, and in 1907 four of Coburn's photogravures illustrated Maeterlinck's book *L'Intelligence des Fleurs* (*The Intelligence of the Flowers*). While there is not much evidence of ponderous intellectual activity or involvement with theoretical models on de Meyer's part during his bustling years in London, it can be said that both

he and Coburn were deeply moved by the dark and mysterious symbolism of Maeterlinck's writing. Some of the curious energy that infuses de Meyer's flower still lifes of this period—photographs that received Steichen's praises—seems to reflect Maeterlinck's concept of the metaphysical, universal signification of plant life (fig. 5). "This vegetable world, which to us appears so placid, so resigned, in which all seems acquiescence, silence, obedience, meditation, is, on the contrary, that in which the revolt against destiny is the most vehement and the most stubborn. The essential organ, the nutrient organ of the plant, its root, attaches it indissolubly to the soil . . . it is the law that condemns it to immobility from its birth to its death. Therefore it knows better than we, who disseminate our efforts, against what first to rise in rebellion. And the energy of its fixed idea, mounting from the darkness of its roots to become organized and full-blown in the light of the flower, is an incomparable spectacle."[23]

De Meyer was in all likelihood familiar with this particular passage: the energy that is "full-blown in the light of the flower" is certainly present in the spellbinding platinum still lifes he made during the opening years of the twentieth century. In his photographs, de Meyer often had an uncanny ability to reflect intellectual principles of his age, albeit without having participated in their construction.

CAMERA WORK AND THE "LITTLE GALLERIES" AT 291 FIFTH AVENUE

Throughout his life, de Meyer had a gift for weaving myriad and often disparate threads of his existence together. During Edward VII's reign, from 1901 to 1910, there can be no doubt that the Baron and Olga were avidly involved in the social whirl. Equally avid, however, was de Meyer's commitment to the pursuit of the highest quality of photographic work. If he had not been seriously devoted to this achievement, it is doubtful that he would have maintained the important friendship and support of Stieglitz.

While the first of de Meyer's letters to Stieglitz is simply a courteous note covering his check for a subscription to *Camera Work* and four back issues, by September of 1906 his tone had become quite intimate. In one rather humble passage, he wrote: "I am much gratified by what you say about my work . . . and hope to steadily improve. Unfortunately the only photographic work I am interested in is in America. I therefore get little inspiration by intercourse with European Links. I hope I don't copy Americans as a body too flagrantly." (Stieglitz Archive, 9/11/06.) Their correspondence continued regularly for several years, discussing arrangements for exhibitions, the complications of printing *Camera Work*'s photogravures, the politics of photographic organizations, and of course the aesthetics of photography, along with the relative "morality" of various printing techniques.

In November of 1906, de Meyer wrote to Stieglitz to say that Käsebier would be lending eighteen platinum still lifes to the 1907 exhibition at New York's Little Galleries of the Photo-Secession. The exhibition was shared with the American photographer George Seeley; each of them contributed twenty-three prints. De Meyer showed a group of portraits (among them pictures of Coburn and Käsebier) and eight still lifes. He was not entirely pleased with the overall effect of the exhibition, and said so to Stieglitz in July: "In a year or two you must let me have another exhibition in New York, I shall then work for it purposely, not like last year where I sent you what I had, with no exhibition experience. The flowers were for a portfolio, not for a wall, whilst the ones I had in London made a fine show, big and bold." (Stieglitz Archive, 9/11/06.)

With this disappointment in mind, he wrote again to Stieglitz, greatly concerned about the proper printing of the negatives, particularly the still lifes, that were to appear as photogravures in *Camera Work* 24, in October 1908. He complained that, while he knew the negatives were difficult to print, Stieglitz had assured him that they were not impossible to do correctly. By February of 1908 de Meyer sounded quite worried: "The proofs you sent me . . . are not luminous, which was the greatest quality of these flower studies, if you do away with that, very little remains. Especially the waterlilies sparkled, water and glass shining in the sun. The proof you sent me looks dull and the result of a grey day. Coburn thinks all this can be altered by using different ink." (Stieglitz Archive, 7/2/07.)

De Meyer continued to work with Stieglitz on correcting the proofs, and ultimately seven photogravures appeared in *Camera Work:* four still lifes (among them the *Water Lilies*, which finally did sparkle) and three portraits. To enhance their effect, the still lifes were printed on laid paper, tipped onto grey mats, and then placed on the page. The three portraits were printed on Japanese tissue, laid over cream paper; they are all made up of involved tonal schemes, velvety in the areas of dark masses.

In the same year, de Meyer wrote to Stieglitz that he believed "straight" photography (that is, processes not involving hand-manipulation in the final printing) was the most valid exercise of the photographic possibility—he meant to advocate specifically the use of platinum or silver paper. De Meyer retouched the surfaces of his prints when the need arose, but only once (in the photographs of the ballet *Le Prélude à l'Après-midi d'un Faune*) did he incorporate an extensive painterly technique in the making of a print.

When Charles Caffin reviewed two de Meyer exhibitions in New York in 1909—a group of still lifes at the National Arts Club and the monochrome and color photographs at the Photo-Secession Galleries—he responded sensitively to de Meyer's fine effort in "rendering the complexities and subtleties of light values." Caffin noted that de Meyer, in the still lifes, "is chiefly concerned . . . with their surfaces, as offering a complex system of facets for the reflection of the infi-

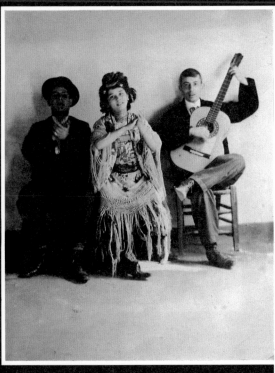

Fig. 7. THREE SPANISH SINGERS,
Seville, 1907. Collection
The J. Paul Getty Museum,
Malibu, California.

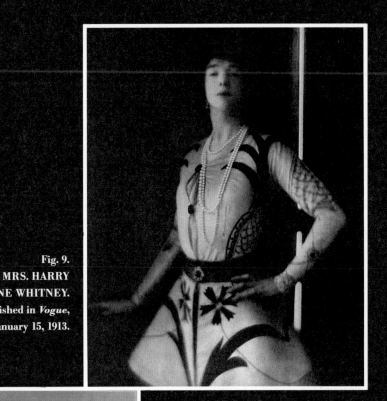

Fig. 9.
MRS. HARRY
PAYNE WHITNEY.
Published in *Vogue*,
January 15, 1913.

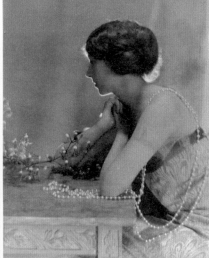

Fig. 8. PRINCESS MIGUEL
DE BRAGANÇA, 1921.
Published in *Vogue*,
July 15, 1921.
Collection The Museum
of Modern Art, New York;
Gift in honor of
Samuel J. Wagstaff, Jr.

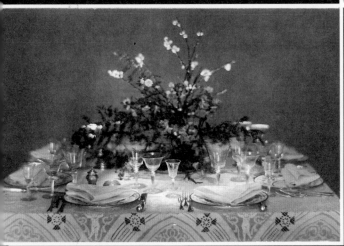

Fig. 11. UNTITLED (TABLE SETTING), ca. 1920.
Collection The Museum of Modern Art, New York;
The Family of Man Fund.

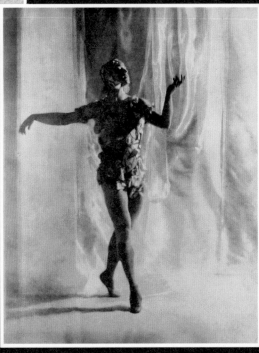

Fig. 10. NIJINSKY
IN THE TITLE ROLE
OF LE SPECTRE
DE LA ROSE,
ca. 1911. Collection
The New York
Public Library for
the Performing Arts,
Roger Pryor
Dodge Collection.

nite nuances of light. He is bent, in fact, on translating his material into a fantasy of abstract beauty. It is almost a rendition of matter into music."[24] The *Water Lilies* seem nourished by an other-worldly, metaphysical light that is de Meyer's visual invention. In a spectacular 1912 platinum print of this image, which was part of Stieglitz's collection, de Meyer presents an interior vision that plays on reality and reflection, material and immaterial, organic life and the transparencies of water and crystal. This print, with its shimmering light, is one of the finest examples of de Meyer's work. If de Meyer's photographic construct seems overly ethereal, perhaps it is because he himself existed in a world of reflections and shadows, and was psychologically detached from the condition of physical reality (pp. 50–51).

Formally, the *Camera Work* still lifes evince the design of Japanese woodcuts—especially Hiroshige's bird and flower prints—which de Meyer may have seen in Japan in 1900, when he traveled around the world;[25] he might also have been made more aware of Japanese art through Coburn. The intelligence and riveting asymmetry of Japanese graphic design remained part of his photographic sensibility, from the Pictorialist years through the last years of his career as a fashion photographer at *Harper's Bazar*. The still life *Hydrangea*, which appeared in the journal, is a particularly fine example of de Meyer's sensitivity to the perfectionism of the Japanese aesthetic (p. 55).

Commenting on the illustrations for *Camera Work* 24, Stieglitz noted that the plates for the three portraits were made under the "personal direction" of Coburn, and that the still lifes reflected de Meyer's spirit, but did not do justice to the "actual quality of the large platinotypes."[26] Stieglitz was pleased with de Meyer's work and wrote that, while de Meyer had been a regular exhibitor at the London Salon of the Linked Ring and was "no newcomer in the field of pictorial photography, . . . his real serious work may be said to have begun after he had come into touch with and under the direct influence of some of the leading Photo-Secessionists and their work."[27] He announced that since de Meyer's advance in photography had been so remarkable, another exhibition would take place at the new gallery of the Photo-Secession. Stieglitz had good reason to be happy with the aesthetic effect of the photogravures de Meyer published in *Camera Work*. If the purpose of Stieglitz's critical effort was to prove that photography could be an expressive, poetic model for artistic intention, certainly de Meyer's technical skill permitted the full range of photographic possibilities, from figurative to (in certain passages) almost abstract conceptualization.

De Meyer's work was seen regularly during these years in the photographic salons of Europe, and the next New York exhibition at the Photo-Secession Galleries took place in February of 1909. At that exhibition he showed both monochrome and color photographs. A color process had been developed in Paris in 1904 by the brothers Auguste and Louis Lumière, utilizing a glass plate coated with potato starch dyed red, blue, and green. A gelatin silver emulsion was applied over this; when the glass plate was exposed in the camera, a colored, transparent positive was pro-

duced. The effect was charming and resulted in an image that had the diffused look of a Pointillist painting. After the process was made commercially available in 1907, Steichen and de Meyer both learned the practical application from the Lumière brothers with great enthusiasm. De Meyer wrote to Stieglitz that he would no longer be content to work with only monochromatic papers. (Stieglitz Archive, 7/21/08.)

It seems, however, that while de Meyer was greatly intrigued with autochromes in 1908, he experimented with the color plates for just a few years—probably between his introduction to the technique in 1907 until the New York exhibition in 1909—and then returned to work in platinum and silver solely. Around 1908 he made autochromes of Tamara Karsavina, the Russian ballerina, in the gardens of Coombe, the Marchioness of Ripon's grand country house in Surrey, and in the same year three still lifes were reproduced in a special edition of the London journal *Studio*, titled "Colour Photography and Other Recent Developments of the Art of the Camera." A few years later, in 1911, de Meyer exhibited a group of autochromes in a show Clarence White organized at the Newark Museum, called "Modern Photography." The Newark show may have included a few of the still-life color transparencies exhibited in 1909 at the Photo-Secession Galleries; there is no indication that he continued to work with color on a consistent basis. Unfortunately, today most of the autochromes cannot be traced. But de Meyer's must have been quite perfect, for he wrote to Stieglitz with a degree of pleasure that, in his own opinion, the autochromes he exhibited at the Paris Salon had been priced too high by Steichen "for those that wish to sell." (Stieglitz Archive, 11/10/08.)

In the 1909 show at the Photo-Secession Galleries, in addition to the autochromes, de Meyer showed twenty-four monochrome platinum prints. Among the society portraits were pictures of Lady Ottoline Morrell, Mrs. Brown Potter, and Olga; the still lifes included prints of the *Water Lilies, Shadows on the Wall,* and *Bunch of Grapes,* and there was also a series of studies of musicians and dancers that was probably done during a trip to Spain the preceding year (fig. 7). De Meyer was well satisfied with the success of the New York exhibition, and was particularly pleased by Caffin's supportive *Camera Work* review, which he found both intelligent and flattering.

De Meyer and Stieglitz finally met in person in Munich in the fall of 1909. "Our first meeting," wrote de Meyer, "seemed to me like the reunion of old friends who had not seen each other for some time and had much to discuss, it was vastly satisfactory to meet in the flesh after so much correspondence." (Stieglitz Archive, 9/29/09.) Throughout de Meyer's aesthetically formative period, the Edwardian years in London, Stieglitz and Steichen both remained critics he admired deeply. After an exhibition at the Goupil Gallery in London, he wrote to Stieglitz somewhat poignantly, "I've worked very hard, and I think with much success and progress . . . I only wish you or Steichen could see it." (Stieglitz Archive, 4/22/10.)

Although de Meyer would exhibit again in Stieglitz's Photo-Secession Galleries, and had an issue of *Camera Work* devoted solely to his work, the initial intensity of his relationship with Stieglitz ended with the installation of the "International Exhibition of Pictorial Photography" at the Albright Art Gallery in Buffalo, New York, in 1910. The show turned out to be a political mine field for Stieglitz. His selections pitted one faction of the American photographic world against another, and enraged certain photographers who felt their work had been slighted by Stieglitz's exhibitions throughout the years of the Little Galleries' existence. Such political infighting destroyed the Linked Ring Brotherhood, and pervaded Stieglitz's fragile organization, making the "International Exhibition" into a finale of sorts for the Photo-Secession. The show was a historical overview of what Stieglitz's and Steichen's choices had been at the Photo-Secession Galleries, primarily in the years between 1905 and 1908. As Stieglitz had intended, the importance of this exhibition turned not only on his curatorial viewpoint, but also on the fact that it was a conscious attempt at a comprehensive "historical survey." Artistic photography had come to the point where viewers could now stand back with Stieglitz (who considered himself architect of the movement), and see what indeed Pictorial photography had accomplished. Many of de Meyer's prints that were shown in Buffalo had been exhibited and published before, in America and Europe. Among the better-known pictures from his first decade of work were: *Mrs. Wiggins, The Silver Cap* (p. 69), *Mrs. Brown Potter, Aïda* (p. 68), *From the Shores of the Bosphorus, Landscapes from Tivoli*, the *Water Lilies*, the *Nymphenburg Figure*, and a series of still lifes.

A year later, in the winter of 1911-1912, thirty of de Meyer's prints were exhibited at the Gallery of the Photo-Secession; he was the only photographer Stieglitz chose to exhibit at the gallery that season. And fourteen photogravures, printed on Japanese tissue, tipped on laid paper, illustrated the October, 1912, issue of *Camera Work* 40. The entire number was given over exclusively to de Meyer's work, and followed immediately the issue that published images by Henri Matisse and Pablo Picasso. This was a compliment either way: de Meyer's photographs were either to assuage or to delight Stieglitz's subscribers. Here was gathered de Meyer's strongest work of about a decade, from the early 1900s through 1912. Two photographs, *The Cup* and a portrait of the Marchesa Luisa Casati, mark out strategies that de Meyer expanded when he formally began his career as a fashion photographer for Condé Nast a year later.

The Cup is de Meyer at his Symbolist and exotic best. The woman in the photograph is wrapped in luminescent cloth, and bears a porcelain cup. Her eyes are subtly veiled: for all the photograph's allure, it avoids directly engaging the viewer; sexual confrontation is discreetly screened, glossed. The picture floats airily, like iridescent tissue, both visually and emotionally. In contrast, the photograph of the fiercely eccentric Marchesa Casati is a direct assault on the viewer, a type of confrontation that was new in de Meyer's portrait work. She was a strident, riveting per-

sonality, as de Meyer's own description of her attests: "The wonderful Marchesa Casati, at sunset, reclining in her gondola, wrapped in tiger skins and fondling her favorite leopard, is a sight to be seen only in Venice."[28] Casati's gaze in this image is compelling, she stares us down, the eyes dominating her strong face. Her body is enveloped in a dark cloak that gives no clue as to her sexual identity. In these two images, we see clearly delineated two of de Meyer's signature approaches to the depiction of women: elusion and complicity.

De Meyer's career would come to comprise the presentation, the packaging, the commodification of women: photographing them for the gaze of both men and women, a task of some delicacy. De Meyer's representation of women's potential sexuality was suggestive and yet ambiguous. The linear forms and decorative surfaces that he appropriated from Klimt's portraits became his expedients for eliding the physicality of the body beneath shimmering clothes. In de Meyer's portrait work as well as later in the fashion photographs, the sitter's face is often turned away, veiled—only in certain instances confronting the viewer's gaze—allowing the possibility of reading layers of psychological complexity into these portrayals of women. It seems clear that he came to terms with photographing women through suppressing their sexuality and ignoring their bodies; possibly he came to think of them as androgynous, or else altogether sexless.

Among the many extraordinary women whom the de Meyers knew well, Eugenia Errezuriz (fig. 3) and Rita de Acosta Lydig—two central figures in Edwardian society—were both captured by the Baron in portraits of exceptional quality. Errezuriz had, according to Beaton, one of those rare personalities that influences the taste of an era. She was a wealthy Chilean, and arrived in Europe in the 1880s, living first in Paris and then in London, the wife of an amateur painter. She was acknowledged as a woman of fashion, friends with "the most advanced musicians and painters," among them Igor Stravinsky and Pablo Picasso. She was, as Beaton saw her, a "grey eminence in the world of artists and cultivated people." Here he describes the Baron's portrait of her: "Nothing could be more simple and restrained than Madame Errezuriz in black taffetas, with an aigrette of osprey in her toque, sitting forward expectantly and almost turning her back to the camera, yet giving more than a mere indication of an impression of the personal appearance, character, and atmosphere of this great individual than any literary portrait could have hoped to achieve."[29]

Another favorite was Rita de Acosta Lydig, a stunning woman of Cuban and Spanish parentage, who married early, and obtained a divorce and an enormous settlement that gave her the ability both to marry again and to spend, between the turn of the century and the twenties, unheard of amounts of money. Sargent, Carolus Duran, and Boldini all painted her; Malvina Hoffman sculpted her, as did Rodin and Émile-Antoine Bourdelle. De Meyer's portrait of her from 1913 owes an obvious debt to Sargent's *Madame X* of 1884—the painting's original hint of infamy

recreated for the pleasure of Mrs. Lydig: after everything had been bought, the feel of a famous painting could still be offered by a clever photographer. The picture is an extraordinary example of de Meyer's capacity for psychic collaboration with his subject (p. 12).

ORIENTALISM: THE BALLETS RUSSES, DIAGHILEV, AND NIJINSKY

Around 1909, there was a shift within the de Meyers' social world; they began to emerge from the lengthening shadows of the Edwardian court. After the king's death in 1910, de Meyer was making the transition from society portraitist and serious amateur, to professional and highly paid photographer. It was work that he would come to depend upon financially, and that he accomplished with greater intelligence and craftsmanship than he has been given credit for.

De Meyer made the change with relative ease, partly because he and Olga were drawn into the circle of the remarkable Russian theatrical impresario Sergei Diaghilev. They were probably introduced to Diaghilev by Lady de Grey, who had by this time grown from being an imaginative hostess into England's outstanding patron of the arts. Diaghilev had successfully produced Russian art exhibitions, concerts, and operas in Paris in 1907 before bringing a group of artists, dancers, and choreographers to France from St. Petersburg in 1909. With that nucleus he founded his own ballet company, which would metamorphose into the legendary Ballets Russes. The singular, creative energy that emanated from Diaghilev's combination of dance and musical talent revolutionized not only the choreography of ballet, but its entire artistic presentation. The costumes and sets that Leon Bakst and Aleksandr Benois designed quickly became the inspiration for Parisian fashions, particularly for the leading couturier of the day, Paul Poiret. Because the ballets were conceived as integral combinations of dance, music, and design, Diaghilev conceptualized each work with a remarkable gathering of composers and painters, among them Claude Debussy, Maurice Ravel, Richard Strauss, Igor Stravinsky; and Picasso, Marc Chagall, and André Derain.

Of all the great Russian dancers, none captured the adoration and imagination of European audiences more completely than Vaslav Nijinsky. Beautiful, exotic, passionately Slavic, he seemed the sum of it all. Some of the most compelling photographs of de Meyer's career were of this extraordinary dancer (fig. 10, pp. 74–91).

Diaghilev's ballet company performed in London in 1911, an arrangement made by Lady de Grey. Frequently, during the season, Russian dancers—among them Nijinsky and Karsavina—would perform in the gardens of Coombe for the Marchioness and her guests, and stay sociably to tea afterwards. But de Meyer's autochrome of Karsavina at Coombe is earlier than 1911, and it is possible that he may have met Nijinsky at Coombe at an earlier date also. In any case, by the time de Meyer made the series of photographs of Nijinsky for the album *Sur le Prélude à l'Après-midi*

d'un Faune, in 1912, the two men were clearly comfortable with each other and confident in one another's artistry. It was reported that Nijinsky was shy and ill at ease socially, a sharp contrast to his commanding stage presence—it must be remembered that he was only in his early twenties, and came from a family of circus dancers. But he was presented at social gatherings frequently, for he was not only Diaghilev's premier dancer and a choreographer of great talent, but he had been the impresario's lover since 1908, when he first came to Paris to dance with the Ballets Russes.

Nijinsky and the Baron met around the time of Edward VII's death, at a point when the de Meyers' social and financial situation had become somewhat precarious. Their resources were diminished and de Meyer knew that he would need to work professionally and at a price. Because de Meyer offers no specific information in his written recollections, it must be assumed that the cause of their financial difficulties is the simplest one: they had spent prodigious amounts of money in the whirlwind of the previous decade. With their royal protector gone from the scene, Olga and de Meyer turned their social talents into lucrative careers. As Diaghilev's ballet company became the creative locus of the performing and social arts, the de Meyers managed to stay at the center of the scene, traveling at times with the troupe, and helping to arrange for the company's successful theatrical and social season in London. When the decision was made to record the highly provocative ballet *Le Prélude à l'Après-midi d'un Faune,* de Meyer either was asked, or else offered, to do the photography.[30]

The ballet premiered in Paris at the Théâtre du Châtelet on May 29, 1912, and was performed there until June 10. It was inspired by Claude Debussy's tone-poem *Le Prélude à l'Après-midi d'un Faune,* which had been written as a lyrical homage to a poem by Stéphane Mallarmé. As Jean Cocteau wrote in the program notes: "This is not Stéphane Mallarmé's *L'Après-midi d'un Faune,* it is, rather, the musical prelude—a brief prefatory scene—leading up to that terrifying episode. A faun sleeps; nymphs elude him; a forgotten scarf assuages his longing; the curtain falls, allowing the poem to begin—in memory."[31]

The first official performance was greeted by the audience with noisy disapproval, despite the great Rodin's public display of support from one of the theater's boxes. Gaston Calmette wrote a puritanical review in *Le Figaro,* which may have served the ballet well: it was a huge box-office success. The public flocked to make its own judgment of the supposedly salacious final gesture by Nijinsky's Faun—the dancer's orgasmic climax as he lay on the Nymph's scarf.

De Meyer's photographs of the ballet show the Faun and the Nymphs posed in difficult, angular movements. In close-up, cropped views of the Nymphs, attention is focused on hand movements and gestures, conveying the innovative plasticity of the choreography. The Nymphs' tunics—Bakst's Greek-inspired designs—are clearly diaphanous, but de Meyer focused his virtuosity on the abstract beauty of the ballet's configuration, and (uncharacteristically) not on the glim-

mering qualities of light and fabric. The photographs of the Faun are dramatic; the glory of Nijinsky's muscular body is central in these images. The Faun kneels sideways before the Nymph's scarf, hands directed toward it with passionate longing, head bent to the object of desire, in a charged moment of suppressed sexuality. That desire explodes in the final two photographs of the album, which reproduce quite closely the final, masturbatory lunge of the ballet—apparently executed with some realism by Nijinsky, just a moment before the curtain fell—it was this movement that scandalized—and drew—both the reviewing press and the Parisian audience (pp. 84–91).

Certainly the photographs are realistic beneath their veneer of Pictorialism. De Meyer made them publishable because of his exquisite, painterly presentation; but the pictures do convey the raw energy of sexuality, of suppressed desire, rejection, and lonely orgasm. It was a world of desire both Nijinsky and de Meyer probably understood well.

NEW YORK AND CONDÉ NAST: SOCIETY PORTRAITS AND FASHION PHOTOGRAPHY

Sur le Prélude à l'Après-midi d'un Faune marked the finish of a particular mode of production for de Meyer, the end of working without a specific, commercial publication context in view. World War I was approaching and threatening to burn Europe's philosophic and social foundations to ashes. It was said by observers of the de Meyers that their sympathies—Olga's by affection, the Baron's by birth—lay on the side of Germany in the coming war.

In 1912, they decided to leave England for the United States. De Meyer wrote to Stieglitz from Newport in September: "We are poor and destitute, no income, no money. I must get work to do. . . . If you hear of any work I can do, think of me please." (Stieglitz Archive, 9/9/12.) In October he wrote again, saying he would come to New York at the end of November or early December.

With or without Stieglitz's help, when the de Meyers settled in New York for the war's duration, they had little difficulty in securing immediate access to the best social circles. The Baron quickly established himself as New York's leading society portraitist. He gained financial security when Condé Nast, the owner and publisher of *Vogue* and *Vanity Fair* magazines, signed him in 1913 to an exclusive contract as staff photographer, paying him one hundred dollars a week.[32] While de Meyer had always been surrounded by the most fashionable people of his day, the world of couture in relation to photography was new to him, and was itself just in its earliest developmental stages.

Fashion photography had originated in Paris before the turn of the century; the magazines began to publish photographs as well as drawings to advertise the important new designs of the couture houses. Fashion was already a major industry in France, and it became one in the

United States in the twenties. The illustrated fashion magazines were an essential ingredient in this industry's success. As the French couture houses produced the designs that the entire civilized world bought or copied, they took great pains to control the dissemination of those fashions in an appropriate manner.

The new photomechanical techniques made printing photographs possible. While drawings continued to be considered elegant and necessary by magazines, photographs made accurate information available. Nast, however, did not use fashion photographs extensively until a few years later, and it was probably for society portraits, and not fashion shots, that de Meyer was hired in 1913. Not until around 1917 did fashion photography appear in *Vogue* as a distinct genre. But the fashion work that made de Meyer of value to Condé Nast came from a new photographic stance: it developed out of Pictorialist thinking.

Since its beginnings, *Vogue* had been illustrated primarily by drawings, showing fashions with great clarity (though little imagination), down to the last button. When Nast began to use photographs in the magazine more freely, they were mostly fairly stiff society portraits, done by commercial studios. The subjects' dull and guileless faces looked out from the pages—faces of women decked out by fathers, protected and used by husbands (except for a wealthy or talented few), all of them commodities.

When de Meyer's photograph of Mrs. Harry Payne Whitney—Gertrude Vanderbilt Whitney—appeared in *Vogue* in the January 15, 1913, issue, it tokened a dramatic change in the way the culture of fashion would be reported. De Meyer had a sophisticated range of techniques and an ability to reflect his culture's artistic practices. Drawing on this complex reserve, he was able to photograph women and men bearing the styles and marks of the moment with a rare and precise intuition for what was significant. When he worked with celebrities—many of whom had a secure sense of themselves—he effected a cooperation with them, giving his best portrait photographs something of the subject's own spirit. Gertrude Vanderbilt Whitney, in line to receive two great American fortunes, was a mesmerizing and challenging woman. In de Meyer's *Vogue* photograph of her, she stares out at the viewer with a penetrating gaze that had not been seen on the pages of a society magazine before. Dressed in a Persian costume that Leon Bakst had created especially for her, her tall, elongated figure fills the page with assurance. The portrait obviously pleased Nast, who kept close watch on his magazine, for it was followed by countless others by de Meyer in *Vogue* (fig. 9).

Condé Nast had bought *Vogue* in 1909, from the heirs of the original publisher, Arthur B. Turnure. Turnure, a prominent social figure, had financed the magazine with the help of some of New York's most significant families, securing a crucial initial readership. His concept of the magazine was twofold: it was to be a vehicle for informing high society about the events that pre-

occupied them, and a way of reinforcing class boundaries—which were increasingly threatened by new money. Household matters, proprieties of dress, and social events, it would seem, had ramifications far beyond the initial purchase or occasion. And this world certainly had ample leisure time to cogitate over these important issues.

At the turn of the century, close to a dozen ladies' magazines were on the stands, all with the same mission: to educate women about the niceties of domestic management and correct fashion—which always came, even if indirectly, from Paris. *Vogue* was unique in its stated intention of attending closely to the viewpoint of society. The first issue appeared on the newsstands of New York City in 1892, with an opening editorial that clearly intoned its attitude: "American society enjoys the distinction of being the most progressive in the world; the most salutary and the most beneficent. It is quick to discern, quick to receive and quick to condemn. It is untrammeled by a degraded and immutable nobility. It has in the highest degree an aristocracy founded in reason and developed in natural order. Its particular phases, its amusements, its follies, its fitful changes, supply endless opportunities for running comment and occasional rebuke. The ceremonial side of life attracts the sage as well as the debutante, men of affairs as well as the belle. It may be a dinner or it may be a ball, but whatever the function the magnetic, welding force is the social idea."[33]

Nast understood that *Vogue*'s appeal had the potential to reach beyond Turnure's initial concept. It was clearly a magazine for the new leisure class of American women, who had been relieved of many of their household and child-rearing responsibilities by radically increased wealth. Most had not yet discovered politics or social work, and so they were not always sure of what to do with their lives, or with their considerable amounts of money. Nast, by inclination an elitist, was never interested in a wide circulation for *Vogue;* he was primarily concerned with cultivating a very rich readership. Needless to say, with the draw of this wealthy subscriber list, advertisers flocked to him and covered his pages with ads for the most expensive jewelry, clothes, furs, and cars.

A large measure of *Vogue*'s success was also due to its editor, Edna Woolman Chase. In a fast-paced world where certainties were disappearing by the minute, she and Nast seemed absolutely sure about everything. *Vogue*'s dictates were read religiously in this anxious climate. De Meyer came from an equally unsteady world, and he knew how to picture it perfectly. He empathized with its denizens and they felt comfortable with him. His sheer technical brilliance, his ability to use design ideas, to integrate them seamlessly within the frames of his photographs, electrified the magazine's pages with his artistic vision and purpose.

Of course, not all of his sittings would test his talents to the full, and not all the portraits were of dazzling theatrical celebrities or social figures. And so early on, as his professional work increased, de Meyer developed a useful substitute for the sitter's character and ability to collabo-

rate, which he implemented when necessary. He devised a format comprised of iridescent back-lighting, and a ravishing array of fabrics and fashion accessories—pearls particularly—supported by a strong graphic structure that gave bones to the whole picture. Without that structure, his pieces might have fallen flat. Within a short time, every other photographer who published in *Vogue* began to emulate his style. Although only a handful of his society portraits appeared in 1913, de Meyer was just beginning his reign over *Vogue's* pages.

During the winter season of the same year, an exhibition of his portraits was held at the Ritz-Carlton Hotel. From the time of his arrival in New York, de Meyer had apparently booked enough portrait sessions with society and theatrical personalities to print new work, and did not need to duplicate the previous year's exhibition at Stieglitz's gallery. New York society took notice of the Baron's work, and embraced his delightful presence. He and Olga began to feel comfortable in their new circles. De Meyer hit his stride at *Vogue* early in 1914, and soon after, the society portrait that opened the magazine's editorial was often one of his photographs. The names of the women who sat for him were from the top echelons: Mrs. John Astor, Mrs. Benjamin Guiness, Mrs. Howard Cushing, Mrs. Harry Payne Whitney, Mrs. William K. Vanderbilt, and many others.

De Meyer began writing editorials for *Vogue* in 1915, observations of the social and fashion world, and reminiscences of the elegant European life he had left behind. At the conclusion of his first article—on the fine art of European entertaining—he turned resolutely to compliment-ing the entertaining of the country that had given him a wartime refuge: "I must say that having had the opportunity of being present at some of the most brilliant of the parties of Newport, I have never had the impression of a too lavish display or of the vulgarity of too much money. What do I care if a rose is so beautiful that it fetches a higher price at the florist's than does a more ordi-nary bloom? If the hostess has fortune enough not to have to consider expense, it would seem almost mean for her not to have the most exquisite rose that could be coaxed to bloom."[34]

Each year at *Vogue* saw an increase in the number of pages bearing de Meyer's images. While others continued to borrow his stylistic innovations, the Baron's photographs all bore his distinctive, Viennese Secession-style signature. The photographs of Arnold Genthe, Ira Hill, and E. O. Hoppé, in addition to the more pedestrian work of the Campbell Studios and Pach Brothers, were used by *Vogue's* editors, as were line drawings, all in keeping with Turnure's original promise that the magazine would be mainly pictorial. But de Meyer's work is outstanding: the luminous quality of his images beams forth in hair, pearls, and fabrics.

Mrs. Howard Cushing (a frequent model for de Meyer) was somewhat exotic in her dress-ing—tending, as *Vogue* pointed out, "always toward the Arabic and the Persian, never toward the Parisian."[35] His portraits of her were published with some regularity in the magazine, and they show de Meyer at his very best. Her expressive face peers out at the viewer from the page, sur-

rounded by emblems of power and wealth: gleaming furs, the perfect pearl at the ear, art discreetly out of focus in the background. She was very beautiful, and we can see in her portraits that rare co-agency enacted by de Meyer with the very assured among his sitters: her aura clearly transcends her packaging (p. 96).

In 1916, de Meyer wrote a few articles on entertaining and decorating, which were often accompanied by his photographs of flowers and tabletop settings (fig. 11). Loyally, he wrote about New York in a rapturous tone, calling it "the most wonderful city of its kind in the world. . . . [It] has its own individuality, its great and inspiring, driving force, which is invigorating and unique."[36]

It was around this time that *Vogue* began using photography increasingly to document fashions, and not only society figures. De Meyer started using theatrical personalities and Flo Ziegfeld's Follies as models—women who did not require lofty Van Dyck presentations, or the artifices he drew from Klimt. Freed from these constraints, de Meyer began placing his models on stagelike sets and moving them about as if they were mannequins. The dancer Irene Castle was a favorite—she never appeared as stiff or mannered, no matter how hackneyed the pose. *Vogue* published more and more of de Meyer's photographs, grouped in units; his images would be spread sequentially over several pages, approximating the "fashion essay" that he would develop seriously in the 1920s at *Harper's Bazar.*

During this period, de Meyer and Olga sought the spiritual guidance of an astrologer, who gave them new names: "Gayne" and "Mhahra." The Oriental craze, which had washed over Paris and London (and had reached a fever pitch with the arrival of Diaghilev and the Ballets Russes), finally hit New York. With it came a fascination for Eastern and other "exotic" religions and belief systems, and the de Meyers were as caught up in the spiritual quest as anyone.

The Baron took up interior decorating, and launched his own line of couture, which he called Gayne House; highlighted by *Vogue*'s editorials, his designs were a great success. Gayne House was situated in an elaborately decorated town house at 59 East 52nd Street in New York, filled with antique European furniture, glass, silver, and tapestries. De Meyer's fashions were touted in *Vogue* as "touched by just the right palette of colors." His shop, Zarah, was known for its support of the war charities and was, in turn, patronized by the socially prominent ladies who ran the charitable organizations. *Vogue*'s March, 1918, editorial and photography layout ran for several pages: "At Zarah's One May Buy Unusual Clothes and Help The Allies; The Proceeds Go To War Charities." The models wearing the clothes for de Meyer's photographs included the Baroness de Meyer herself, along with other recognizable names. The de Meyers were at the fulcrum of the social centrifuge; he and Olga were arbiters of taste and manners in all spheres—fashion, society, theater, décor. And it was at this point almost de rigeur for any *grande dame* or theatrical star to have her portrait published in *Vogue*, with de Meyer's signature.

Fig. 12. HARPER'S BAZAR,
May, 1926.

Fig. 13.
JOHN BARRYMORE.
Published in *Vanity Fair*,
January, 1920.

Fig. 14. VOGUE, November 15, 1918.

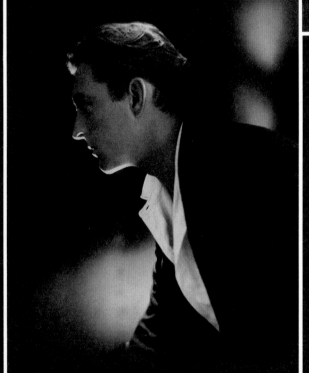

Fig. 15.
MRS. WILLIAM
RANDOLPH HEARST.
Published in *Harper's Bazar*,
July 1921.

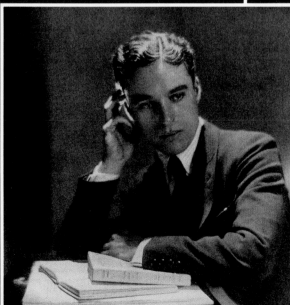

Fig. 16.
CHARLIE CHAPLIN.
Published in *Vanity Fair*,
January, 1921.

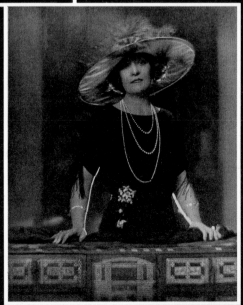

Nineteen-eighteen was de Meyer's most prolific year at *Vogue:* the sheer number of photographs he published is astounding. In May, he produced a stunning collection called the "Bride's Yearbook." His subjects in this series were transformed into ethereal, innocent creations, bedecked in lace, veils, pearls, and gleaming satins—pure fantasies of femininity. The Baron camouflaged completely any hint of sexuality in these nymphs, by swathing them so thoroughly in poetic allusion that no trace of real woman remains. This propensity to make his models into doll-like androgynes increased as de Meyer's workload intensified; one can only surmise that critical acceptance of his highly stylized work encouraged him.

One of de Meyer's loveliest bridal portraits is of Natica Nast, the young daughter of Condé Nast and Clarisse Coudert. A styling decision was made by Coudert that only a very young girl (such as her own teenaged daughter) could carry off the qualities of the wedding veil by Thurn and the wedding dress by Tappé. And so de Meyer assembled the snowy tableau of the American Bride of 1920. Natica is evocatively backlit, in profile, her bouquet held stiffly upright in her lap. The ribbons of the dress swirl about her in loops, the flowers of the veil assure that her eyes are hidden, only the angle of her nose and soft mouth are visible. Her rounded chin, neck, and shoulders are bare beneath sheer gauze, but not seductive; there is no erotic suggestion of the bosom, her childish figure gives no indication of maturity. She was her mother's and de Meyer's perfect invention of bridal and childish innocence; a vision to arouse neither lust nor anxiety. These bridal pictures give us some of de Meyer's finest work of this era; the series also provides a clear example of his ability to represent, through fashion, his own distinct construct of the feminine (p. 100).

In an article on de Meyer for *Vanity Fair,* John Savage described how appreciatively the photographer was viewed during those first years in New York: "Since his arrival in this country seven years ago [de Meyer] has successfully built up three separate business enterprises. Besides being a photographer, he is an interior decorator and a designer and maker of women's clothes. . . . From a hundred sources de Meyer will draw his conceptions, but the results are absolutely his own, stamped with his own taste, and all touched in some way with that fantastic exaggeration which is part of his genius . . . [but de Meyer's photographs are] those of his creations most worthy of our attention. . . . Practically every celebrity in the social and artistic worlds of Europe and America has been photographed by Baron de Meyer" (figs. 13, 16, pp. 94, 99, 102, 103).[37]

After World War I, de Meyer traveled frequently to Paris to photograph the couture collections. While line drawings were still printed alongside photographs in the magazine, American editors were now able to arrange special photo-sessions to record the new styles overseas and ship them home for publication. This gave rise to couture-pirating, but more importantly, it brought increased visibility to a fashion industry rebuilding itself after the ravages of the war. The publicity was necessary, and the industry protected itself by cooperating with the magazines on the timing of collection releases.

Aside from the glamorous collection work, the number of de Meyer photographs published in *Vogue* decreased sharply after 1920. The reasons for this are unclear: perhaps he simply was not in New York. Quite probably, de Meyer felt a need to return to the freer, more creative and fashionable air of Europe, particularly Paris. And it is likely that the Baron and Edna Woolman Chase had a disagreement over the amount of time he was spending away from the Condé Nast offices in New York.

PARIS BETWEEN THE WARS: MODERNISM AND HARPER'S BAZAR

By 1922, de Meyer had left *Vogue* and joined the staff of its chief competitor, *Harper's Bazar*, which was owned by William Randolph Hearst. The Baron and Olga moved to Paris, eager to take up their former position in European society. Chase wrote in her memoirs that she felt personally betrayed by de Meyer's desertion—Hearst frequently raided Nast's magazines for well-trained talent, and he offered defectors far more generous salaries than either Nast or Chase was prepared to pay. However, in de Meyer's case, the change to *Harper's Bazar* may have been induced by other factors. Chase controlled the entire artistic production at *Vogue*. At *Harper's Bazar*, de Meyer was given more freedom to create whole layouts, which serve as evidence that his contract with Hearst included incentives beyond an apartment in Paris and an increased salary.

De Meyer's photographs had appeared in *Harper's Bazar* as early as 1915, but the pictures belonged to the clients, and it was in all likelihood they who chose to use them for the magazine. De Meyer was under an exclusive contract to Condé Nast, with the understanding that his photographs would appear in *Vogue* and *Vanity Fair* only. The contract was purportedly for ten years; however, as early as May of 1921, *Harper's Bazar* ran a photographic editorial called "A Fashion Composition": "In his contribution to this issue of *Harper's Bazar*, Baron de Meyer portrays his conception of modern fashion. Rather than a detailed study of the gown of the actress, he subtly presents an impression of a certain elegance attained by silken fabrics, of many jeweled bracelets and a becomingly individual coiffure. Each detail that goes to make a costume of distinguished perfection is suggested by Baron de Meyer's study."[38]

Harper's Bazar was a different magazine altogether from *Vogue;* it was known, for example, for publishing very good fiction, and during de Meyer's years, it printed stories by Edna Ferber, D. H. Lawrence, Somerset Maugham, and Alec Waugh, in addition to the work of lighter luminaries such as Dorothy Parker and Anita Loos. The magazine's editor, Arthur Samuels, was a member of New York's famed literary congregation, the Algonquin Round Table. Carmel Snow, who had been Chase's protégé at *Vogue* before joining *Bazar* as Fashion Editor in 1932, notes in her reminiscences that Samuels had very little interest in fashion. At *Bazar*, literature flourished,

as did photography and drawing. There were fashion illustrations by Drian and Bernard Boutet de Monvel, and bright, graphic tours de force by Erté on the covers.

Accompanying a self-portrait, an editorial by de Meyer appeared in the September, 1922, issue of *Bazar*. It was his formal introduction to the magazine's readers and an assurance that he would fill a particular role as arbiter of style in the years to come. "You ask me for a forecast of the autumn mode. . . . An answer must be hardly more than an intuition and observation on my part. And yet. . . . One does not live in this very busy center of fashion without observing. . . . Even if but very vague, my talks with M. Jean Patou, with Mme. Boulanger of Cheruit, and my own observations here in this beautiful garden, surrounded as I am by what Paris considers smart and elegant, have given me food for thought. . . . What a problem, to distinguish between real elegance and mere chic! Harmonious elegance is produced quite naturally. It is the outcome of assured taste: whilst chic may be but an angle, an impression, something intangible."[39]

Without a chief editor to mark boundaries as rigorously as Chase and Nast had, de Meyer's work in the 1920s *Harper's Bazar* had a new creative freedom: a sense that anything that enhanced the desirability of fashion could be tried—anything, that is, within clearly recognized standards of elegance. Those standards would change dramatically in the following decade, but in the twenties, de Meyer's intuitive sensibility was right on target. His women looked like mannequins: sleek, with tiny heads, hair, and hats lacquered close. When George Hoyningen-Huené and de Meyer both began using wax heads to model hats, around 1925, the faces were almost indistinguishable from those of the live models.

From Paris, de Meyer wrote editorials for *Bazar* in vast numbers, and they came from a deeply serious commitment to Paris's fashion mission to the world. He wrote in *Bazar*'s January, 1924, issue: "Anyone acquainted with the inner workings of a dressmaking establishment in either Paris or New York, . . . will easily realize the difference between Paris and almost any other center in the world. It is a difference of temperament. Paris is full of atmosphere, full of tradition, of inborn interest in women's wear in any shape or form. Men and women concerned in this business . . . are possessed of infinitely higher mental qualities, and they view what to them is almost an art from the very highest angle."[40]

Not a great deal of attention has been paid to de Meyer's fashion work of the twenties; connoisseurship has focused instead on his painterly, exhibition material of the Pictorialist years. The merits of photography as a medium of art production are often measured through the quality of the print, and thus judgment has traditionally faltered at the photomechanically produced page. The truth of the matter is that, although de Meyer was renowned for his superb printing techniques, a good portion of his best work appeared on commercially printed pages. And much of this work was produced during the twenties. As most of the prints were lost or destroyed during production, little

has survived to hang on museum or gallery walls. Another problem with evaluating de Meyer's work of the twenties is the overwhelming mass of it. Much is dazzling and innovative, but the continuing pressure of ongoing deadlines also forced him inevitably into repetition and cliché.

It is interesting to note that de Meyer was in his early fifties when he arrived in Paris, after the end of World War I, to work for *Harper's Bazar*, nevertheless his energy level seems not only undiminished, but heightened. Some accounts allude to the Baron and Olga's use of drugs during this period. However, de Meyer's phenomenal level of production at the magazine proves that his involvement was not to such an extent that it impeded his work in any way. The Paris years were enormously fruitful: it was during this time that de Meyer's photographs reached new heights of artistic vision and creativity.

The Baron and Olga continued to travel and entertain lavishly; indeed, their lives kept up the brisk pace they had set nearly twenty years before. They continued to summer at the Palazzo Balbi-Valier in Venice, and also kept a house in Constantinople. Their friends included the elegant Eugène de Rothschilds, the wild Violette Murat, the Comte and Comtesse Étienne de Beaumont, and of course Diaghilev, whom they joined each year in Venice. Through it all, de Meyer and Olga remained spirited and unquestionably chic.

In addition to his photographic layouts in *Harper's Bazar*, which frequently ran several pages an issue, in 1922 de Meyer began a series of fashion articles that he would continue to write for the magazine until he left ten years later. The concept did not change dramatically over the years: the pieces often took the form of imaginary conversations with women visiting Paris to shop. Essentially, the articles were de Meyer's commentaries on the great couture houses, and on the implications of the newest designs. Those designs lured women into a belief that they could reinvent themselves each season, into an endless search for the perfect new manifestation of beauty and grooming.

Fashion and society were a way of life for a large number of leisured men and women; how they looked and where they were seen were endless preoccupations. Clothing was chosen with a view to the completed picture and to the class message it encoded. In his editorials and the accompanying photographs, de Meyer detailed the proper assembling of an outfit, the establishment of a look, a persona—the correct layering of hat, scarf, jewel, or flowers over a dress or suit. As he reported it, fashion in Paris during the twenties was understood by his readers to be a highly creative and significant art. The great houses of Chanel, Chéruit, Patou, Boulanger, Lanvin, Poiret, Lelong, and Worth created clothes and images of fantasy that were imbued with intangible but indisputable powers.

Serving as faithful mirrors (in their own commercial interest), the fashion magazines reported on a magical enclave far removed from the political realities and confusions of the period

between the two world wars. Interestingly, issues of *Harper's Bazar* of 1929 and after carry no word whatsoever of the Depression to mar the crystalline elegance of the pages. Fashion has always relied on the fatuous notion that a new hat or scarf or jewel signifies a new day, a new beginning— light on the horizon.

During the years in Paris, de Meyer chose to live exclusively in this hermetic world of clothes, mannequins, and mirrors; his writing and photographs for the magazine reflect that choice. There is no reference in any of his editorials to biography, literature, or the progressive art movements of Paris. However, something of the Modernist sensibility found its way into his images. Again, the Baron's work reflected the aesthetic tenor of his environment, even if he himself did not play a part in the development of its principles.

It was agreed among avant-garde intellectuals in Europe during the twenties that photography presented a possibility of printing on paper the myriad experiences of the mind, through the seemingly unlimited potentials of the camera's new technology. There was an intellectual fervor for the energized combinations of techniques, both graphic and photographic. The interaction of graphics, typography, and photomontage—with its layering of solarization, fragmentation and photograms—was idealistically labeled the *Neue Optik* (New Vision) by Lásló Moholy-Nagy. While de Meyer was not enmeshed in the hyperintellectual games of Dada or Surrealism, nor did he participate in the political idealism of Russian Constructivism or the teaching of the German Bauhaus, he seemed to absorb subliminally the finished forms of these movements. In his later photographs for *Harper's Bazar*, a new graphic look structured and fractured the page layouts; forms are angled and clean edged, tonal contrasts are sharp.

Of all the Modernist groups, the Surrealists might well have attracted de Meyer's attention, emanating as they did from Paris, and inciting a degree of lunacy and a high regard for the mazes of psychology. Although de Meyer did not mention them in his meditations on elegance and mode, it can be assumed that he at least knew of the Surrealists' photographic work. In 1925, Man Ray was commissioned to photograph the couture section of the Paris "Exposition des Arts Décoratifs." The pictures were published in the French and American editions of *Vogue*, and one of the photographs appeared on the cover of the Surrealist magazine *La Révolution surréaliste*.[41] De Meyer would certainly have seen these images—with their extensive use of wax mannequins on constructed stage sets—and it seems that they played a significant role: at this point his photographs begin to record a similarly surrealistic constructed vision.

De Meyer's photograph of a model wearing a hat by Agnès appeared in the August, 1925, issue of *Harper's Bazar*, and displays his evolving Modernist sensibility. It was titled *Green and Silver Leaves* and in it, de Meyer offset the geometric construction of the fashion shown—the hat, with its intricate leaves—with the doubled-black and outlined cone to the left, and with the rec-

tangles softly outlined in the background. The tonal contrasts emerge sharply. The costume envelops the model completely: only the nose and mouth are an indication that the figure is human. The space of the shot is constructed as a modernistic stage; and the figure in the frame is equally stylized. The stillness and balance that de Meyer has achieved intuitively reflects the prevalent new forms, although without engaging in their theoretical meanings.

De Meyer's "Modernist look" is also seen in *The Black Spangled Smoking*, a photograph of a Chéruit design that appeared in January of 1927 (p. 130). This image abstracts the construction of space even more dramatically, with carved geometric shapes that function as a foreground for the figure of the model—hand on hip, a thoroughly modern mannequin. In *Evening Sandal* and *Sports Sandal*, which appeared in September of 1928, one photograph contrasts the complexity of double-exposure against the fetish of a single object, the shoe (p. 129). The layout is fractured and then recombined in a new balance, giving the shoe as an object the look of art, luxury, and infinite desirability. Both photographs have a clarity of intention that is on a par with de Meyer's most seductive still lifes. The Hermès fashion page, *Smart Luggage*, is one of the best examples of de Meyer's use of the mannequin as a graphic form and the space as constructed set (fig. 12). The juxtaposition of flat, cutout forms, shaped by the black-and-white contrast, dominates the page: the body is no longer living, but an armature from which to hang clothes. De Meyer's growing tendency to turn his models into lifeless mannequins is strikingly illustrated in a page showing a Patou dress from 1931. A female form, her face masked by a jeweled hat, is draped on a chair. Glistening fabric serves as a backdrop to her silhouette; the chair and her form are in profile on a raised platform. The photograph is undeniably beautiful as an object; its very seductiveness obscures the fact that it is impossible to tell if the form is wax or human, only the essentials of form and light and fabric are left on de Meyer's stage.

De Meyer stayed with *Harper's Bazar* for ten years. Olga died toward the end of his tenure, around 1930. It has been observed that her last years were ones of despair and increasing involvement with drugs, and de Meyer also is said to have been leading a somewhat dissolute life. If he was, it is all the more a tribute to his complete professionalism that his work for *Bazar*, up until the very month that he left, was of such outstandingly high quality.

When Carmel Snow arrived as fashion editor in 1932, her charge was to give the magazine a fresh look and determined editorial leadership; this, apparently, required chasing de Meyer's increasingly jaded-looking mannequins from the pages, and making room for the fresh-faced beauties of the Depression era. It was the start of a fundamental change in fashion photography and the way women were imaged. The public's fantasy no longer desired icy paragons of glimmering perfection; the viewing audience, mired in economic and political troubles, needed nurturing, and a different packaging for its females. Snow hired a young Martin Munkacsi, who took his models out of the studio and into the sunlight on beaches. And in 1932, she let de Meyer go.

RETURN TO AMERICA AND THE FINAL YEARS IN HOLLYWOOD

After his wife's death, de Meyer drifted for several years about Europe, and was seen in Venice, Salzburg, and on the Riviera, often accompanied by good-looking young men. He brought one of these young men, Ernest, with him to the United States when he fled Europe and the oncoming war in 1938. Ernest was first de Meyer's chauffeur; later, to validate their relationship and assure the young man's ability to stay in America and inherit a small estate, de Meyer adopted him as his son.

Drawn by the climate and a few friends in the film world, de Meyer spent his last years in Los Angeles, with Ernest. He wrote a number of romantic novels (none were published), and held occasional lectures; intermittently, he did society portraits. In 1940, Mrs. Edward G. Robinson arranged to have an exhibition of his work at her home. De Meyer had so few of his earlier photographs on hand that he wrote to Stieglitz to find out what he had. He admitted ruefully to having destroyed most of his own photographic work, and wrote: "What is left—is due to fortunate incidents—some of my work being elsewhere. I tell people—I had a fire in the house I had my studio in—all was destroyed. They would not understand—I should have waited—never to see any of it again! Now I regret it since I take a serious interest in all I have done myself!—My object at present is to assemble a small collection of my life work—I shall have some 40 prints all told." (Stieglitz Archive, 2/15/40.) The Baron died in California in 1946; strangely, sadly, his death certificate lists his profession as "writer (retired)," and does not mention his photography.

De Meyer did not reflect at the time he wrote his letter to Stieglitz that the magazines he had filled to overflowing with his magical images would serve as a lasting repository for his best work. And though the major archive lies in these magazines—*Camera Work, Vogue, Vanity Fair,* and *Harper's Bazar*—there are still a number of platinum and silver prints that have survived and found their way into museum collections.

Fashion magazines answer a social and intellectual need for a prescribed image of femininity in our culture. In an uncertain era, de Meyer responded to this need with feeling and brilliance: his representation of the feminine is an elegant fantasy, which was invented in his studio, and which moved easily from there to the printed page. In all of his work—from the early, luminous still lifes, through the Modernist-inspired constructions of the late 1920s—he shows an astounding eye for style. Drawing many elements of his photographic innovations from fine-art movements at the turn of the century—the sinuous lines of Art Nouveau, the coded layers of

Symbolism, the emotional shadings of Tonalism—de Meyer's genius for technique transformed painterly qualities into strong, graphic elements in his work.

Although de Meyer's photographs alone would be a rich legacy, he left us with even more: we can see his influence in the work of innumerable photographers who followed his conceptual bases, including Cecil Beaton, Edward Steichen, Man Ray, Louise Dahl-Wolf, and George Hoyningen-Huené. The Baron had a singular and wonderful gift: the ability to devise the perfect style for his era, to mirror an age in portraiture, and to record not only its fashions but its representations of identity. The period of his life—spanning two world wars—was a time of both anxiety and great creativity. De Meyer reflected the energy and the psychology of his day with brilliant and empathetic insight.

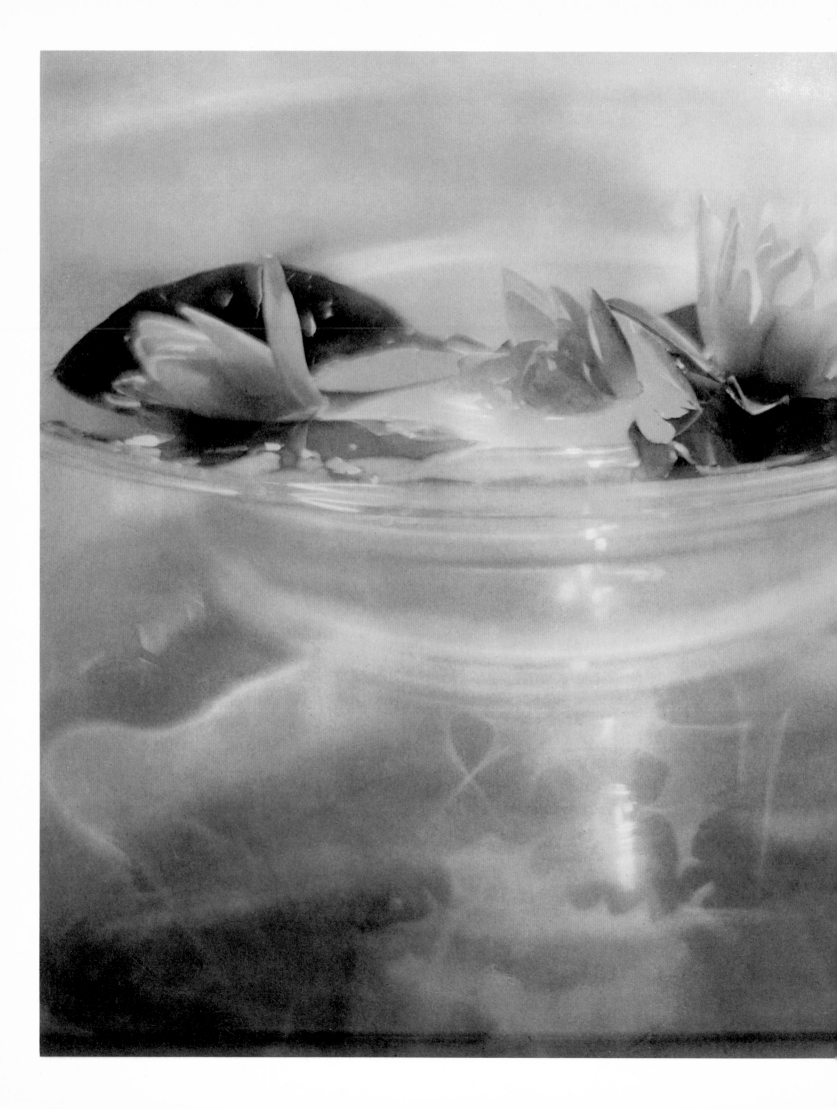

WATER LILIES
negative ca. 1906; printed 1912.
Collection The Metropolitan Museum
of Art, New York, Alfred Stieglitz
Collection, 1933. Published in
Camera Work 24, October, 1908.
De Meyer was rightfully proud of the
luminous quality of this print,
which fully displays his technical
virtuosity. In his correspondence with
Stieglitz concerning the issue of
Camera Work in which this image
appeared, de Meyer complained
that the commercial printers had lost
the sparkle of his original print—
"water and glass shining in the sun."
He asked that Stieglitz have
the proof reprinted so the highlights
on water, glass, and flowers
would be accurately reproduced.

PICTORIALISM

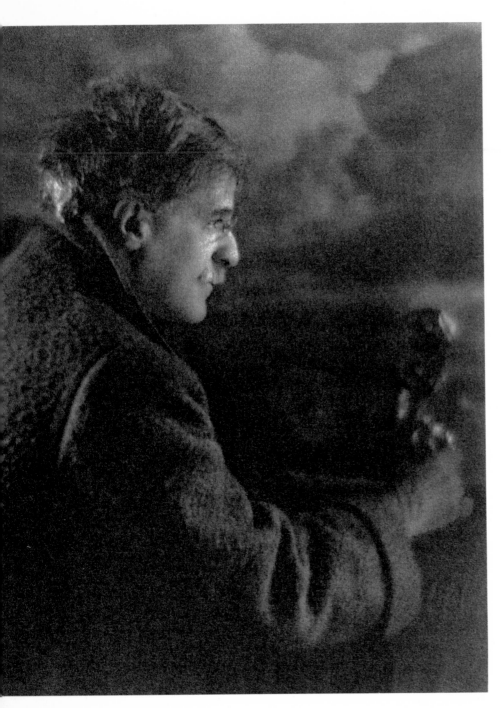

Left, ALFRED STIEGLITZ
ca. 1910–1920. Reproduced by
permission of the Australian National
Gallery, Canberra. Stieglitz changed the way
the world understood photography: it was
largely due to his efforts—the seminal journal
Camera Work, his gallery at 291 Fifth Avenue in
New York, and many international exhibitions
held under his auspices—that thoughtful
viewers were convinced of photography's
merits as an expressive medium of art. Stieglitz
exhibited and published de Meyer's
work regularly, and had a great appreciation
of his fine craftsmanship. De Meyer, in
turn, looked to Stieglitz as an
important mentor.

Right, THE SHADOWS ON THE WALL,
"CHRYSANTHEMUMS"
ca. 1906. Collection The Metropolitan
Museum of Art, New York, Alfred Stieglitz
Collection, 1933. These shadowy flowers
may reflect the symbolism of Maurice
Maeterlinck's theories on the inner
forces of plant life, published in 1906 in
his book *The Intelligence of the Flowers*.
Maeterlinck's concept was of a primal struggle
between the flower's rootedness and
its thrust toward light, a drive toward freedom;
an apt metaphor for de Meyer's own
urge to free himself from bourgeois reality
through the fantasy and beauty
of photography.

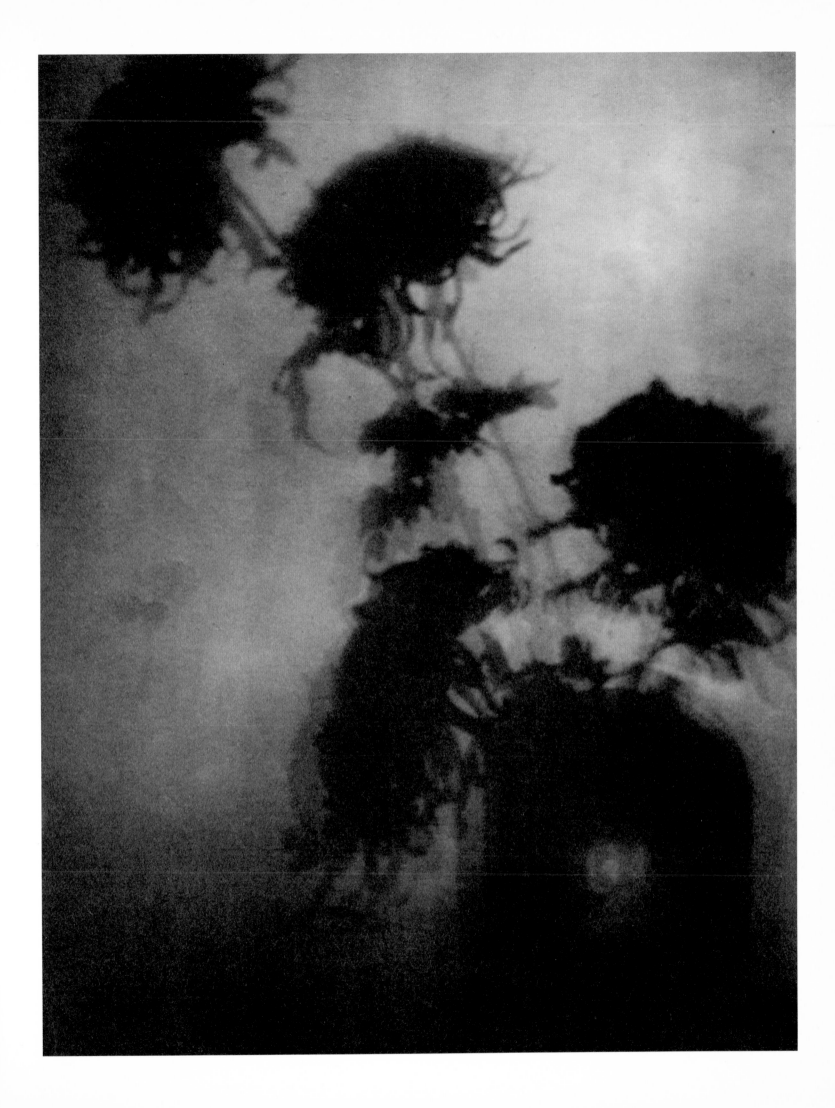

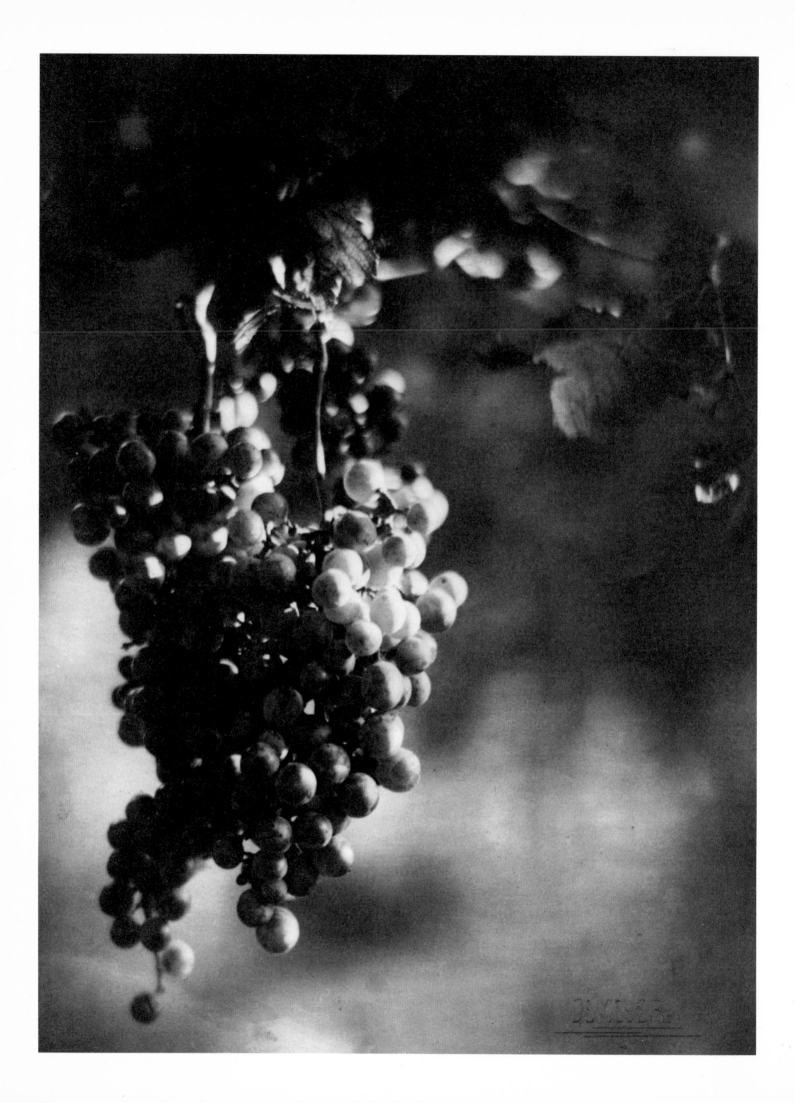

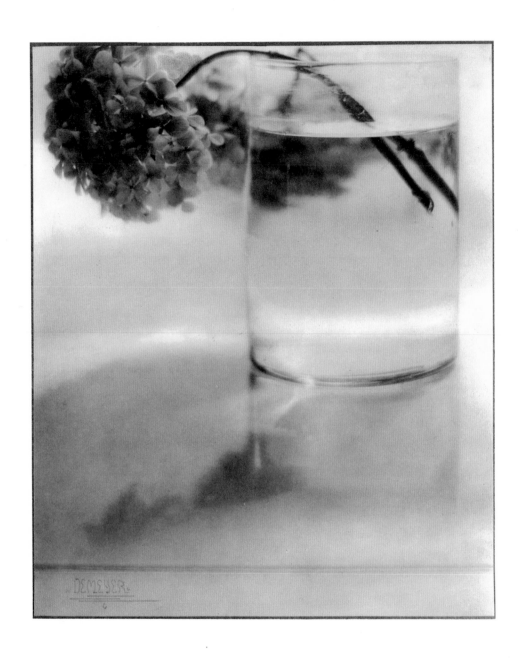

Left, GRAPES
ca. 1908. Collection The Royal
Photographic Society, Bath, England.

Above, HYDRANGEA
ca. 1908. Collection The Royal
Photographic Society, Bath, England.
Published in *Camera Work* 24,
October, 1908.

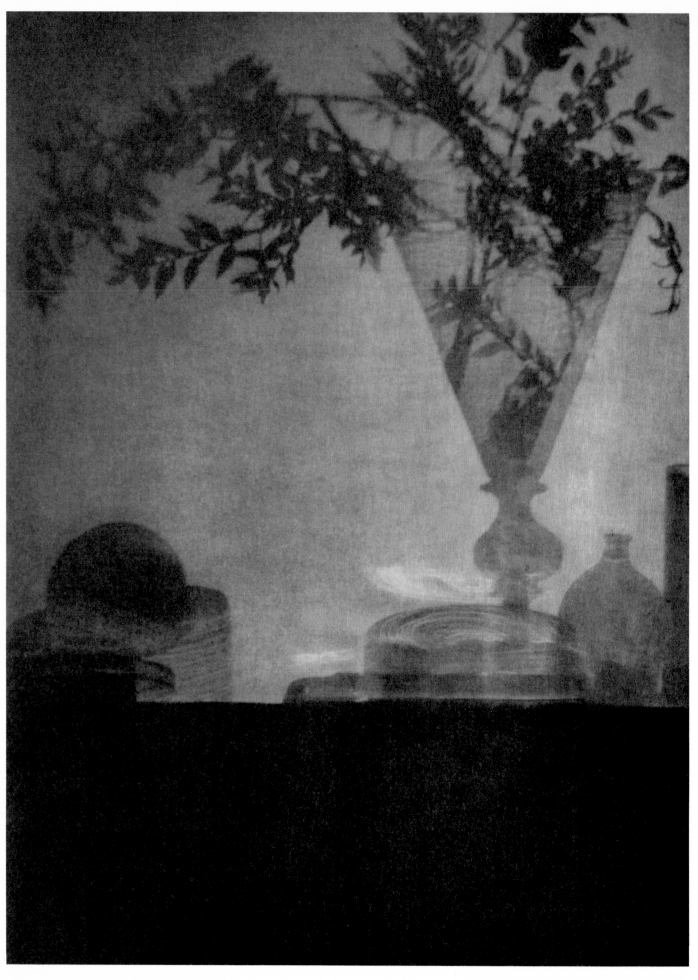

GLASS AND SHADOWS, ca. 1909. The Baltimore Museum of Art: Purchase with exchange funds from the Edward Joseph Gallagher III Memorial Collection; and Partial Gift of George H. Dalsheimer, Baltimore. Published in *Camera Work* 40, October, 1912.

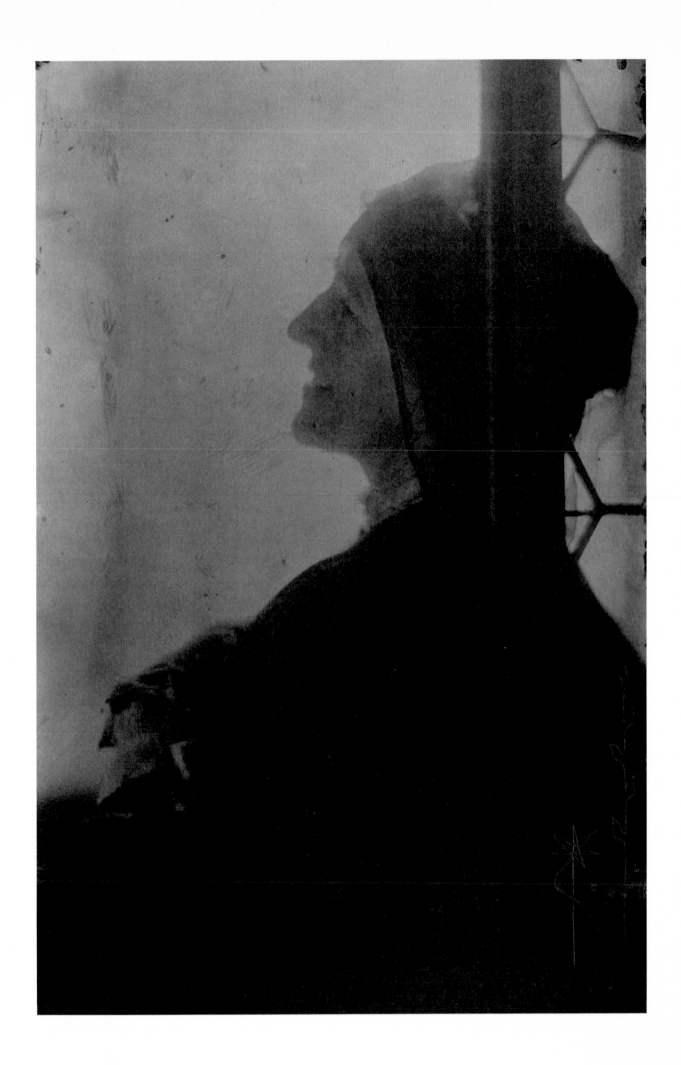

Previous page, GERTRUDE KÄSEBIER
n.d. Collection The Museum of
Modern Art, New York. Gift of Miss Mina
Turner. Käsebier was a highly successful
portrait photographer in the
early twentieth century, and was a
respected member of Stieglitz's
Photo-Secession circle—the first issue
of his journal *Camera Work*
was devoted solely to her photographs.
She perfected an artistic, soft-focus style
of photography that was highly
influential on de Meyer's work; she was
supportive, and possibly instructive,
in his early efforts in the Pictorialist genre.
The Viennese Secession-style
floral design, traced on the right side
of this image, indicates that the photograph
dates from early in de Meyer's career.

Right, MARCHESA LUISA CASATI
1912. The Baltimore Museum of Art:
Purchase with exchange funds from
the Edward Joseph Gallagher III Memorial
Collection; and Partial Gift of George
H. Dalsheimer, Baltimore. Published in
Camera Work 40, October, 1912. De Meyer
met Casati in Venice, where she
reigned in the years before World War I,
not only as a supremely exotic
personality but also as a woman of discerning
and original taste. Her extravagant
costumes, many designed by Leon Bakst, were
offset by white makeup, kohl-rimmed
eyes, and flame-colored hair. She floated in
her gondola on the Grand
Canal accompanied by leopards and
coiled snakes, and appeared at
evening festivities trailed by gilded servants.

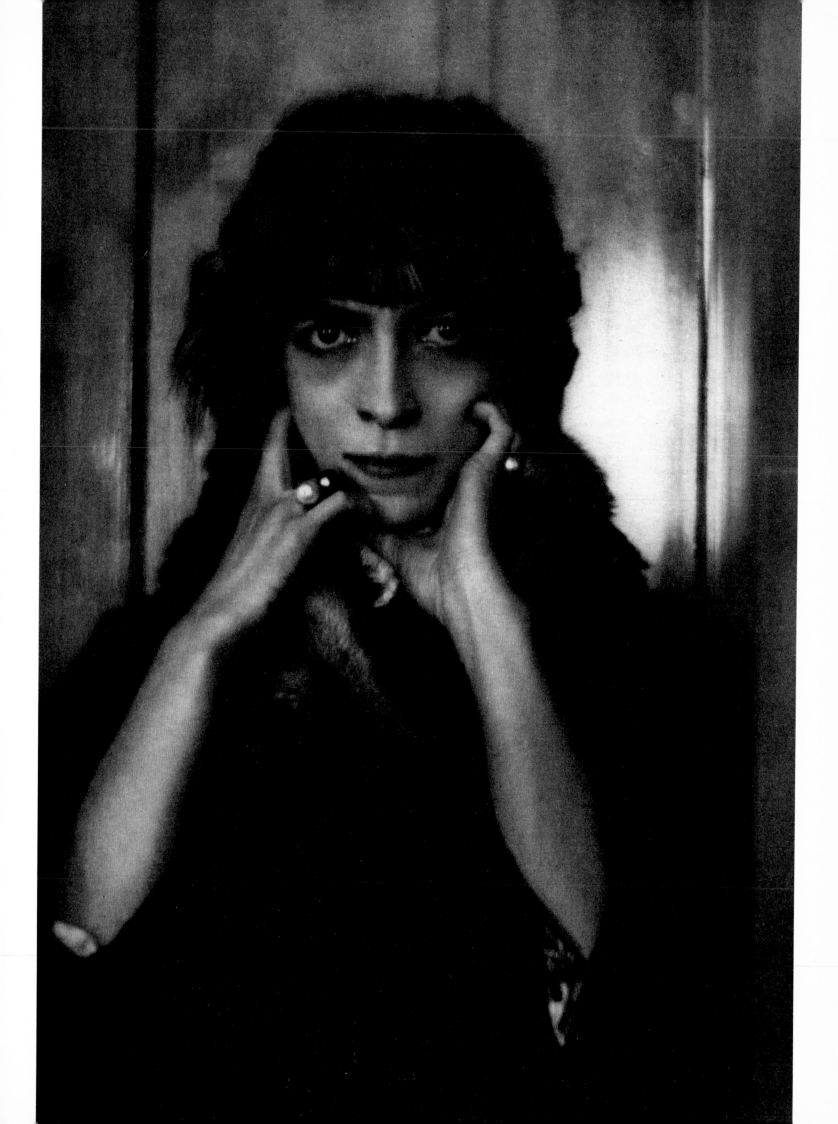

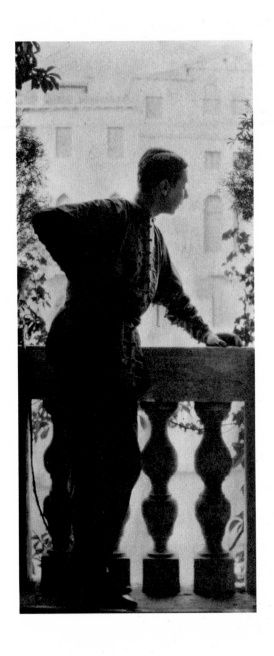

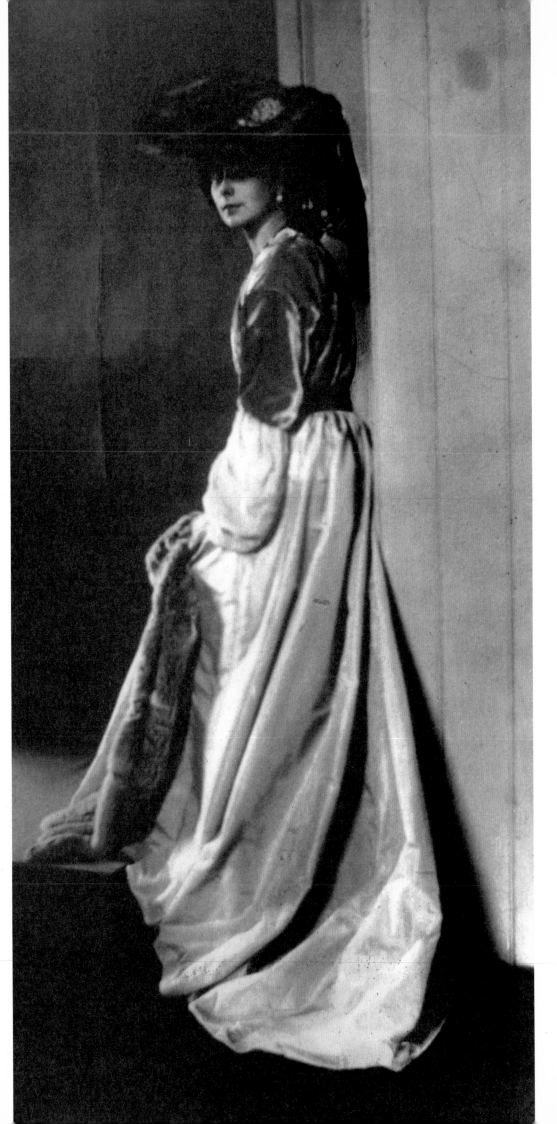

Far left,
SELF-PORTRAIT
1900. Collection
The J. Paul Getty
Museum, Malibu,
California.

Left, PORTRAIT
OF A LADY
n.d. Collection
The Royal
Photographic
Society, Bath,
England.

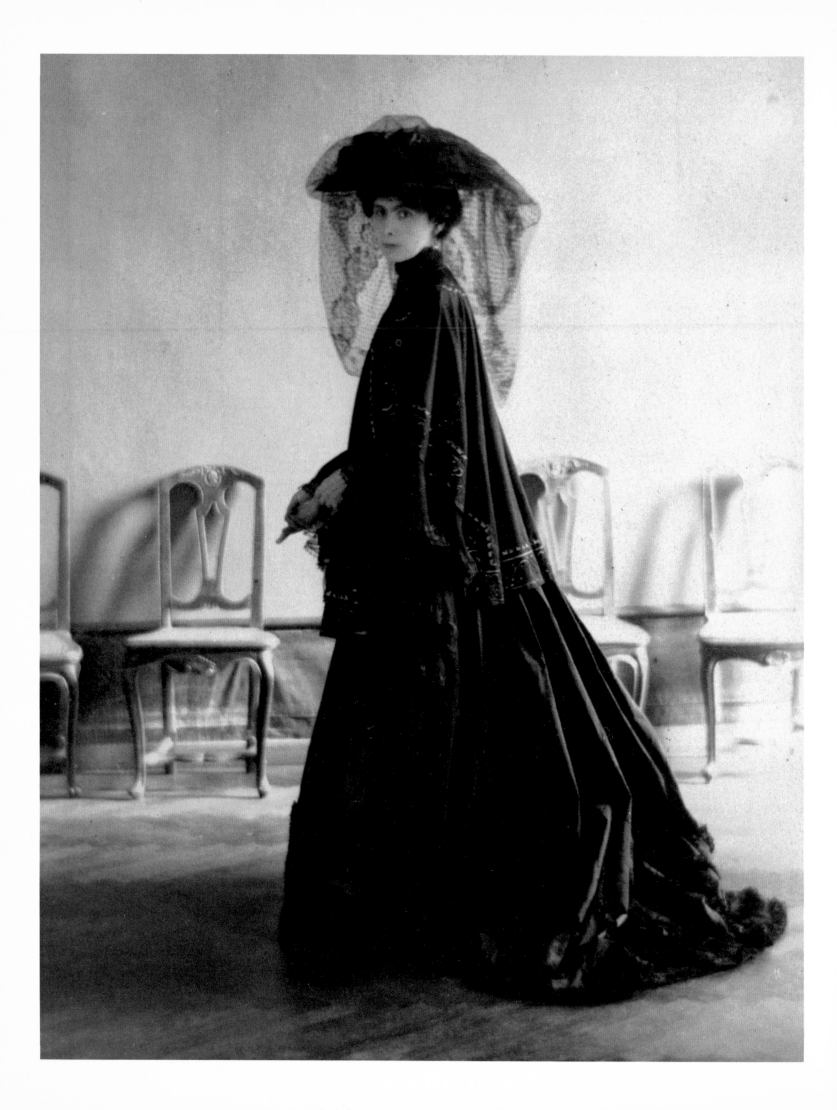

Left, BARONESS OLGA
DE MEYER
ca. 1900. Collection The
Museum of Fine Arts,
Houston; The Sonia and
Kaye Marvins Portrait
Collection, Museum Purchase
with Funds Provided
by Sonia and Kaye Marvins.
De Meyer phtographed
his wife Olga frequently:
she was a natural
model, and had sat for
portraits since childhood.
In addition to her
engaging, distinctive
features and her graceful
mien, Olga had a decidedly
mysterious air that
captivated the artists
who painted her while she
was growing up.
This portrait was probably
taken around the time
of her marriage to de Meyer,
before he acquired a
Pinkerton-Smith
soft-focus lens.

Right, UNTITLED
(OLGA DE MEYER)
ca. 1900. Collection
International Museum of
Photography at George
Eastman House,
Rochester, New York.

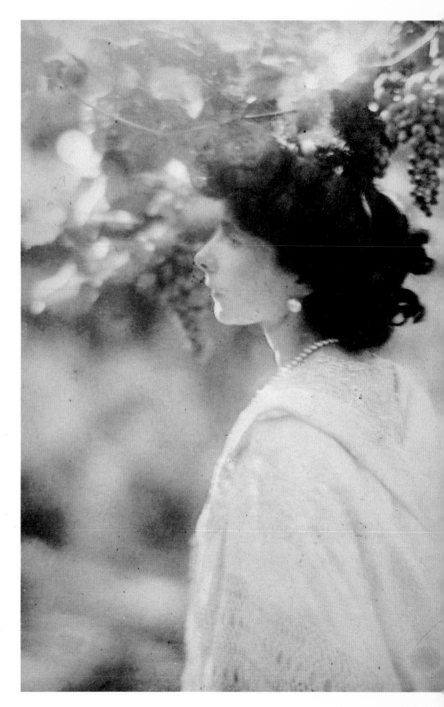

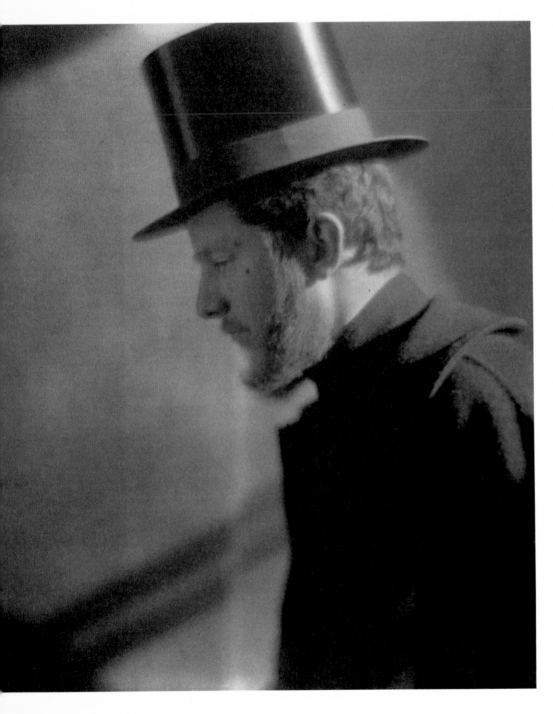

Left, ALVIN LANGDON COBURN
ca. 1905. Collection
International Museum of
Photography at
George Eastman House, Rochester,
New York. De Meyer
and Coburn were close friends.
In the years before World War I,
they organized exhibitions
together, and Coburn frequently
carried de Meyer's photographs back
to Stieglitz in New York.
An American photographer, Coburn
moved to London in 1899; by
the following year, his photographs
were being shown with the
Pictorialist group the Linked Ring
Brotherhood. A distant
cousin of F. Holland Day, Coburn
was an artistic photographer
whose pictures were informed by the
Symbolist aesthetic.

Right, TEDDIE
ca. 1910. Published in *Camera
Work* 40, October, 1912.

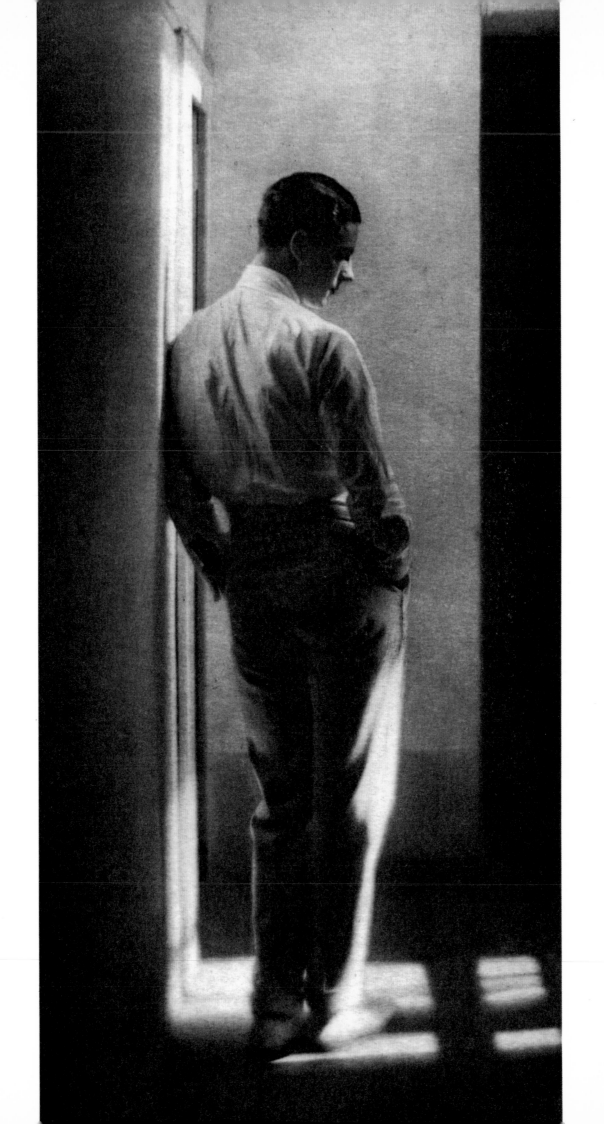

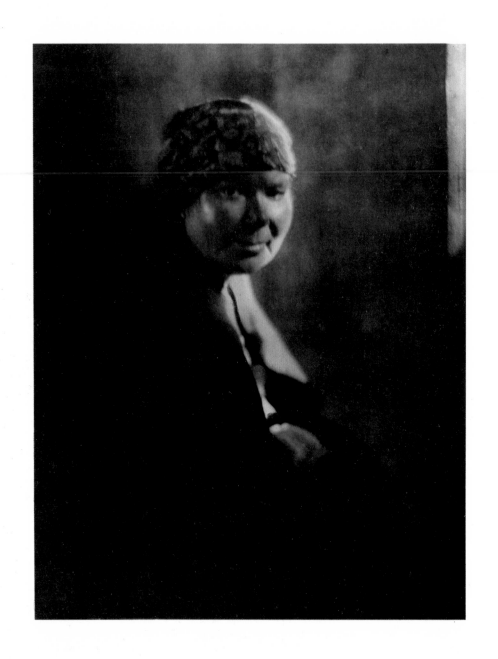

Above, PORTRAIT OF A
PEASANT WOMAN
1905. Collection The J. Paul Getty
Museum, Malibu, California.

Right, THE BALLOON MAN
early 1900s. Courtesy G. Ray
Hawkins Gallery, Santa Monica,
California. Published in
Camera Work 40, October, 1912.

AÏDA, A MAID OF TANGIERS, negative ca. 1910; printed 1912. Right, THE SILVER CAP, negative ca. 1909; printed 1912.
Collection The Metropolitan Museum of Art, New York, Alfred Stieglitz Collection, 1933.

Above, NORTH AFRICAN
PORTRAIT STUDY/BLACK MAN
STANDING WITH A BASKET
1907–1911. Collection The J. Paul
Getty Museum, Malibu, California.

Right, NORTH AFRICAN
PORTRAIT
1907–1911. Collection The J. Paul
Getty Museum, Malibu, California.

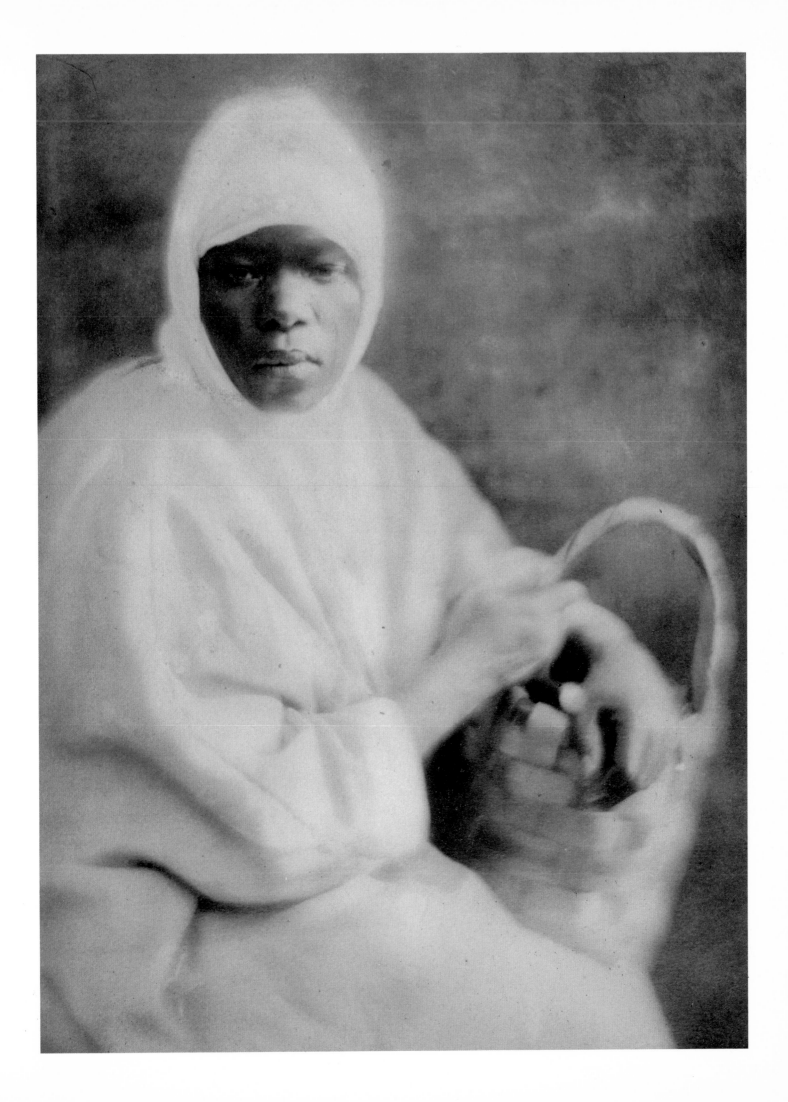

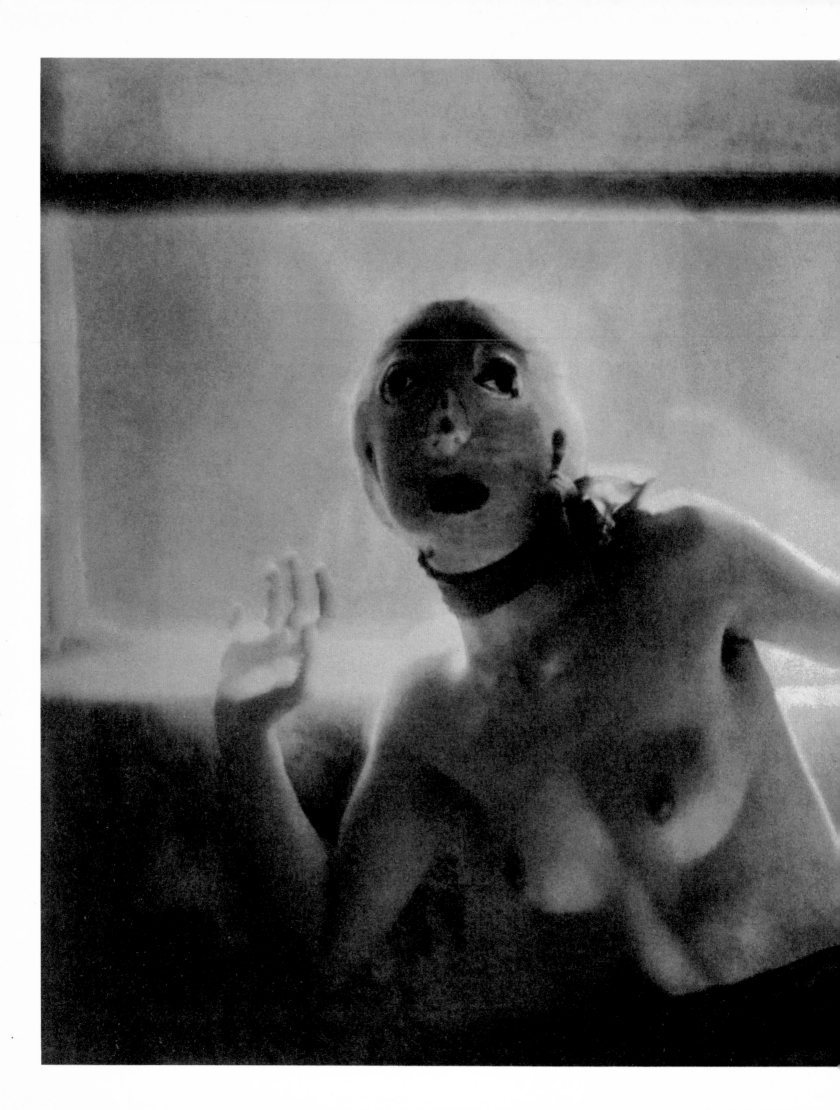

DANCE STUDY
ca. 1912. Collection The
Metropolitan Museum of Art,
New York, Alfred Stieglitz
Collection, 1949. This
print is probably from the
same year during which de Meyer
photographed Nijinsky
in *Le Prélude à l'Après-midi
d'un Faune*. It is a highly unusual
image: no other photograph
of a nude by de Meyer has been
preserved. The gender of the figure
is clear from the feminine
torso, but the head and hair are
concealed by a fantastical
mask with staring eyes—the
figure is at once sexual
and sexless. This may have been
a conceit of the dancer's; if it
was de Meyer's concept,
it would seem to indicate his
unease with overt feminine
sexuality.

DANCE

Right, VASLAV NIJINSKY AS THE
FAVORITE SLAVE IN SCHÉHÉRAZADE
Collection The New York
Public Library for the Performing Arts,
Roger Pryor Dodge Collection. Published in
Vogue, May 15, 1916; in *Vanity Fair*, May,
1916. The legendary Nijinsky is often
considered the greatest male dancer of the
twentieth century, and was largely responsible
for the success of Diaghilev's Ballets
Russes. Although the dancer was
photographed often, it seems that de Meyer
alone was able to capture successfully
his power and grace. Nijinsky's face was
reputedly nondescript without makeup, but in
costume and on stage he was transformed
into whatever creature he played,
human or animal. As the premier dancer
of the Ballets Russes, Nijinsky originated all
the great roles for the company—many
were created to showcase his amazing talent.
Diaghilev's lover, Nijinsky was forced from the
company when he married. Nijinsky
was freed from an Austrian prisoner-of-war
camp to dance with the company in New York
in 1916. Insanity ended his career in
1919, three years after this striking portrait
appeared in the Condé Nast magazines.
He was institutionalized in Switzerland and
England for most of the remainder of his life.

Following two pages, SCHÉHÉRAZADE
ca. 1911. Collection The New York
Public Library for the Performing Arts,
Roger Pryor Dodge Collection. *Schéhérazade*
was a one-act ballet created especially for the
Ballets Russes by Bakst and Fokine, set to
music by Rimsky-Korsakov. Audiences
were entranced by the spirit and powerful
eroticism of Nijinsky's performance
as the gilded Favorite Slave. Bakst's lushly
colorful costumes and set were drawn loosely
from Persian and Indian painting.
With *Schéhérazade* Diaghilev reintroduced
European and American audiences to
a sensational and provocative Orientalism.

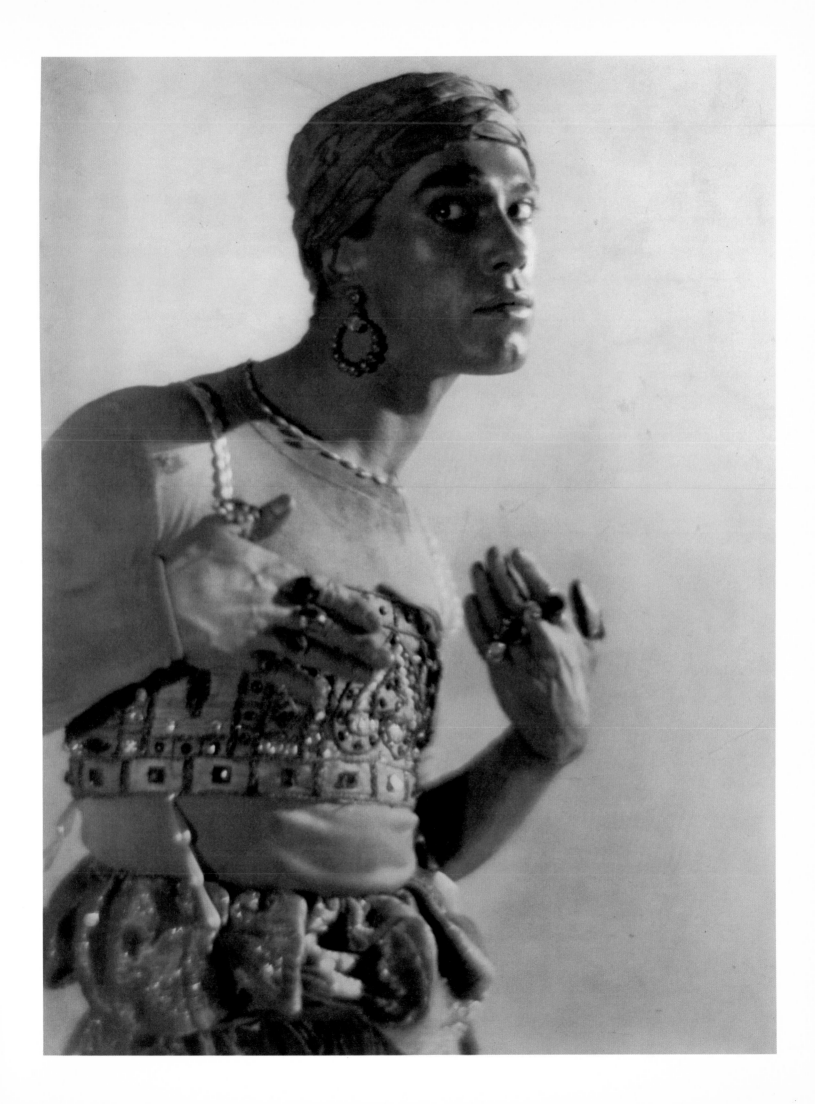

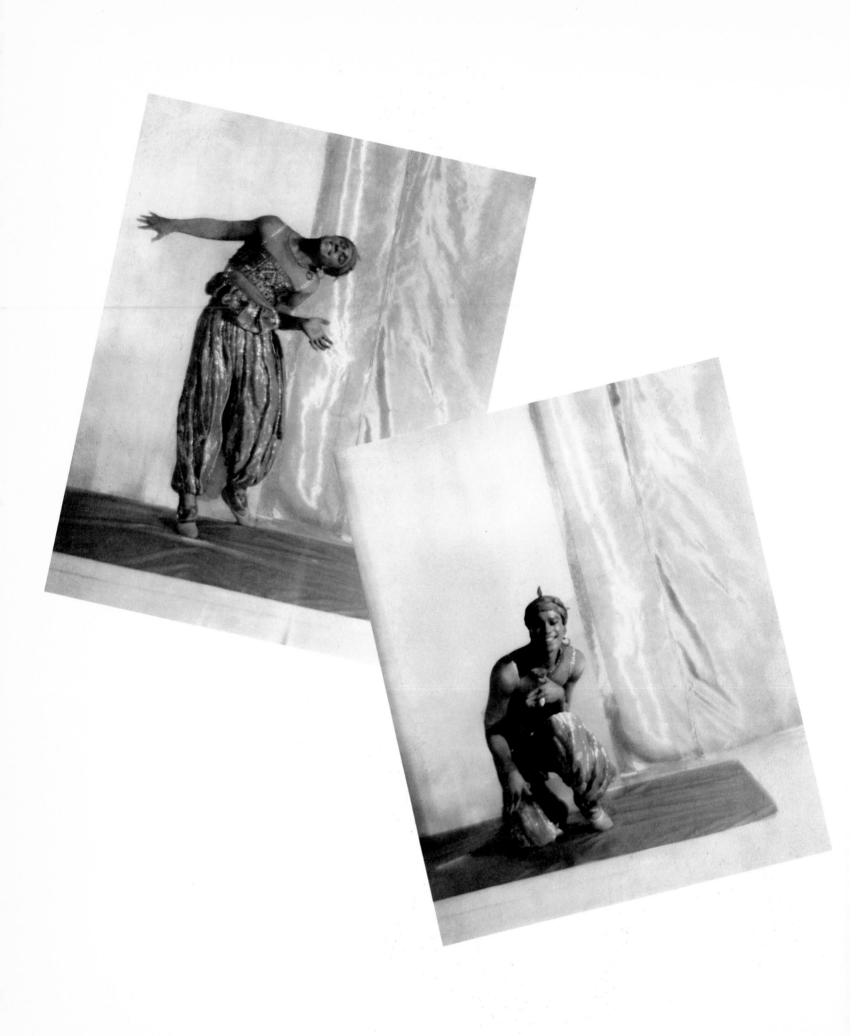

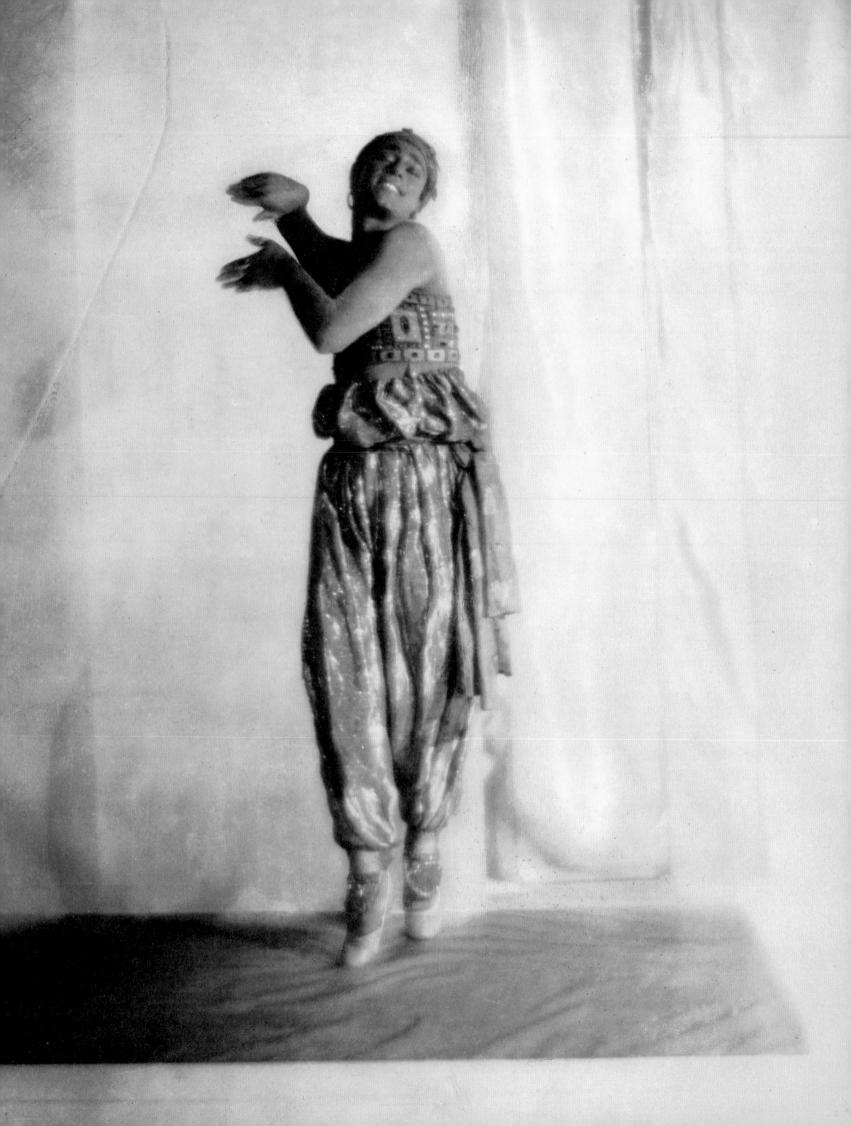

This page and following three pages,
LE CARNAVAL
1911. Collection The New York
Public Library for the Performing
Arts, Roger Pryor Dodge
Collection. Fokine choreographed
this one-act ballet, set to
music by Schumann, with characters
based on the Italian commedia
dell'arte; Leon Bakst designed the
costumes and set. The ballet
premiered in St. Petersburg in
February, 1910, and was then seen
in Berlin and Paris, where it
was a great success, winning critical
praise for both Nijinsky and Tamara
Karsavina. Although, as Lincoln
Kirstein notes, Nijinsky danced
in full trousers for London
performances in 1911, de Meyer's
photographs show the dancer
wearing tights that expose his heavily
muscled legs. In this series,
de Meyer records the choreography
of a single movement of the
ballet sequentially, almost cinemati-
cally, capturing some of the theatrical
quality of Nijinsky's performance.

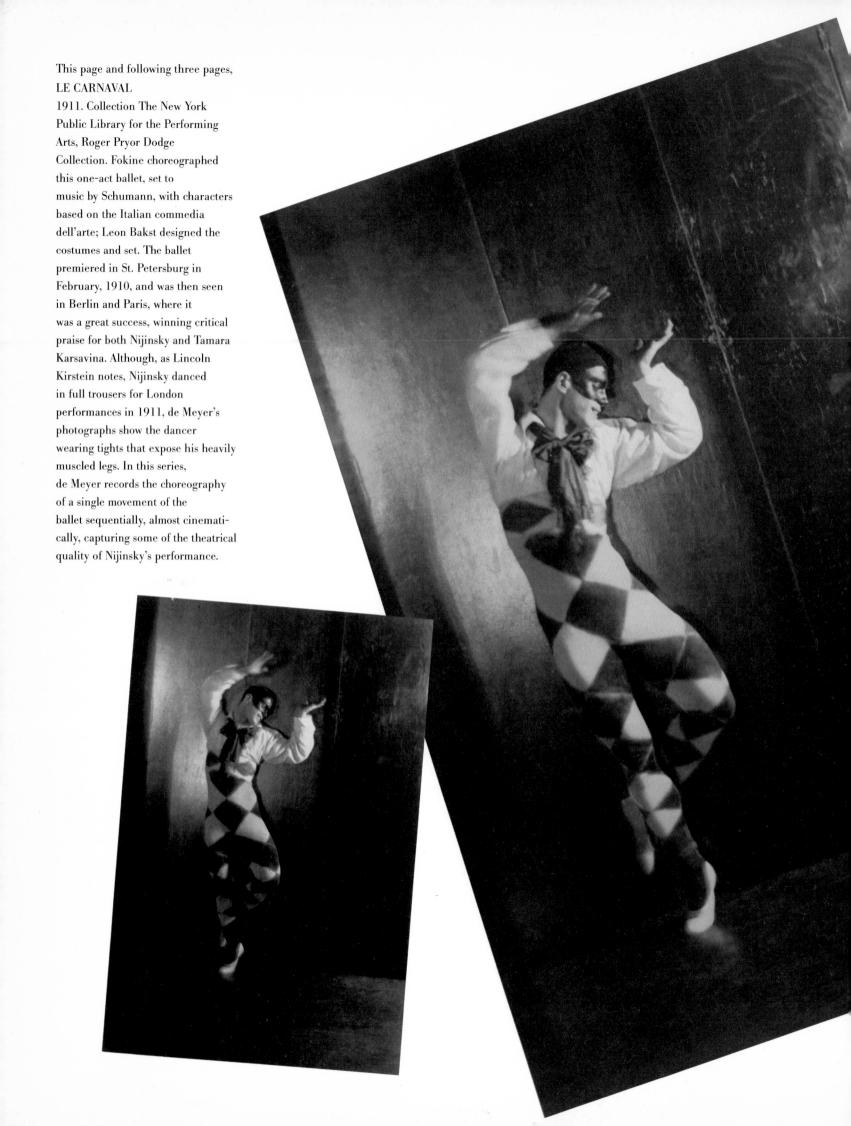

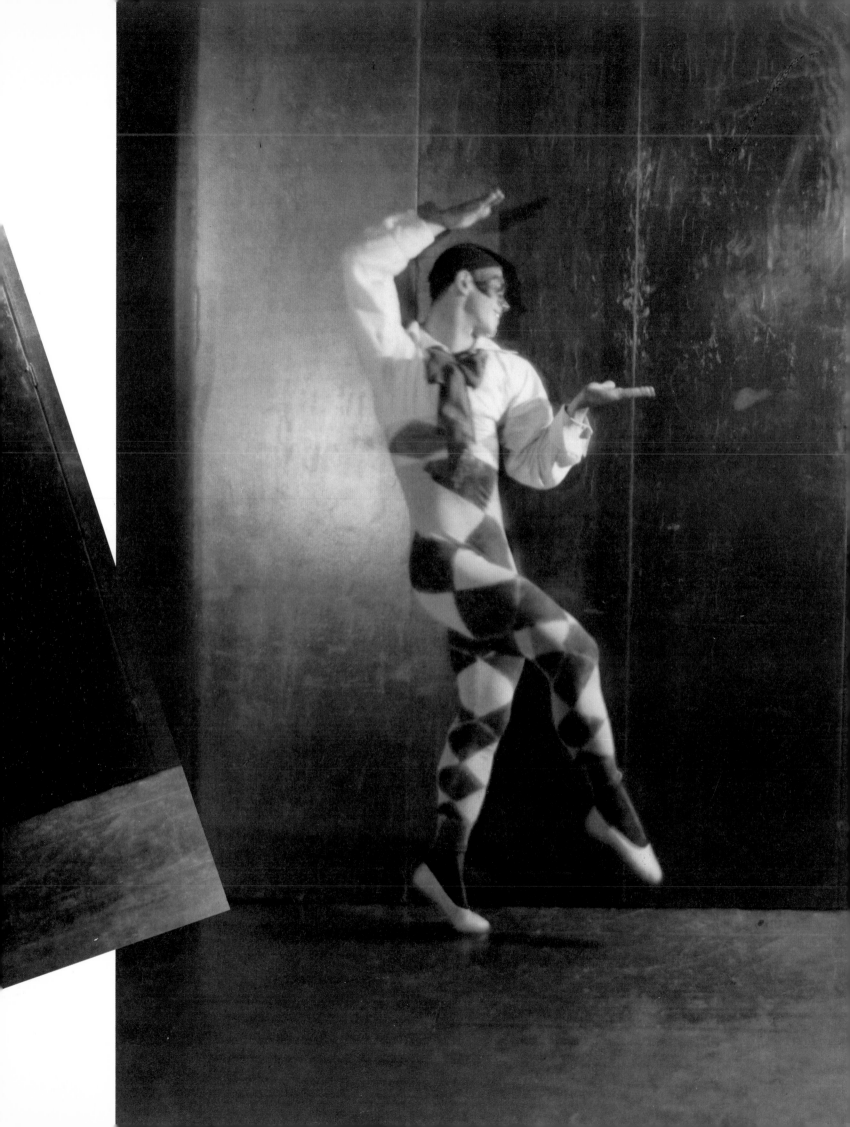

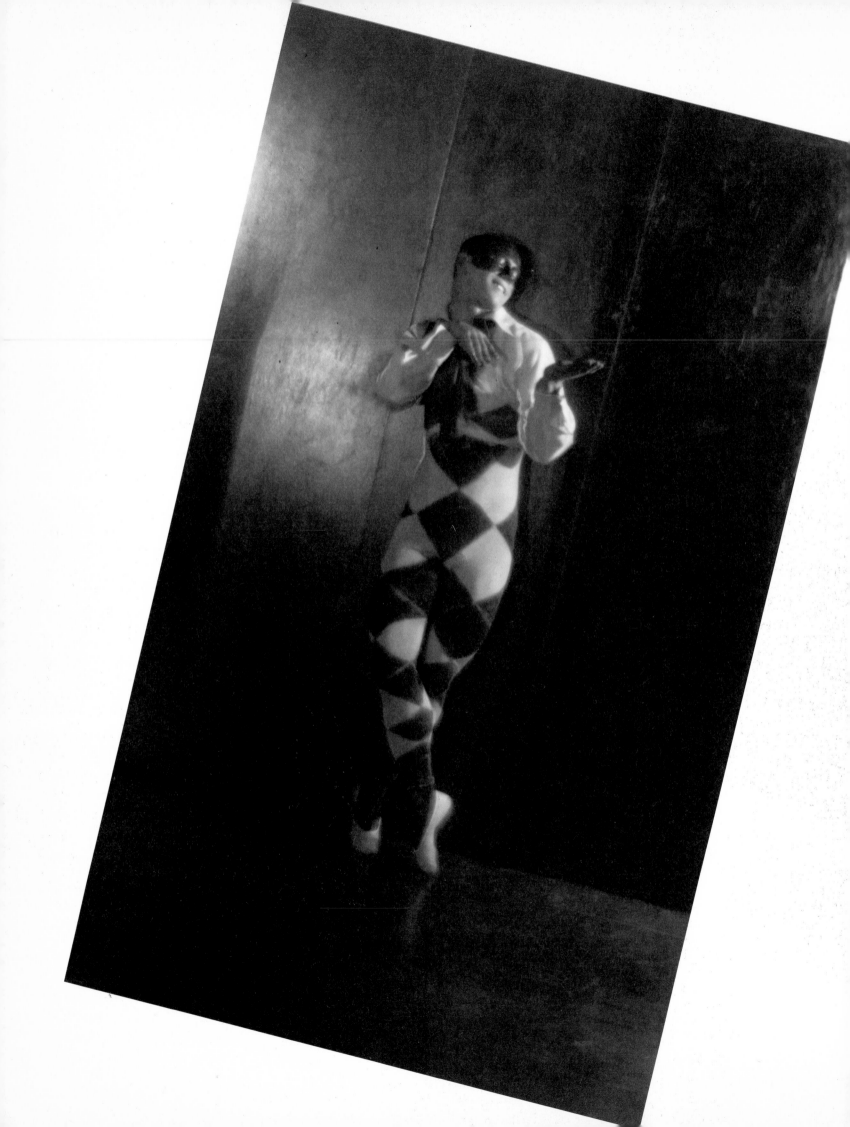

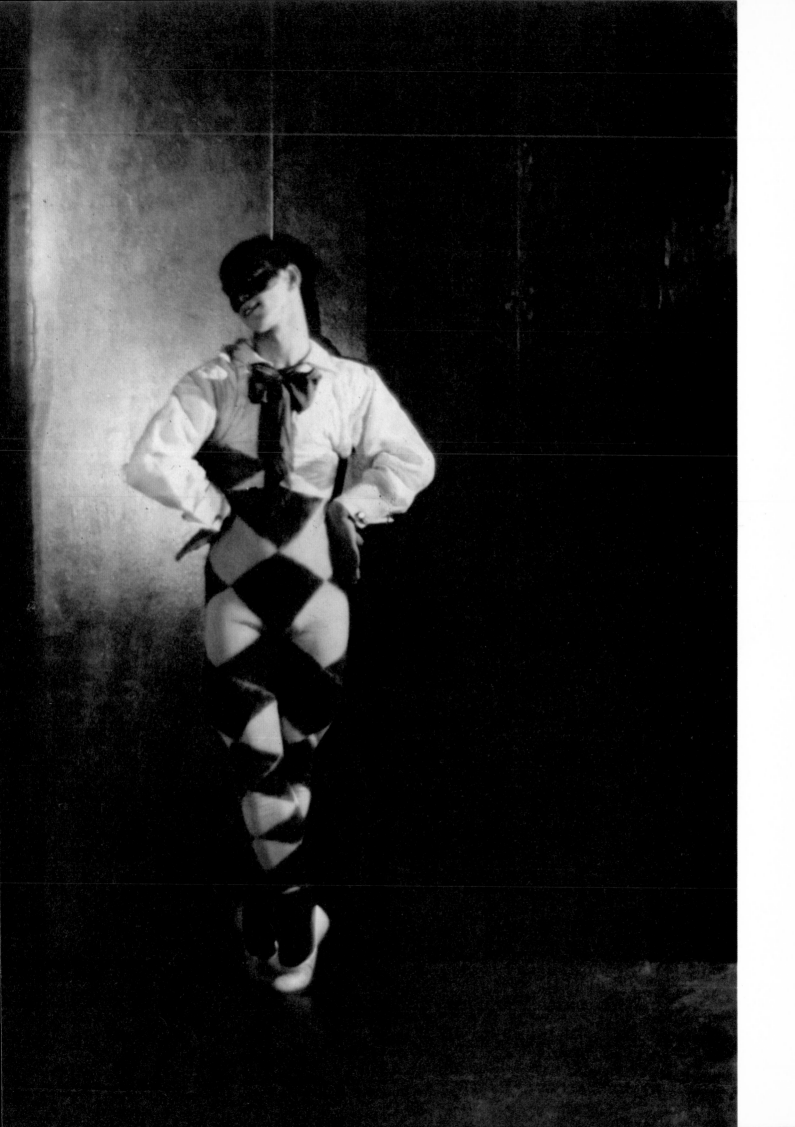

LE PAVILLON D'ARMIDE

1911. Collection The New York Public Library for the
Performing Arts, Roger Pryor Dodge Collection.
Le Pavillon d'Armide, produced by Sergei Diaghilev, was
the first ballet performed by the Ballets Russes in Paris, at the
Théâtre du Châtelet on May 19, 1909. Loosely based
on a story by Théophile Gautier, the ballet was choreographed
by Michel Fokine, with sets and costumes designed
by Alexandre Benois. In his book *Nijinsky Dancing*, Lincoln
Kirstein describes the young Russian as "the first
dancer in history who seems to have collaborated consciously
with a photographer on the level of art. . . . Nijinsky and
Baron Adolphe [*sic*] de Meyer produced . . . five
miraculous series which are artworks in themselves."

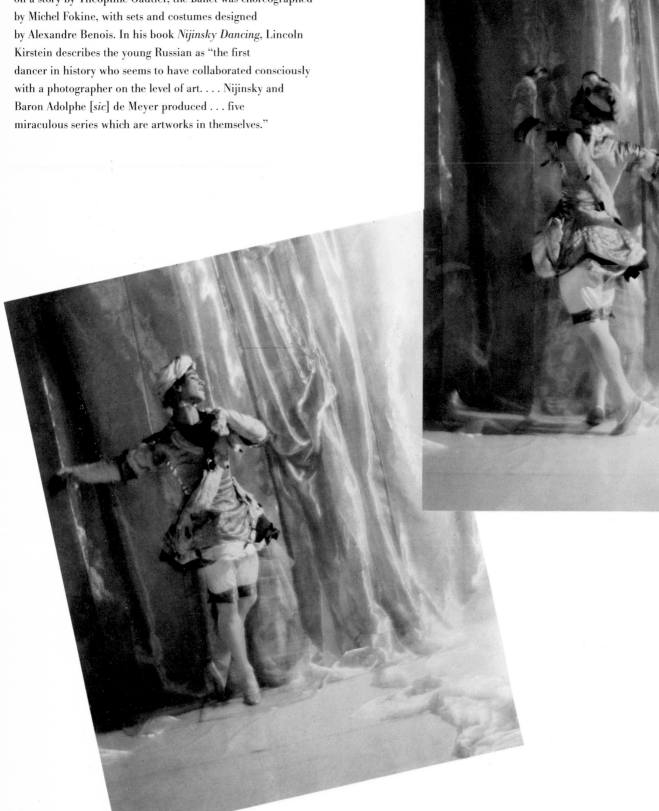

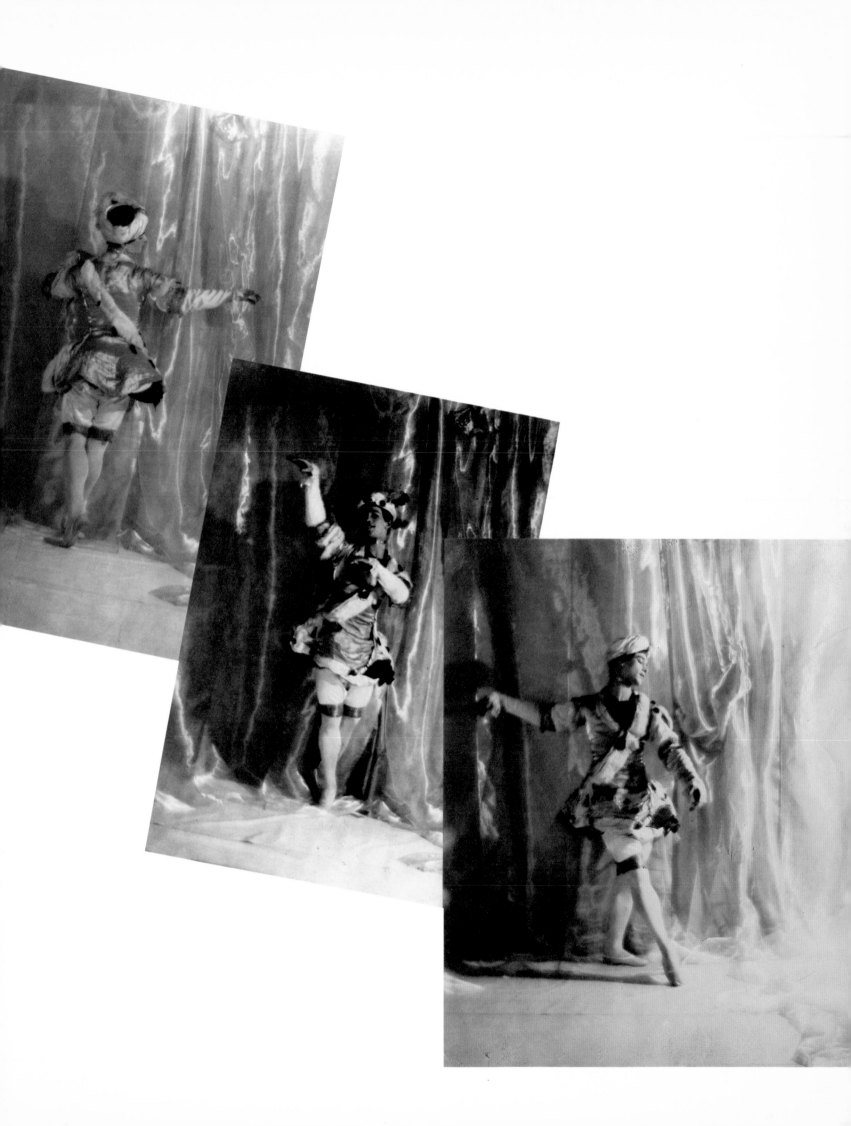

Right, THE SKETCH
February 26, 1913. Photograph of Nijinsky in
Le Prélude à l'Après-midi d'un Faune by
Baron de Meyer. From the collections of the
Theatre Museum. By courtesy of the Victoria and
Albert Museum, London.

Following six pages, SUR LE PRÉLUDE À
L'APRÈS-MIDI D'UN FAUNE
1914. Collection Robin Symes, London. Stéphane
Mallarmé's poem of 1865 was the inspiration
for Debussy's "Prélude à l'Après-midi d'un Faune,"
1892. Diaghilev received the composer's
permission to create a ballet based on the score; it
was Nijinsky's first choreographic effort.
Bakst designed the set and costumes: the Faun's had
to be painted on at each performance—brown
and white patches on cream-colored tights,
green vine leaves at the waist, a small tail and gold-
en horns. The highly stylized choreography—
drawn from both modern dance and Greek vase
painting—along with Nijinsky's animal-like gestures
and painted body, scandalized Parisian
audiences when the ballet premiered at the
Théâtre du Châtelet on May 29, 1912. Diaghilev, a
brilliant impresario, had the ballet performed
twice on the first evening, to ensure its impact on
the public. The audience and critics were
particularly incensed by the final
movements—the Nymph's sexually suggestive
manipulations of her veil, and the Faun's clearly
orgasmic climax. One of Nijinksy's fellow
dancers in the ballet later wrote in her memoirs:
"Nijinsky as the Faun was thrilling. Although
his movements were absolutely restrained, they were
virile and powerful, and the manner in which he
caressed and carried the nymph's veil was so
animal that one expected to see him run up the side
of the hill with it in his mouth. . . . It was superb
acting." Kirstein dates this series of photographs to
1912; they were taken for an album on the ballet,
with contributions by Auguste Rodin,
Jacques-Émile Blanche, and Jean Cocteau.
The timing for the book was unfortunate: with the
outbreak of World War I in 1914, the printing
of the luxury publication was interrupted. Of the
1,000 copies planned, only six are known to
exist today. (A modern portfolio *L'Après-midi d'un
Faune* was produced by the Eakins Press Foundation
in 1977, rephotographed by Richard Benson.
With the aid of Lincoln Kirstein, the 1977 version
has been reordered to more closely duplicate
Nijinsky's choreography.) Following seven
photographs © The Eakins Press Foundation,
New York.

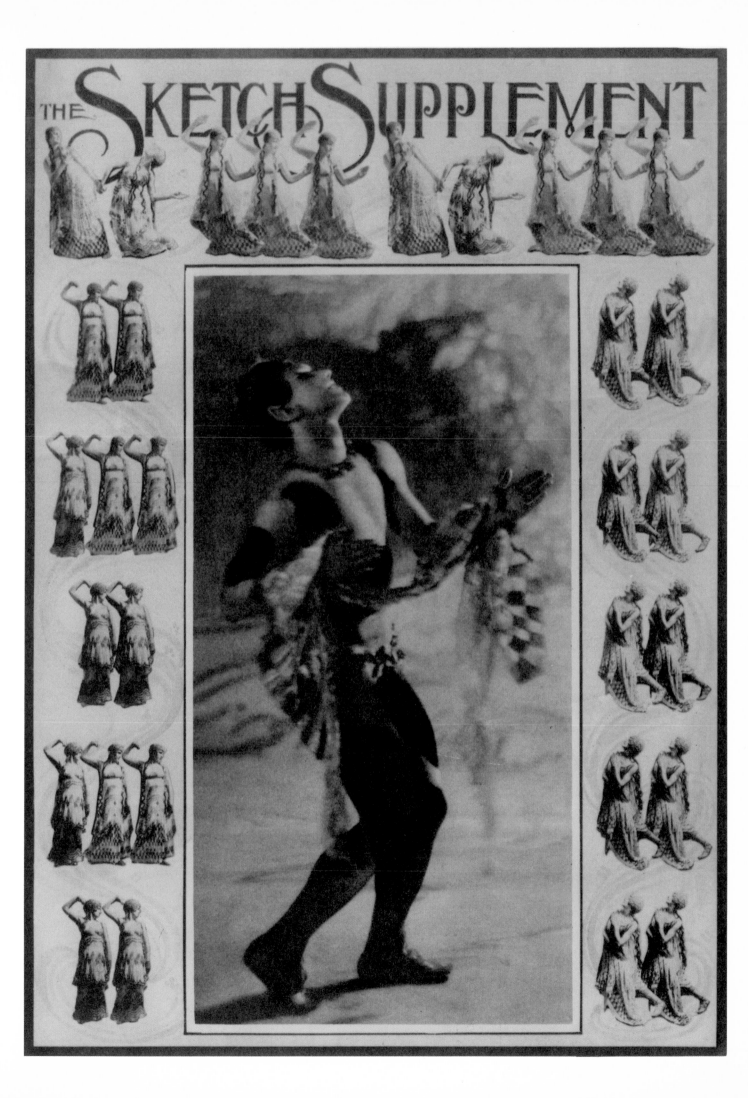

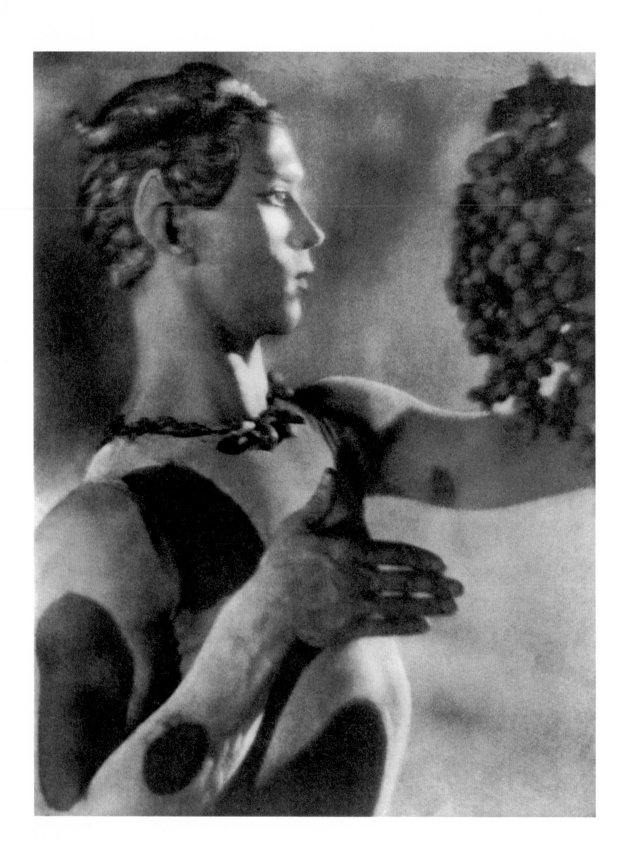

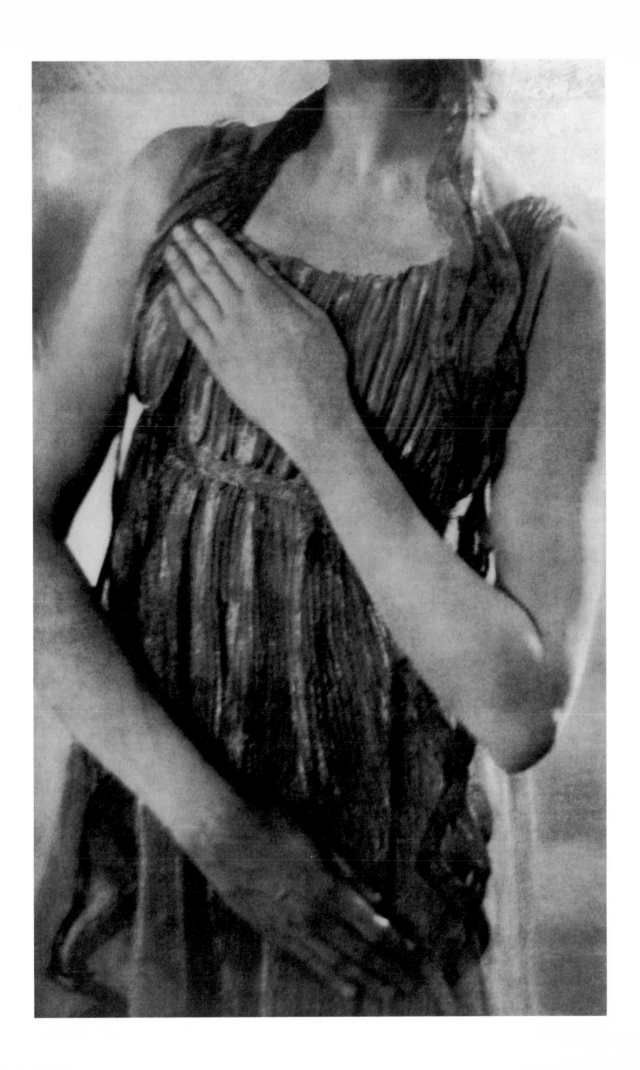

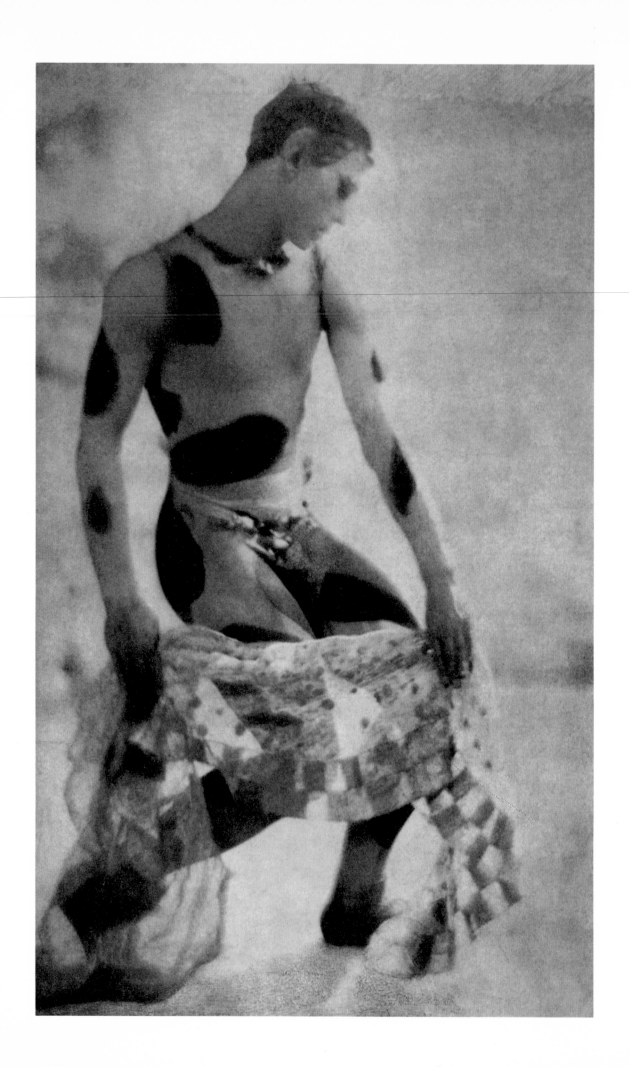

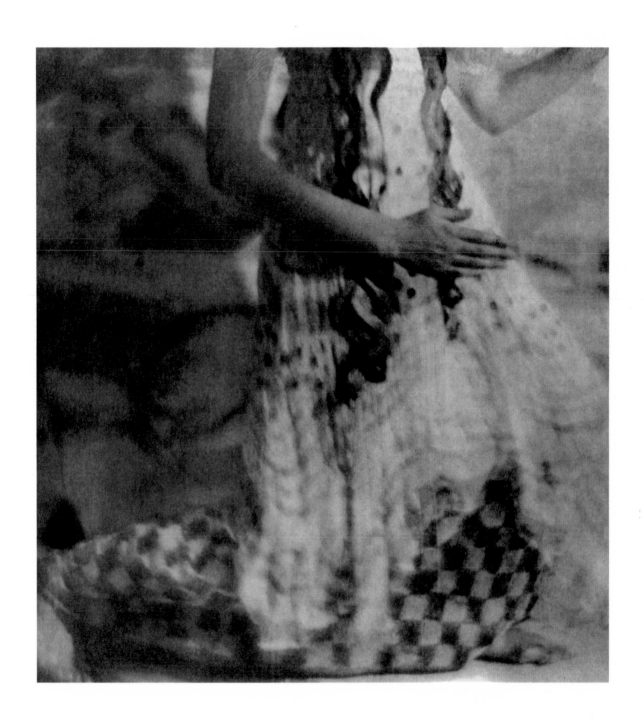

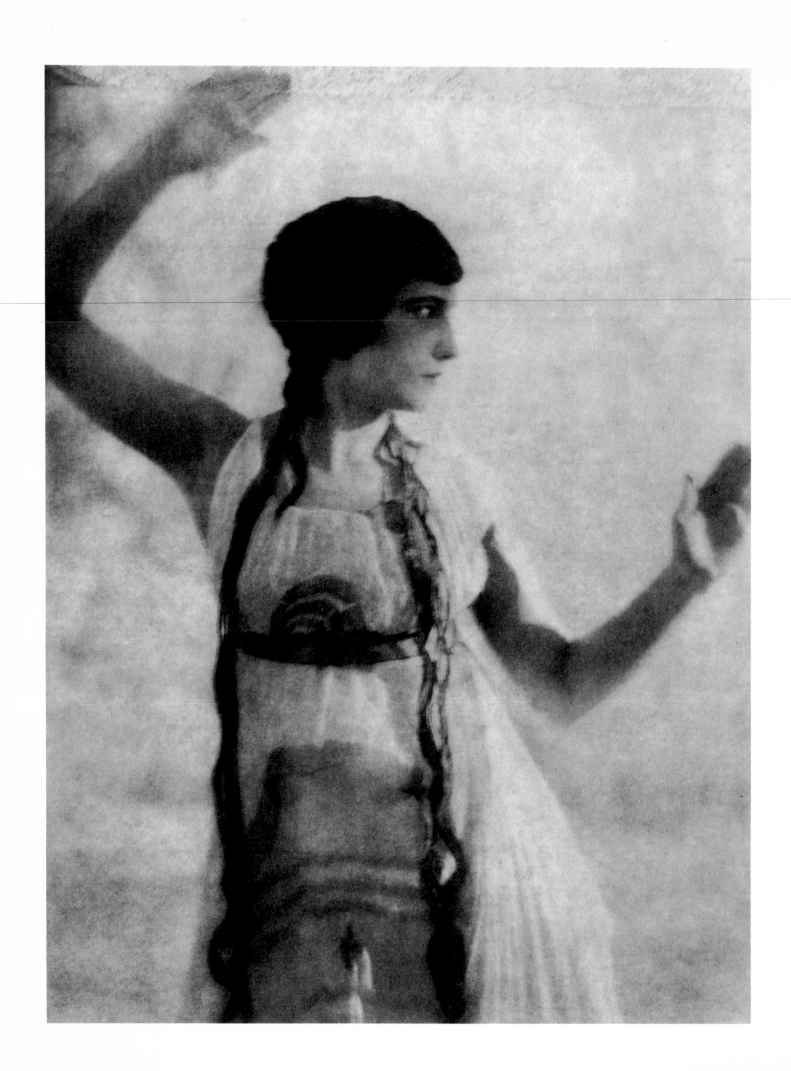

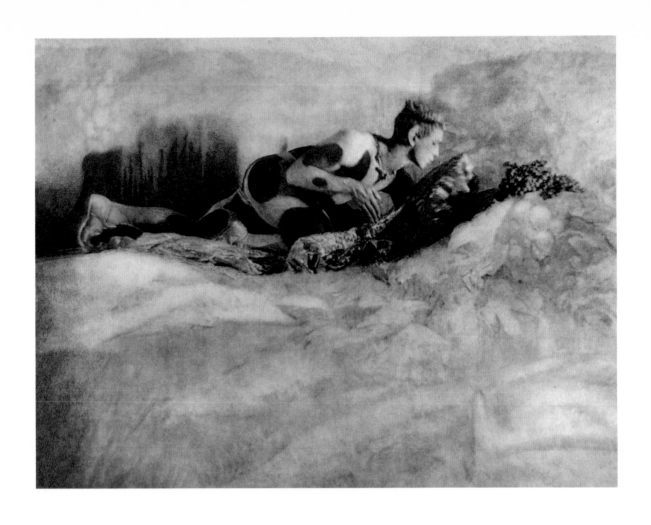

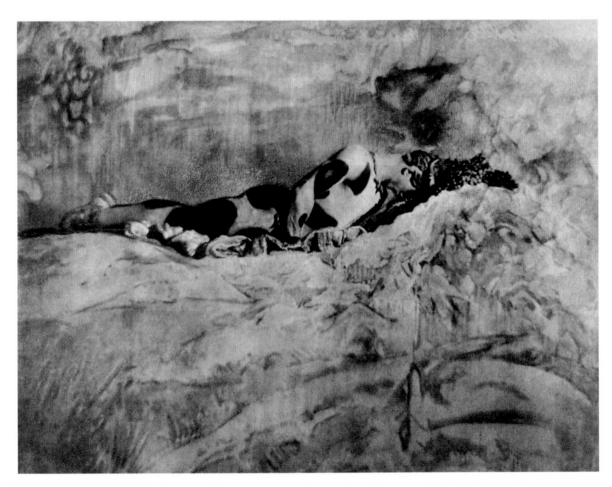

MARGOT ASQUITH,
THE COUNTESS OF OXFORD
AND ASQUITH
1922. Collection National Portrait
Gallery, London. Published
in *Harper's Bazar*, June 1922. "The
conventional caption will never
do for 'Margot' Asquith, the much dis-
cussed and altogether extraordinary
British observer and gossip . . . the odd
fact that she always wears that
Shetland shawl tied around
her head when she writes, and that
her new book, *My Impressions
of America*, is now on the presses,
will entertain her admirers." She was
married to Herbert Henry
Asquith, elected Liberal Prime
Minister of Great Britain in 1906;
together they belonged to
an elite intellectual circle known
as "The Souls."

MAGAZINE
WORK

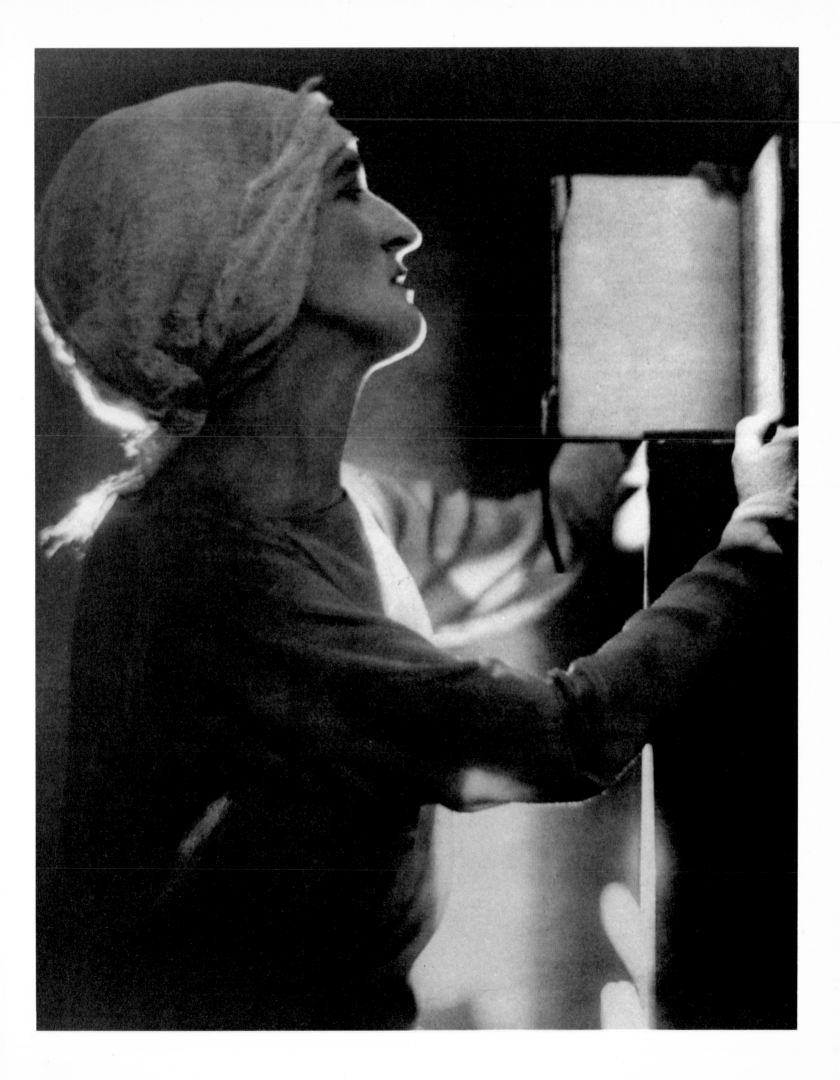

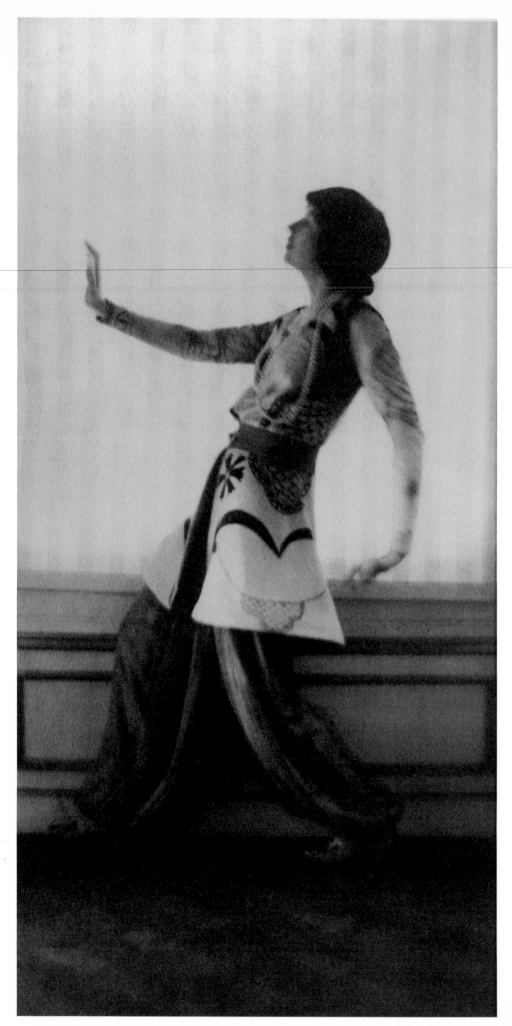

Right, MRS. HARRY PAYNE
WHITNEY
ca. 1912. Collection Flora Miller
Biddle, New York. Published
in *Vogue*, February 1, 1914, and
Vanity Fair, March, 1917.
Gertrude Vanderbilt's marriage to
Harry Payne Whitney joined two
of the greatest fortunes in America—
one made in railroads, the
other in oil. The luxury of their
estates was legendary, and they held
a position at the forefront of
New York's social Four Hundred. A
talented artist herself, Gertrude
Vanderbilt Whitney was a patron
and founder of New York's Whitney
Museum of American Art. For
this sitting, Whitney donned an
outfit created for her by
the Ballets Russes designer Leon
Bakst. She strikes a pose of
supreme independence
and highly individual style.

Far right, MRS. HARRY PAYNE
WHITNEY
ca. 1916. Collection Flora Miller
Biddle, New York. Published in *Vogue*,
January 15, 1917. Often portrayed
as a somewhat daunting figure, here
she appears graceful and
elegant, surrounded with an aura of
theatrical fantasy.

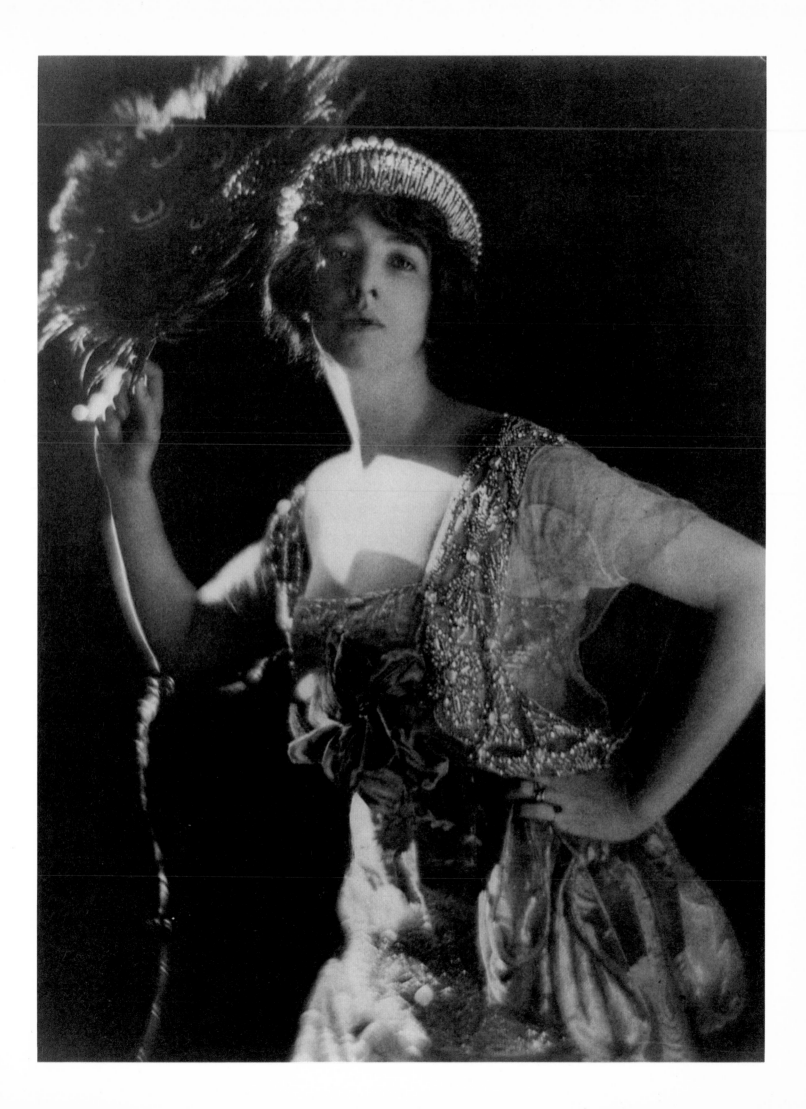

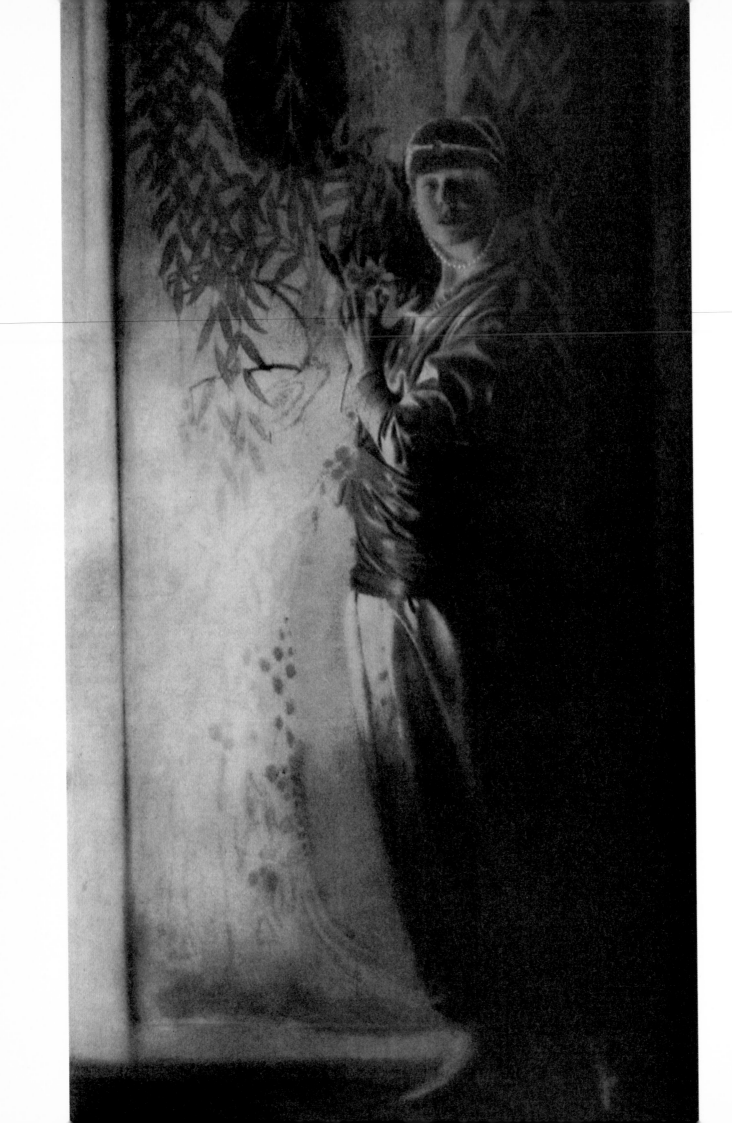

Left, MRS. HOWARD G. CUSHING
Published in *Vogue*, November 1, 1914.

Right, MRS. PHILIP
LYDIG IN A VENETIAN COSTUME
Published in *Vogue*, September 15, 1913.
Vogue's accompanying text for this
image reads: "A Venetian costume was the
inspiration for this unique house dress,
and from Venice came the rich fabrics of which
it is composed—the old, Venetian-red velvet
for the sable-bordered coat, and the satin for the
trousers; the girdle of antique, gold
galloon threaded with faded colored silks;
the lace vests; and the gold chain from
which swings an emerald-set tassel." While
such costumes were not for everyone in
Vogue's readership, Rita de Acosta Lydig was
one of the international beauties who
set new standards for acceptable exotic
behavior and dress, and who added interest
to *Vogue* editor Edna Woolman Chase's
often conservative fashion pages. Cecil Beaton
described the "fabulous Mrs. Lydig," as a roman-
tic creature "who graced the opening cycles
of the twentieth century with a perfectionism
that would have been rare in any period since the
Renaissance." De Meyer photographed her
in various costumes for both *Vogue* and
Harper's Bazar. According to Beaton's account,
her sensational evening dress (see page 12,
published in *Harper's Bazar*, March, 1917)—cut
right down to her lower back—caused a great
stir at the opera. Her backless dress and
coquettish pose are certainly references to
John Singer Sargent's notorious portrait of
Madame Gautreau, *Madame X.*

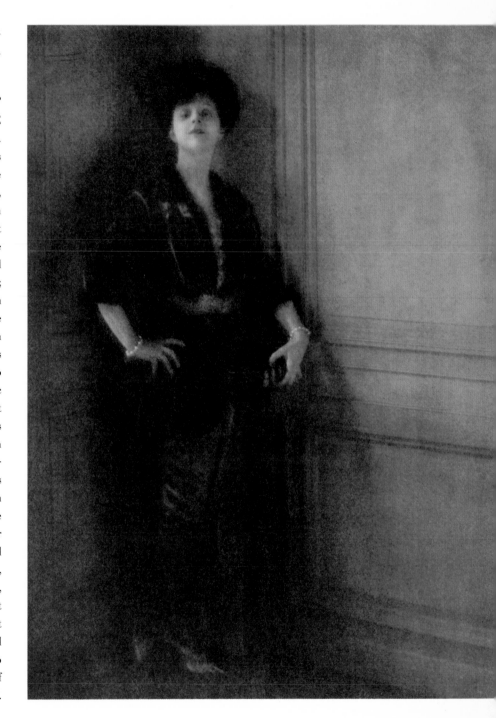

Right, HELEN LEE WORTHING
1920. Collection The Museum of
Modern Art, New York City;
Gift of Richard Avedon. Published in
Vanity Fair, August, 1920.
Helen Lee Worthing was a popular
performer in musical revues.
In this photograph, she wears a dress
that shows the taste of the
day in New York for Louis XVI-style
and opulence. The accompanying
copy reads, "Helen Lee Worthing, as
She Appears in the Bridal
Pageant in 'What's in a Name?'" In
April of the following year,
Vogue published a portfolio of bridal
photographs, in which Worthing
was again featured, modeling a simi-
larly lavish wedding dress,
which was designed by de Meyer.

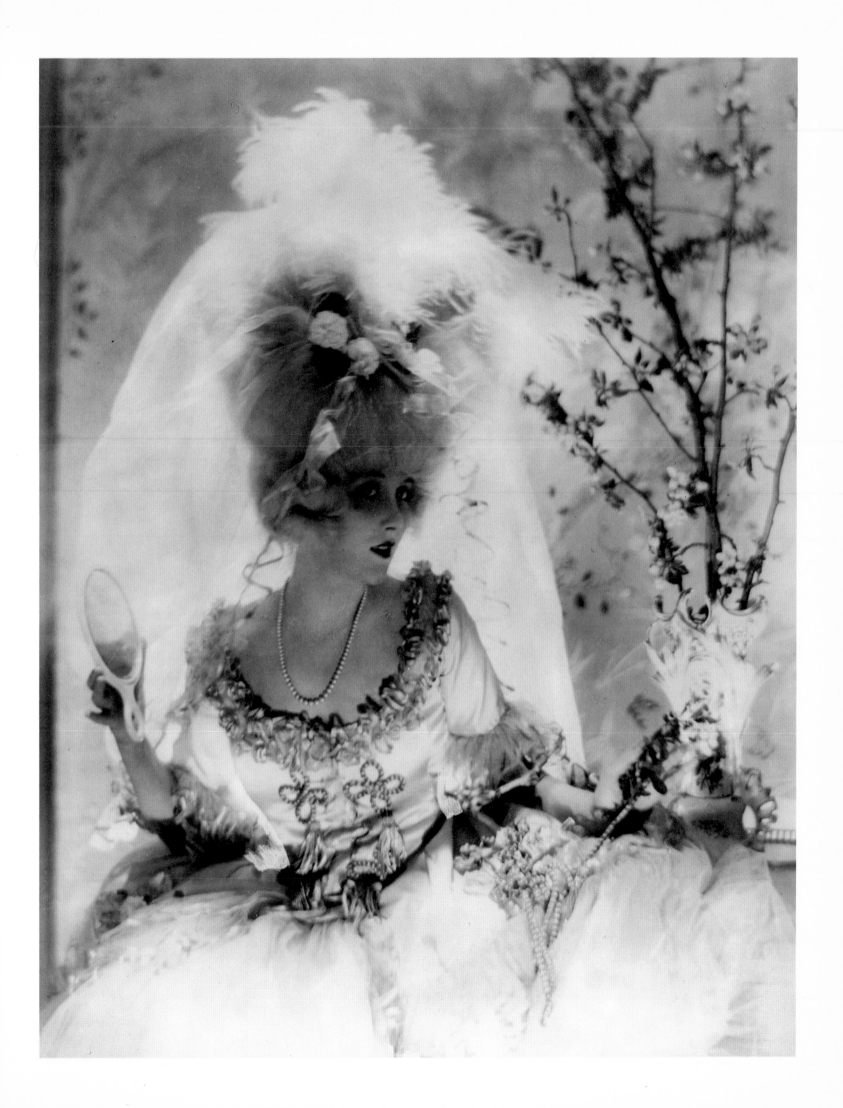

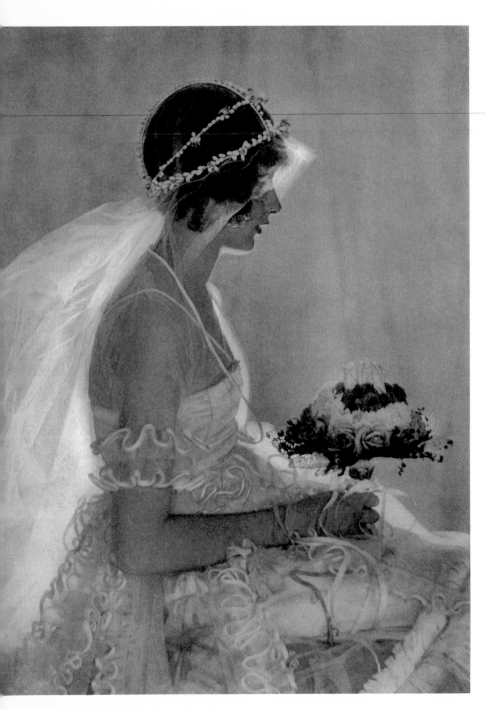

Left, MISS NATICA NAST
Published in *Vogue*, January 15, 1920.
Natica Nast was fifteen years old when she
modeled a wedding dress by the
American couturier Tappé for an issue of
Vogue that featured bridal fashions.
It was Clarisse Coudert, Natica's mother
and Condé Nast's wife, who insisted
to de Meyer that only someone as young
as Natica could portray the ideal of
American bridal innocence. Tappé's pique at
having to make the dress in such a
tiny size was mollified when Mary Pickford
bought it to wear at her wedding to
Douglas Fairbanks.

Right, MARY PICKFORD
1920. Collection Ira Resnick, New York.
Published in *Vogue*, February 1, 1920.
Here, Pickford is wearing the dress
Natica Nast modeled the month before.
Vogue's caption read: "This charming
young face, which belongs to Mary Pickford,
is one of the most famous world over,
and though she looks almost
helplessly feminine, she makes every
year a tremendous fortune." Pickford
began her film career with director
D. W. Griffith in 1909. Popularly known
as "America's Sweetheart," she was
also a successful businesswoman. In 1919
she joined Griffith, Charlie Chaplin,
and Douglas Fairbanks in forming the United
Artists film-distribution company, and
continued to produce films for the company
after her acting career ended.

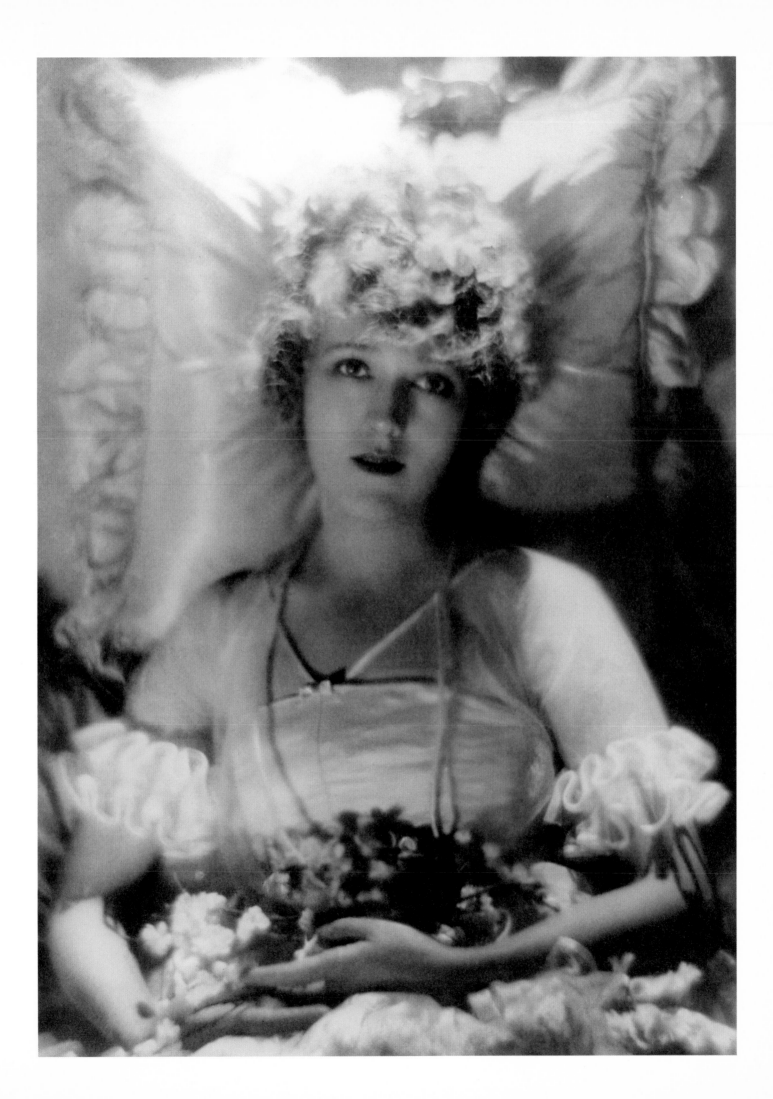

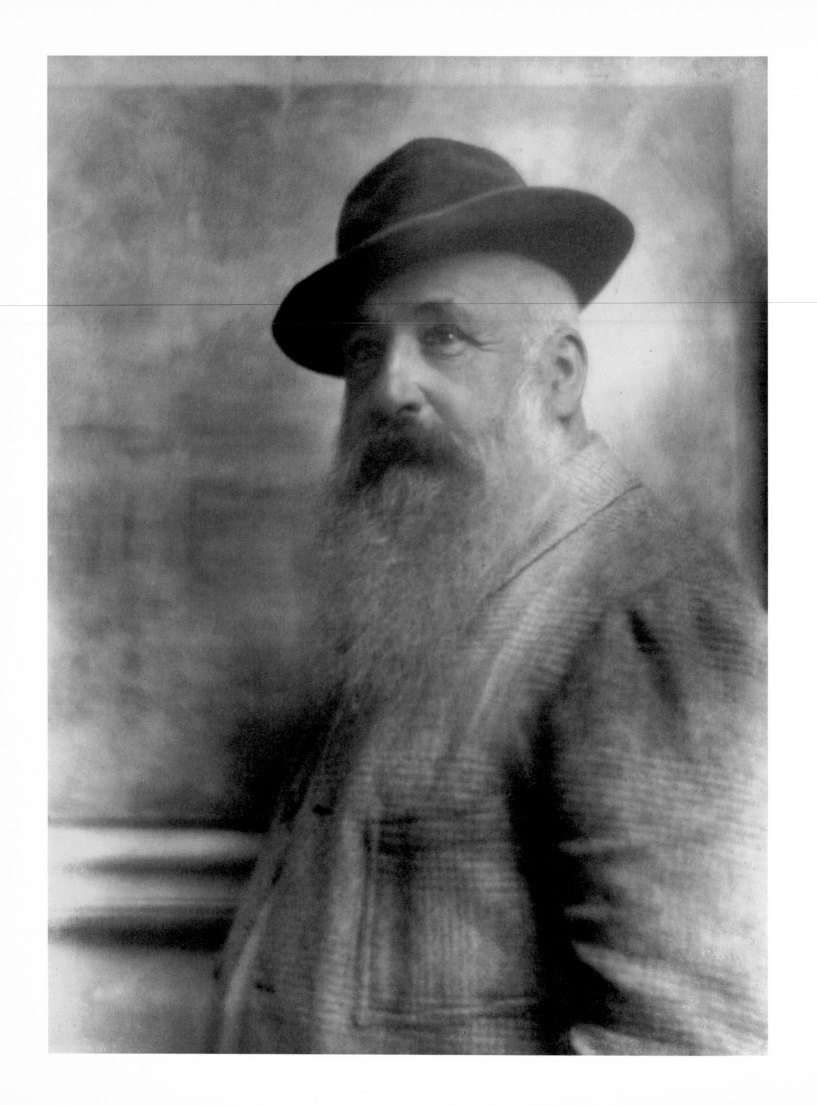

Left, CLAUDE MONET
1921. Reproduced by permission of
the Australian National Gallery,
Canberra. Published in *Vanity Fair*,
March, 1921.

Right, ANNA PAVLOVA
Published in *Vanity Fair*, January,
1921. Pavlova began dancing at
the illustrious Maryinsky Theater in
St. Petersburg in 1899. Her
sublime artistry and classical tech-
nique were showcased in the
West in 1909, when she danced in
Paris with Nijinsky and the
Ballets Russes. Her American debut
was made in the following year,
and she subsequently toured interna-
tionally with her own company.
Pavlova's fame was equal to the great
Nijinsky's; she represented the
epitome of the Russian ballerina.
According to Edna Woolman Chase,
Vogue's editor, Pavlova arrived
at the magazine's studios in full cos-
tume as the Dying Swan for her sitting
with de Meyer. As the ballerina's
toes were too tired to support her on
point, the photographer
arranged a half-length portrait that
framed the dancer's graceful
head position and elegant hands.

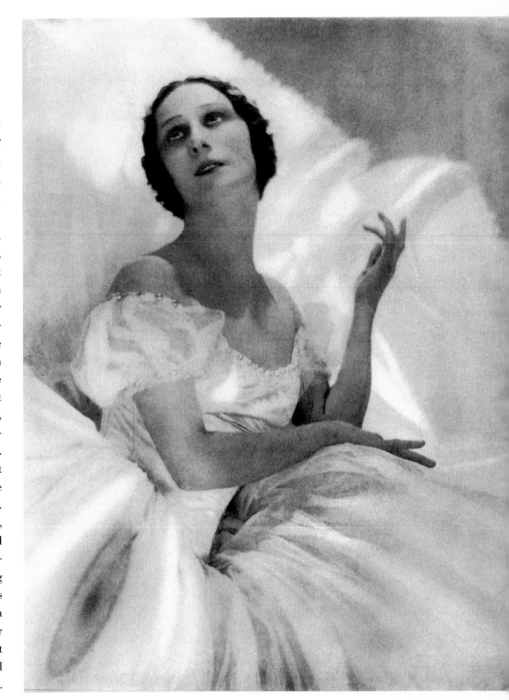

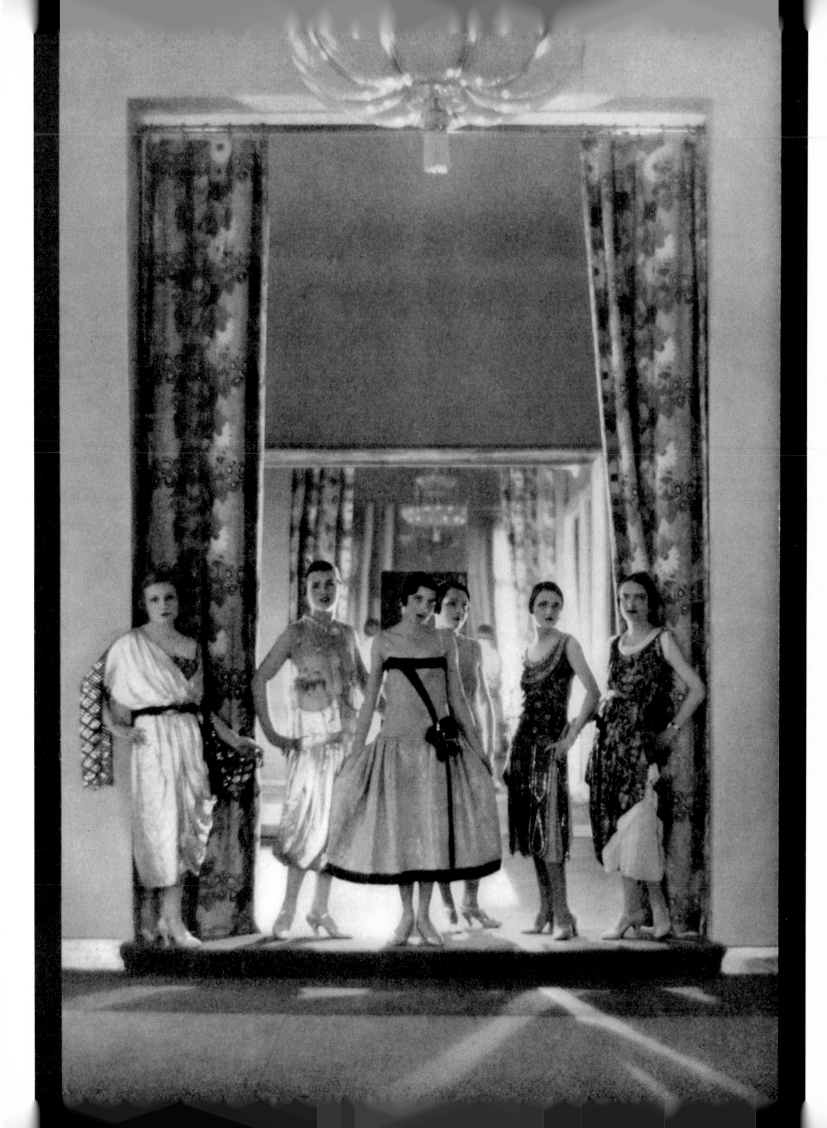

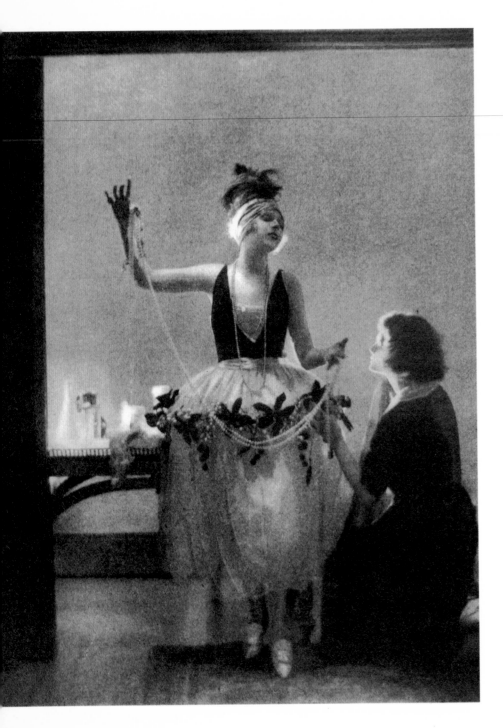

Left, GAYNE HOUSE MAKES
THE WINTER EVENING GOWN
DECORATIVE AND COLORFUL
Published in *Harper's Bazar*,
January, 1922. The model here
is the actress Ina Claire, wearing a
dress designed by de Meyer. From the
very beginning of his tenure with
the Hearst organization, de Meyer's
Gayne House couture line was
given particular prominence in
Harper's Bazar. A sense of theatrical
pagentry pervades this photo-
graph, which was taken in New York,
not in Paris where de Meyer
was living. De Meyer used profes-
sional models increasingly
in Paris in the twenties; without the
strong characters of his society
and theatrical models—and the style
of portraiture those characters
demanded and expected—
he developed innovative graphic
qualities in his fashion photographs.

Right, HARPER'S BAZAAR
March, 1930.

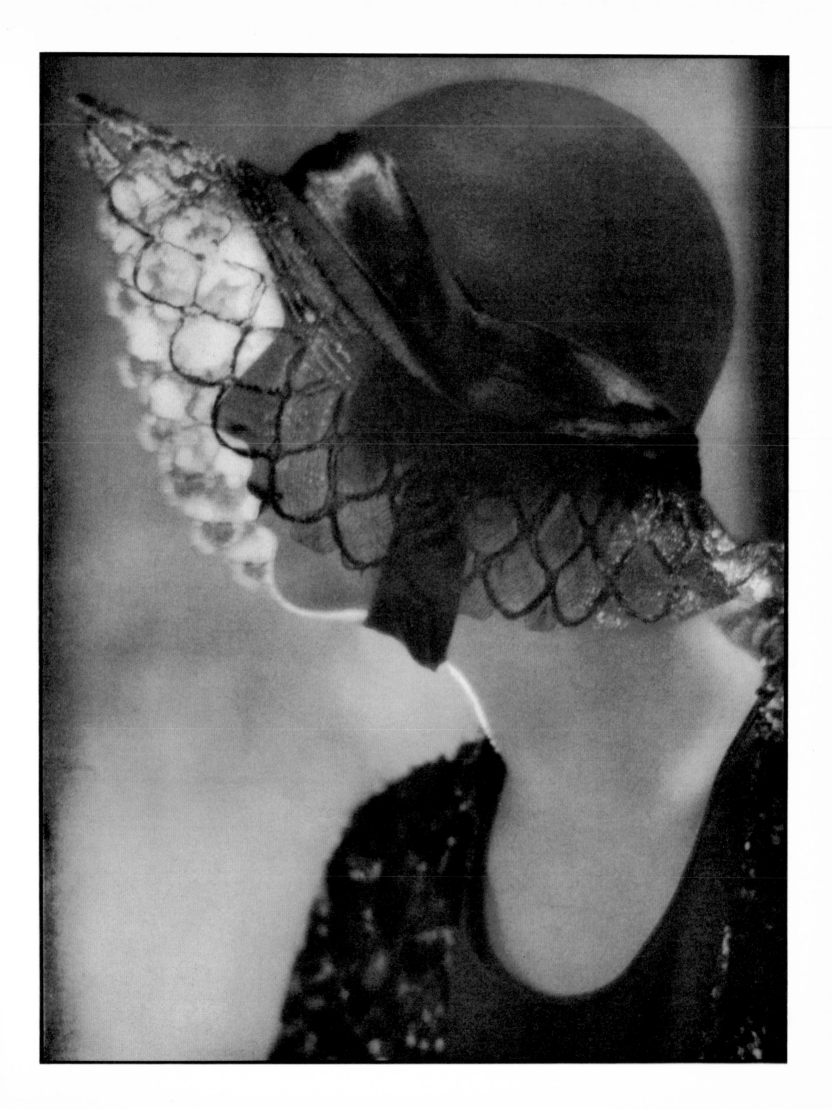

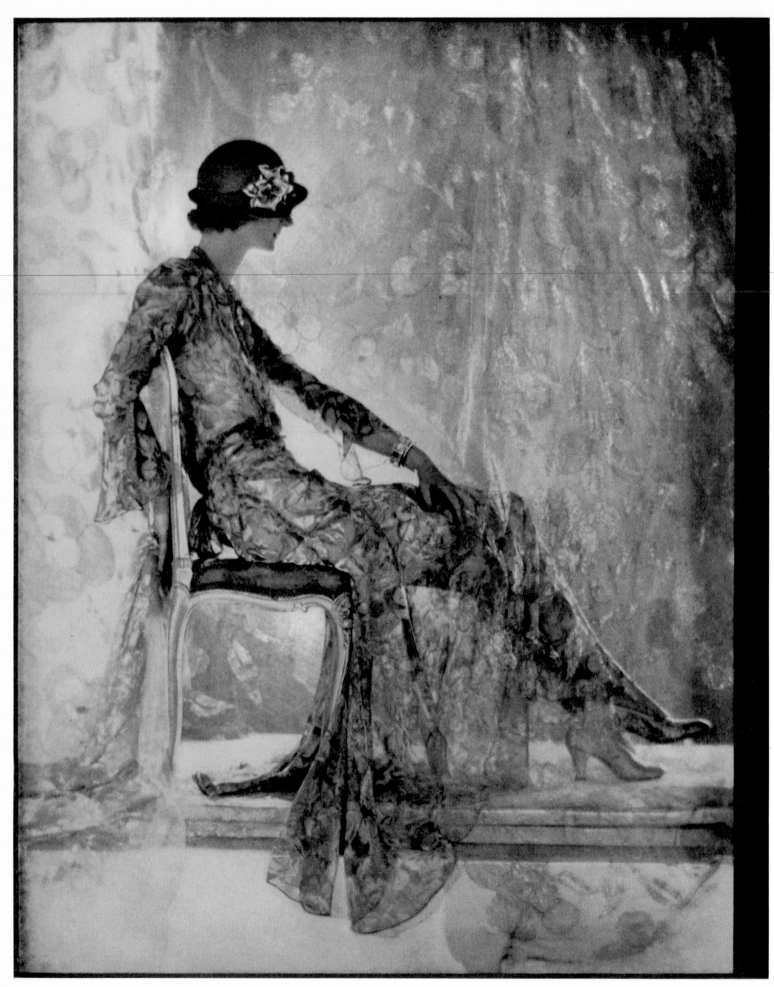

Above, HARPER'S BAZAAR, July, 1933. Right, HARPER'S BAZAAR, September, 1931.

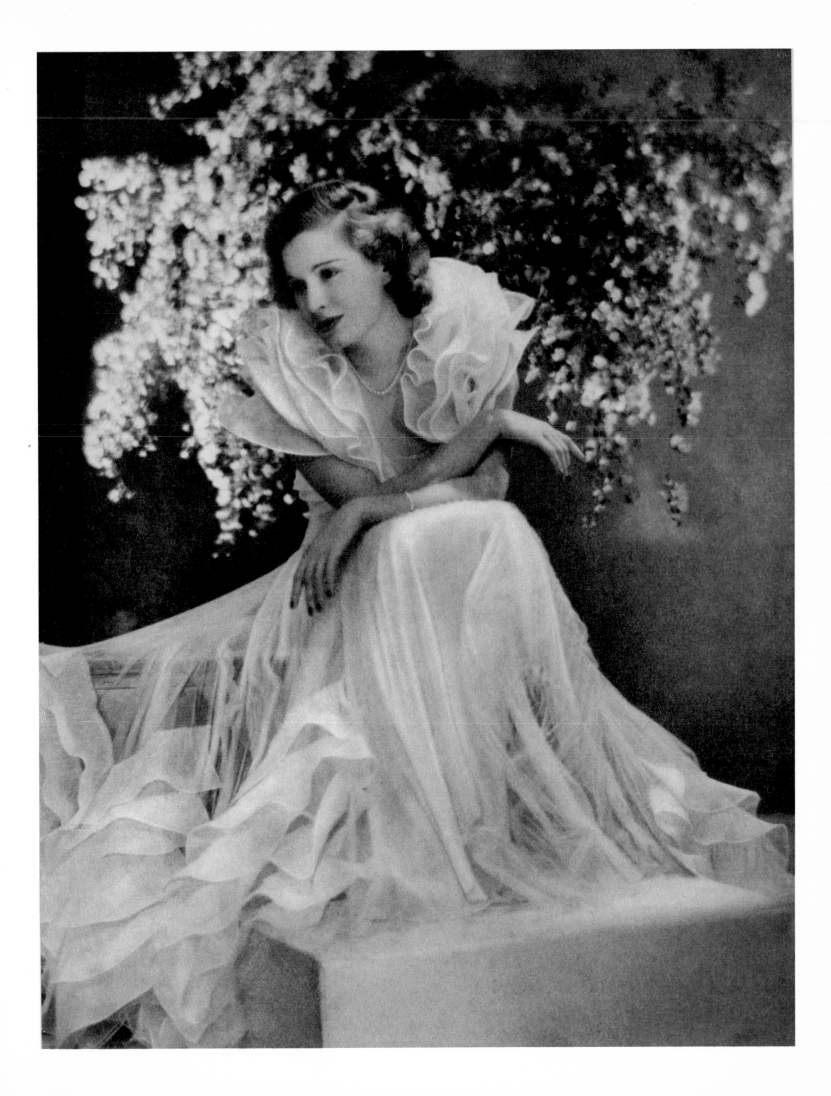

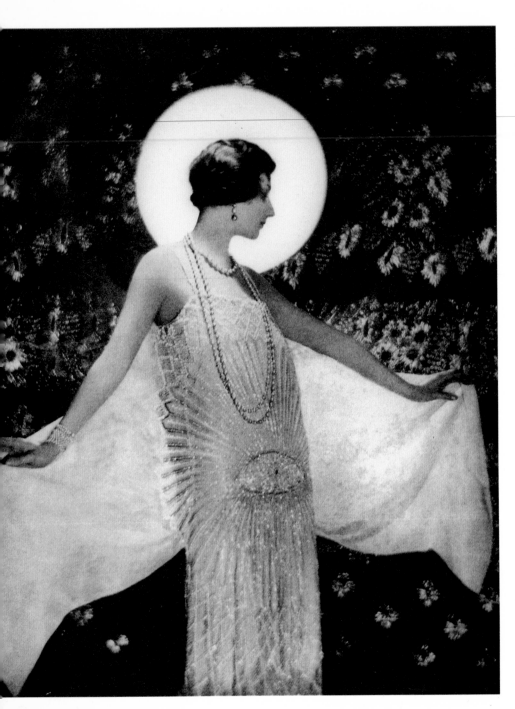

Left, HARPER'S BAZAR
April, 1925. "White Mousseline
embroidered in pearls, silver and
rhinestones." Dress by Chanel.

Right, GABRIELLE CHANEL
Published in *Harper's Bazar*,
February, 1923. De Meyer inter-
viewed Chanel several times
for *Harper's Bazar*, and seemed to
have a genuine admiration for her.
Chanel came to prominence
as a designer in Paris in the mid
twenties. She startled Paris by using
a comfortable new fabric—jersey—
for simple dresses and suits, which
were shown to the couture market and
copied for working women. Her
suits sported box jackets and were
worn with costume jewelry;
white piqué collars and cuffs became
a signature mark. Chanel's star
was just rising in 1923 when de Meyer
approached her for this fashion
interview on new trends in Paris.
He wrote: "Her brilliant mind, precise
and accurate, absolutely original
of its kind, was the very one I needed.
Her name is Gabrielle Chanel. . . .
It is not my intention to speak to you
of Chanel the dressmaker—you
all know of her, and as such she is
famous—but to present to you
Gabrielle Chanel, the one you don't
know in America, the woman
of refinement, of instinctive elegance
and faultless taste."

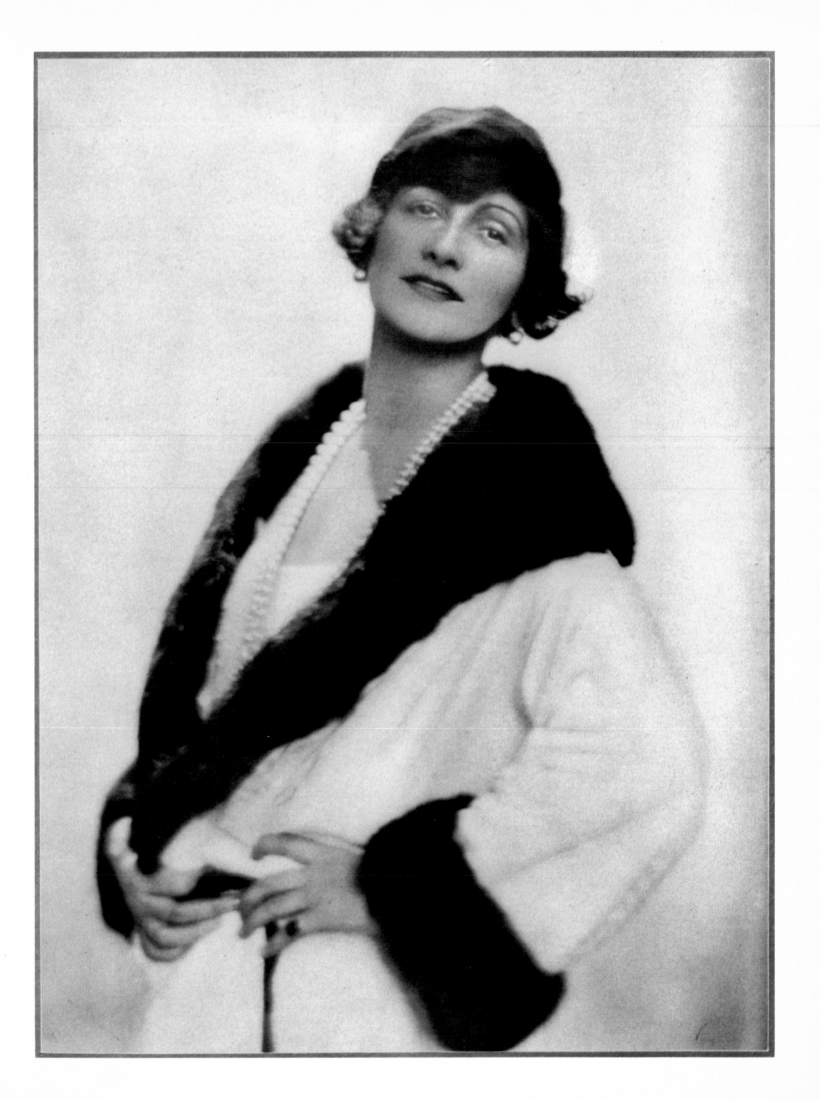

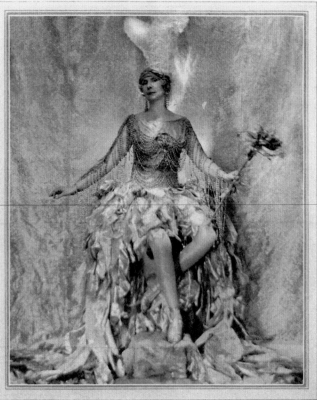

La Baronne de Meyer

Photograph by Baron de Meyer

The Baroness de Meyer appeared at the Bal du Comte Etienne de Beaumont in an extraordinary costume designed by Alice Bernard. It was entirely of gold and represented a rose, in glistening lamé tissue.

FÊTES OF UNSURPASSED MAGNIFICENCE

The Baron de Meyer Writes That Appearing in Costume
Is Actually Becoming a Habit; Paris Designs Remarkable
Costumes for Itself and Goes to a Succession of Brilliant Fêtes.

60 rue de Varenne, Paris.

DURING this frivolous season of uninterrupted costuming, of fancy-dress affairs and festivities of all sorts, my proper place should have been in a glass case, not on a ballroom floor.

I wandered through it all as a bit of lacquer, a figure off some screen, and for one night's entertainment as a carved piece of rock crystal, detached from its pedestal. Through red lacquer eyes, Chinese and elongated, people seemed to take on distorted shapes, fanciful, like figures from a picture book illustrated by Bakst or Dulac come to life.

Early in the season, I had designed a costume for myself. A Chinese figure, lacquered red, period Louis Fifteenth. I planned to wear it at one very special ball, maybe at a second party, but never imagined it would become a habit. Lacquering one's face is no easy matter, but washing off the lacquer quite a feat. Therefore, having had little opportunity between the parties of getting clean, I ceased to wash at all, and went through the season red and shiny with long drooping mustaches and eyebrows raised to heaven. I could naturally not go about much during the day and was only visible at night when fancy-dress parties were given.

THE consequences were alarming, for seeing nothing but Chinese goddesses or women dressed as fairy princesses in costumes made by Poiret, Chéruit, or by Alice Bernard, I began to think these were the new styles. They seemed to me so novel and different. The mode, at last, was undergoing a radical change. What a relief! I was delighted.

We were actually breaking away from the "chemise gown," in fact from the fashions Chanel had imposed upon us and standardized. Her much advertised "costly simplicity" was now a thing of the past. I smiled at the thought of recent interviews with one or two of the great knowing ones, who had assured me "there will be hardly any change in line and fashions will alter but very little next season." I had a good laugh, inwardly.

I shall never be able to adequately express my disappointment when finally, in July, after I had washed and scraped my face clean of all the paint, I realized reality, sordid reality, and that my view-point had merely been distorted.

TO prevent any sort of misunderstanding, let me tell you, before proceeding any further, that women still wear woolen sweaters and plaited skirts and are still pulling small felt hats over their eyes. What a pity! Anyway, there is another month before I am called upon to speak of the *Maisons de Couture* and their new fall collections—another month to get my view-point readjusted—so I won't anticipate. As costume balls and festivities are still vividly in my mind, I'd rather speak of these now.

To begin with, of Count Etienne de Beaumont's great fancy-dress "fête," the most perfect private entertainment of the season.

It was followed by the Gavarni Ball at the Opéra, at which later function pandemonium reigned. At one moment it appeared as if two or three million people were trying to reach the dancing floor all at once. It was, however, a phenomenal success, and Domergue proclaimed king of organizers.

There followed fêtes in the old Palais Royal

Drian sketched this Chinese lacquer costume in which the Baron de Meyer went to several costume balls.

La Parisienne

Selects Her Hats

Baron de Meyer

Observes and Writes

You are asking for the one thing every one is trying to hide from me. . . To tell you in full what the Paris couturiers are planning for the autumn might easily be misleading and yet—I have decided to give you satisfaction! One does not live in this busy center of fashion without observing, at least I don't. . . Women who count in Paris refuse to be blackmailed into startling innovations, no. . . Women have never been better dressed. Taste and exquisite reticence have become one of the fine arts. Eccentricity is thought a crime and is actually the most "démodé" and unfashionable thing a woman can indulge in nowadays!

PARIS GOSSIP BY A MERE MAN

BARON DE MEYER

Drawings by Jean Gabriel Domergue

I WRITE as I sit among borders of bluest delphiniums in the Comte de Valmont's garden. This is the heart of Paris, and the terraces of this lovely old family mansion are thronged with Parisian society, for once not international, gathered for a "five o'clock."

You ask me for a forecast of the autumn mode. You are asking for the one thing that every one is trying to hide from me and to which an answer must be hardly more than intuition and observation on my part. And yet—I have decided to give you satisfaction! One does not live in this busy center of fashion without observing—at least, I don't. Even if but very vague, my talks with M. Jean Charles Worth, with M. Jean Patou, with Mme. Boulanger of Chéruit, and my own observations here in this beautiful garden, surrounded as I am by what Paris considers smart and elegant, have given me food for thought.

FIRST, I will tell you what "they say," and then I will tell you what I, myself, have observed.

M. Worth has assured me that black has seen its day. He will replace it by somber and rich tones of brown, by cold dark greens or violets. Such tones, he says, are more austere than mere black. Such gowns need fur and jewels. Immense sleeves will become even more of a feature.

In contradiction to this statement, M. Patou says, "No hanging sleeves. Tight, very tight and glove-like sleeves are going to be much more chic." Please take your choice. M. Patou confided in me to the extent of actually assuring me that he intends to raise the waist-line, very gradually, of course. This autumn, models will have the waist-line above the normal in front, but sloping to the back, to its present low location. He adds, "It will be most becoming."

I should not be surprised if the development of this idea was not actually the most important novelty of the 1922 fall season.

M. Worth tells me that he will do away with floating panels, hanging scarves and other bits of textures. They have had their day. To replace this supple and graceful line, produced by these same panels, and to which the eye has grown accustomed, a good deal more material will be needed for the skirts.

M. Worth, and also M. Lelong whom I consulted on the subject, agree with me in predicting the period of quite full skirts to be near. It may take one year, maybe two or three, but come in again they will, gradually but inevitably.

Some sort of support, alas, will follow; neither crinoline nor bustle, but something new and cumbersome we shall certainly know well by 1925.

Mme. Lanvin is faithful to what is called *la robe de style*—full, long skirts and straight, tight bodices, with varied waist-lines. Instead of organdie and taffetas, velvet and brocade are used for winter. These bouffant styles, so far reserved for evening wear alone, will certainly be worn in serge and broadcloth—the tendency to *moyen âge* much accentuated. Details at Lanvin's vary.

Every season one special trimming is a feature, and is used on almost every model. Last year, it was shells. This spring, small rosettes assembled in edgings and clusters. But what will it be next month? A mystery, so far. Silver will be replaced by steel, gold by bronze and copper. We shall see splendor more austere, more magnificent textures, a tendency toward gorgeous Renaissance, not in actual line or detail, but in atmosphere, especially Spanish and Italian. We shall see less of the more dainty Louis XV. and Louis XVI.

No smart French woman would consider ordering her clothes before the supplementary models have been added to the stock, some time in September.

SOMETHING hardly as yet realized out of Paris is that hats, as one was wont to buy them, models entirely novel in shape, created new every few months, are no more worn by really smart women! It used to be an unheard-of thing for a leader of fashion to wear a last year's hat and—"get away with it." Now, they are so similar from year to year that no one knows the difference. This is, of course, never a matter of economy, but simply because fashions as worn in Paris change so little that if your hat has been designed by a modiste who happens to be an artist, like Marie Louise or Reboux, the style cannot go out of fashion as long as fashion preserves the prevalent atmosphere varying in trifles only, such as a skirt length or the shape of the neck-line.

The real standard by which a woman's elegance is measured is her success in looking perfectly stunning in an absolutely plain and unadorned hat, completing a very simple costume. It, of course, requires an artist to design such a hat, perfect in line, perfect in material and finish, producing a result even recognized by mere man as smart.

There are, however, dozens, nay hundreds, of modistes who still, each season, produce the necessary quantity of new models required for what

A DUTCH WEDDING

1922. Collection The Museum of Modern Art, New York. Gift in honor of Samuel J. Wagstaff, Jr. This is a variation of an image that was published as part of a fashion essay in *Harper's Bazar*, in May, 1922. The issue announced de Meyer's arrival in Paris and his new position at *Bazar* as photographer and Associate Editor. The fashion feature was titled "A Dutch Wedding from the Top of its Cap to the Tip of its Slipper is Designed by Tappé." As the editorial accompanying the photographs noted, "A wedding is one of the few ceremonies left to modern life (shorn of crusades, royal progresses, and triumphal entries) that lends itself to picturesque pageantry. Here costumes, rather than dresses, may be worn and the atmosphere of any chosen time or country reproduced to give charm and loveliness."

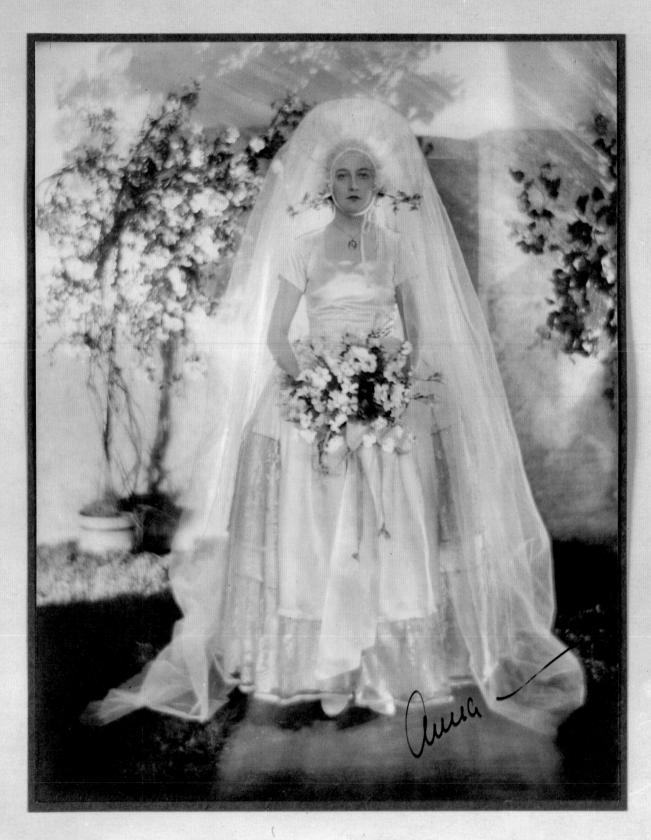

DEMEYER

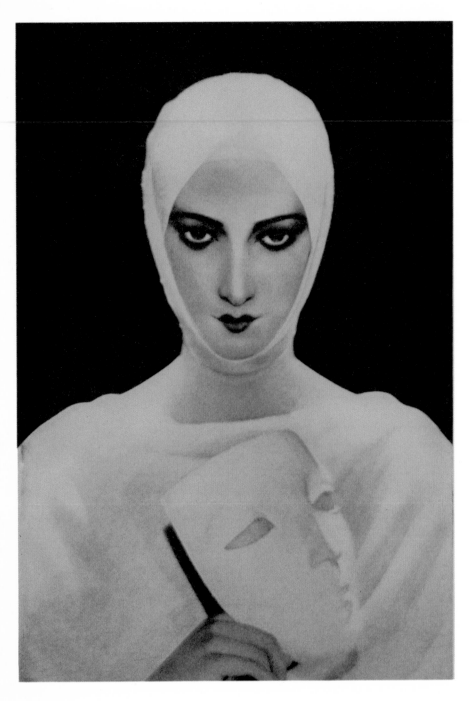

Left, HARPER'S BAZAAR
November, 1931.

Right, ELIZABETH ARDEN
ADVERTISEMENT
ca. 1927. Reproduced by permis-
sion of the Australian National
Gallery, Canberra. This photograph
is among the earliest in a series of
successful advertisements
that de Meyer created for the
Elizabeth Arden cosmetics company;
they were published throughout
the 1920s in *Harper's Bazar*. In this
photograph, the head is that
of a human model; in the following
years it was altered and manipulated
almost imperceptibly in sequential
photographs, and was transformed
finally into a wax mannequin.
Surrounded by perfume bottles or
human hands, de Meyer's wax heads
have a disturbing quality of
constructed femininity. This concept
of the substitute female pervades
de Meyer's work during the twenties,
as his models become increasingly
unnatural and stylized.

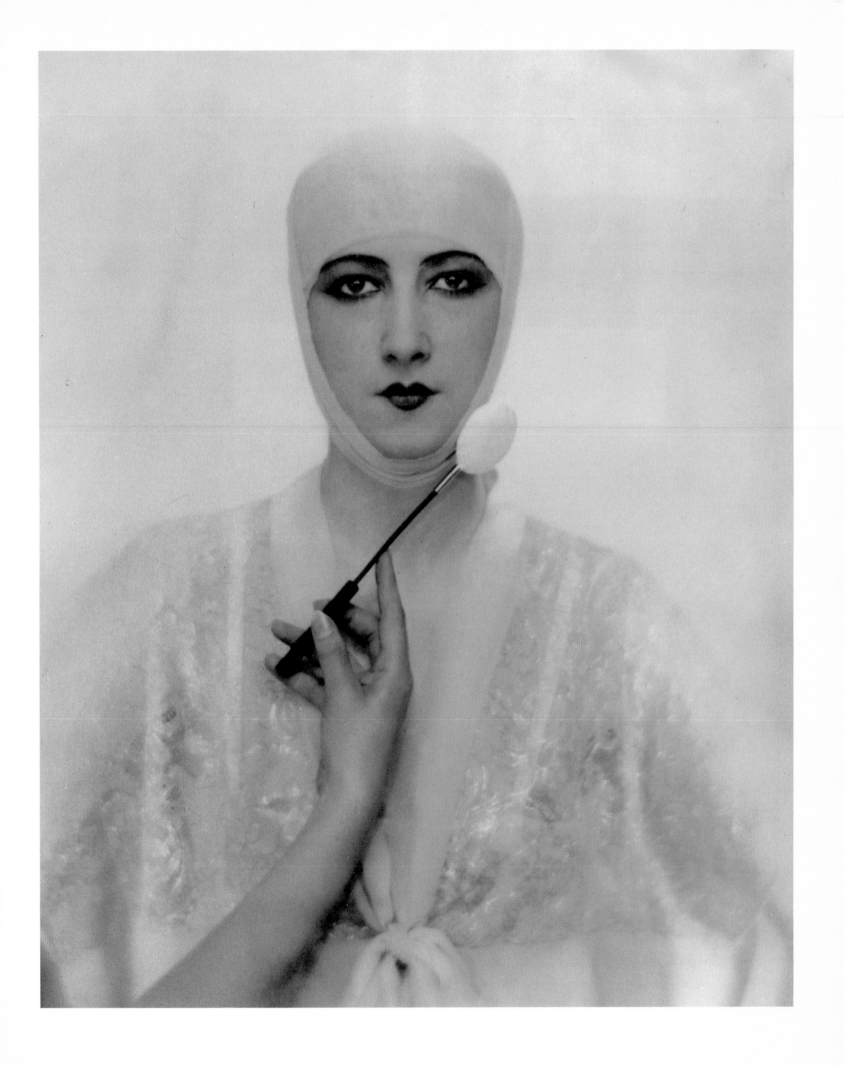

DEMEYER

The New Hat Called "Violette"

Worn by the Honorable Mrs. Reginald Fellowes

ALEX

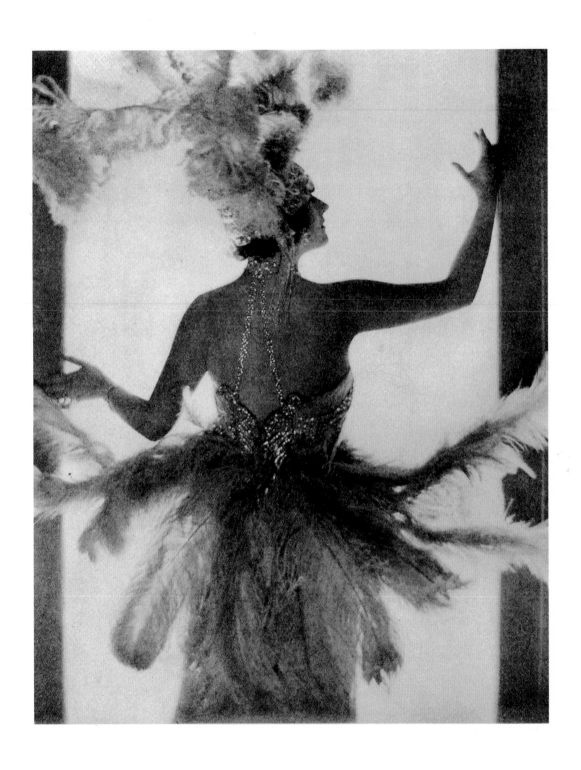

Left, HARPER'S BAZAR
February, 1928.

Above, HARPER'S BAZAR
October, 1921.

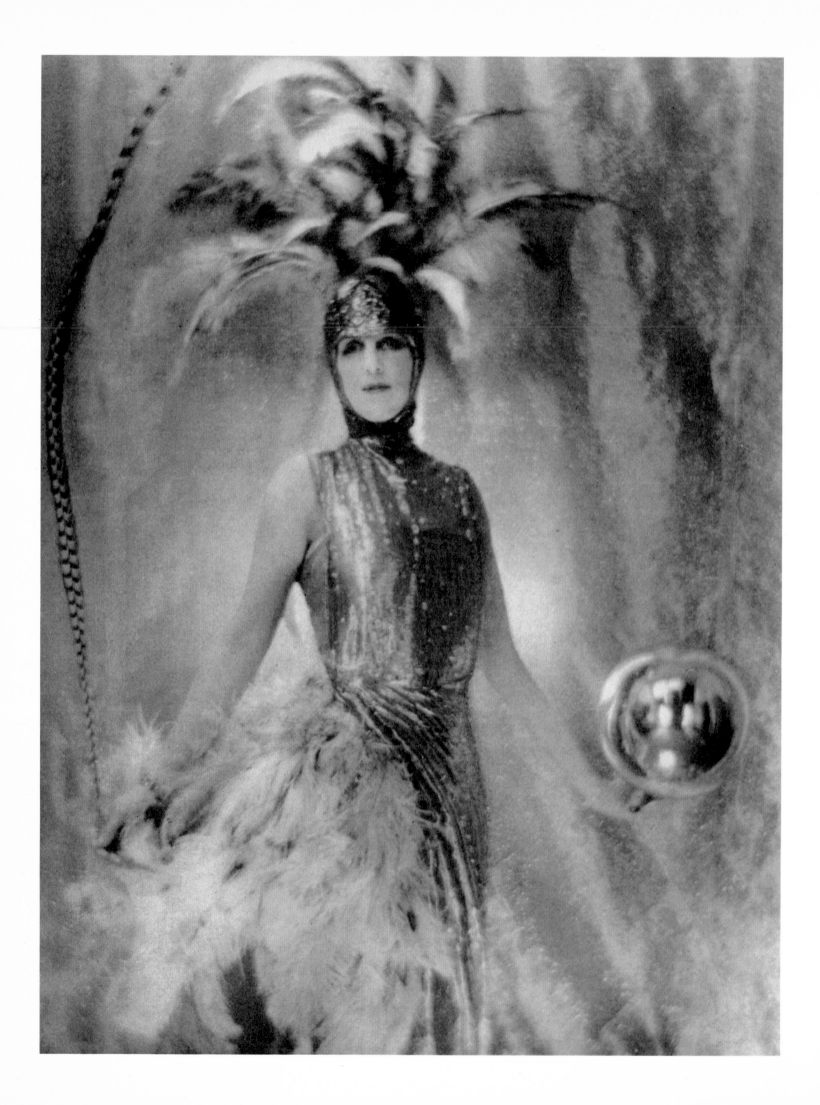

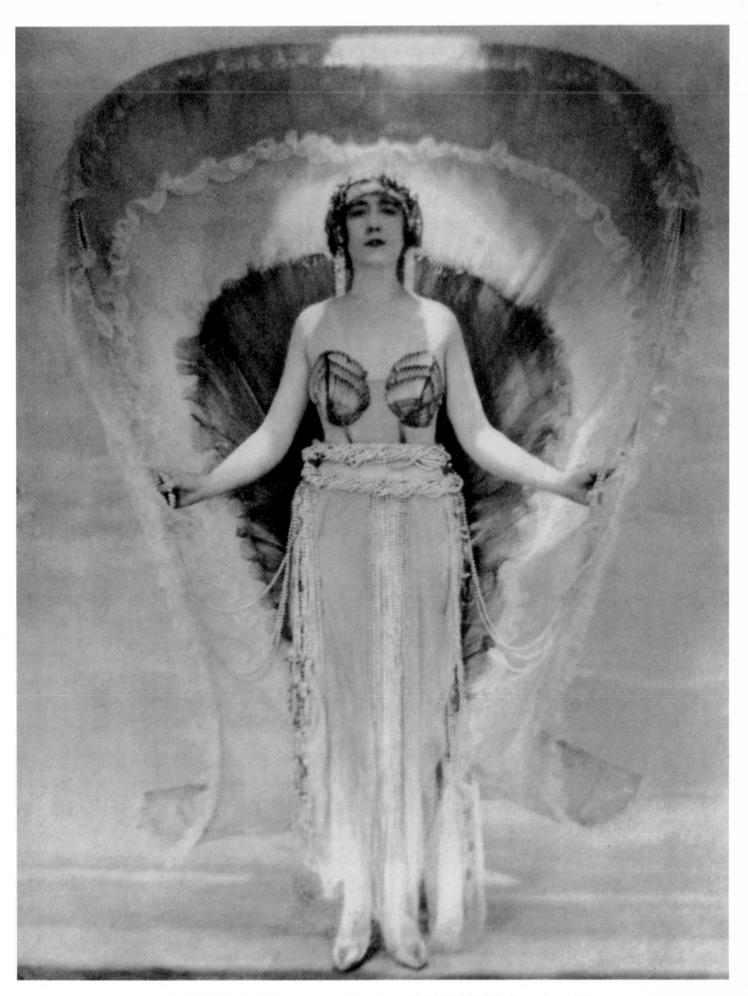

Left, HARPER'S BAZAR, September, 1923. Above, HARPER'S BAZAR, September, 1923.

FRESH FLOWERS TO WEAR

ROSES, PANSIES, CAMELLIAS

*Baron de Meyer Defines the New Mode of
Wearing Natural Instead of
Artificial Flowers*

¶ THE artificial flowers that bloomed in last spring's buttonhole have nothing to do with the case.

¶ THOSE artificial ones that women wore during the day, even on tailored suits—blooms nestling in frayed fur neck-pieces or lace ruffles, securely fastened. These have no more the atmosphere of a fragrant flower than a painted stage horizon has a semblance to the sky. Any flower proclaiming its artificiality by aggressive freshness after prolonged wearing is displeasing. When soiled, however, it is worse—it is positively offending.

¶ WHY not wear real flowers? Because they fade? To object to a fading bloom is an error. Herein lies part of its charm. Better short-lived and genuine than a long career of faked freshness.

¶ THE selection of a beau who has taste ought to be one of the principal rules of *savoir vivre*, the providing of flowers being one of his privileges. To buy them for oneself is, by some women, considered a disgrace. Flowers sent by a beau seldom suit one's gown. To wear them is often a lack of discernment. Alas, a beau's devotion is too often measured by the cost of his floral offerings.

¶ THE feminine world is divided into two sections, the one who receives orchids, the other—who does not! An orchid's atmosphere is artificial, quite unromantic, *nouveau riche*. When sending orchids in Europe a man means to convey the maximum of admiration. In America these blooms have become a habit, a mere tribute of polite indifference.

¶ FOR the hair, wreaths of real flowers suit romantic personalities. A lovely fashion for a keepsake beauty. A wreath of cornflowers, a white muslin dress, a midsummer night—a perfect combination!

¶ TO CLING to one scent alone or to wear one kind of flower only are smart fads. Yet—to change the flowers one is wearing emphasizes their transitory glory, while constant repetition of the same effect accentuates an undesirable impression of durability. Real flowers need never match a gown in color. There is a choice between two methods: "harmony of tone," or "the

discordant note." It requires an artist's eye, however, to make the discordant note harmonize.

¶ SAYS Clarita: Blue hyacinths and the shade known as "American beauty" are a perfect combination. So are deep red carnations on a certain shade of green. The kind of flowers suitable to be worn with day gowns is limited. An even lesser number is correct at night. Most flowers seem to harmonize with one's spring and summer clothes, but very few look well in winter.

¶ IN SPRINGTIME, because of their scarceness, flowers are an almost precious feature of an elegant woman's toilette. As summer progresses, they lose some of their rare charm.

¶ FLOWERS in the fall present a problem. This is a difficult season. The chrysanthemum reigns supreme. In its size resides its splendor; pinned to a gown it becomes ungainly. If in doubt, revert to gardenias or carnations. They are safe wearing throughout the year. Perfect always, they are suitable for both day and night.

¶ THE fad of the moment—florists carefully turn back the petals of a tulip, also those of roses. Transformed, the tulip becomes a novel looking *fleur de corsage*. The black variety is particularly chic. No manipulation of any kind enhances the beauty of the rose. She is the Queen of Flowers, supreme at any season! Her evanescence makes her life more precious while it lasts.

¶ WHAT lasts too long often ceases to please the sooner. A principle is here at stake—the perishable moment of enjoyment in contrast to the staleness of unending pleasure.

¶ CLARITA continues to give her opinion. All through the year, for evening wear, gardenias, camellias, white and deep red roses as well as mauve and white Parma violets are suitable. Orchids, though worn extensively, only imply wealth, not smartness. They lack individuality. Perfect in fur are dark violets during the day. They don't light up at night.

¶ DELIGHTFUL for early spring wear, even if sentimental, is a nosegay composed of primulas, pink daisies, forget-me-nots, and pansies. Also—red and violet anemones, mixed. Original are hyacinths, both in blue and rose, each stem to be fastened separately on to the gown, one spray pointing up, the other downwards. Cornflowers produce a gorgeous touch of blue. Tightly clustered, their intensity of color lasts. On any costume in May, preferably on green, lilies-of-the-valley look exquisite. Alas, because of a tendency to droop, they are best suited when a short appearance is planned. They convey a breath of spring, freshness, youth.

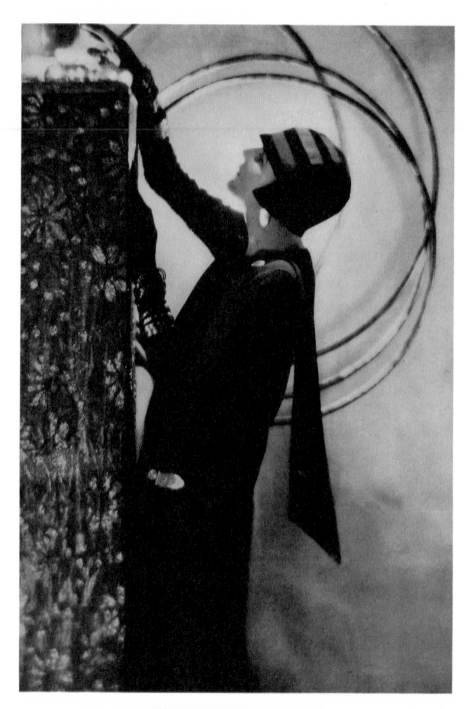

HARPER'S BAZAR, January, 1927.

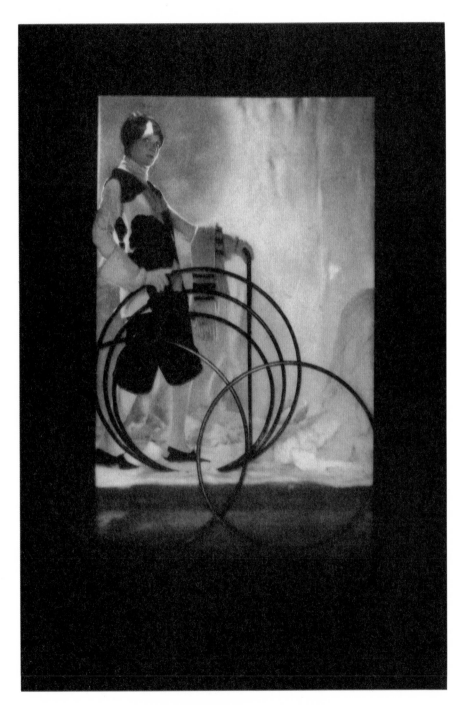

HARPER'S BAZAR, December, 1926.

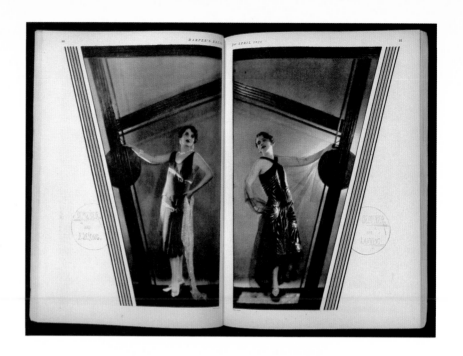

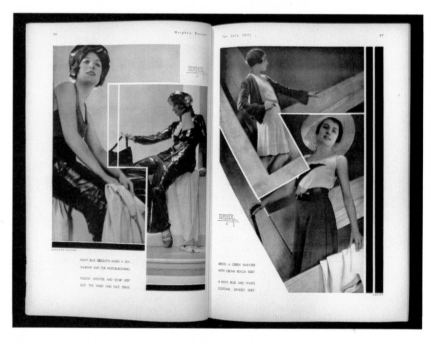

Right (top to bottom),
HARPER'S BAZAR
April, 1928.
HARPER'S BAZAAR
July, 1931.
HARPER'S BAZAR
September, 1928.

Far right, HARPER'S BAZAR
November, 1928.

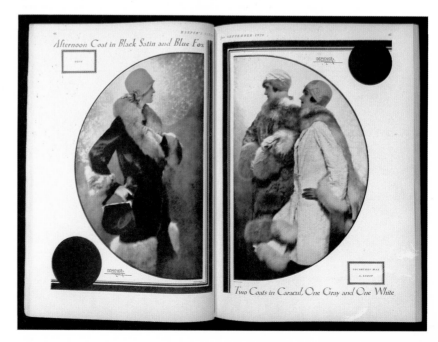

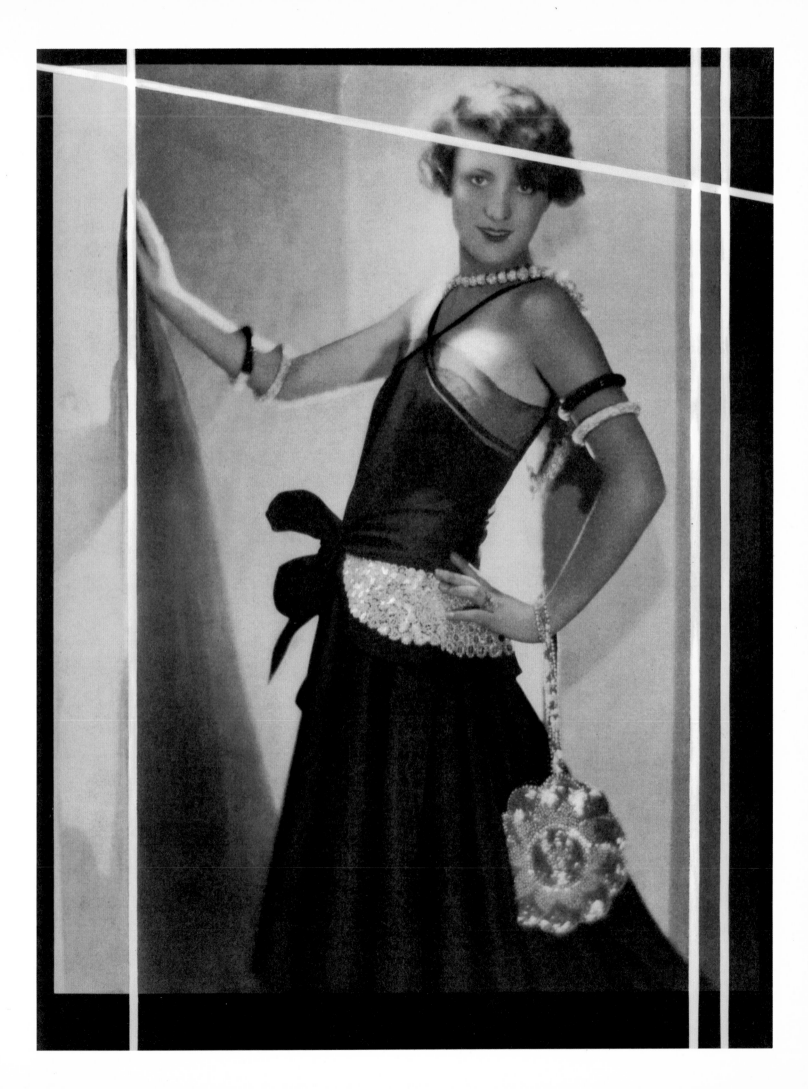

PERUGIA

A Fantasy in Red Antelope
and Golded Leather

DEMEYER

A Sandal in Silver
Embroidery

A Sandal in Many=
Colored Strass

DUCERF-SCAVINI

Evening Sandal in Pink Nacre
Kid and Rhinestones

Sports Sandal in Woven Raffia
and Brown Leather

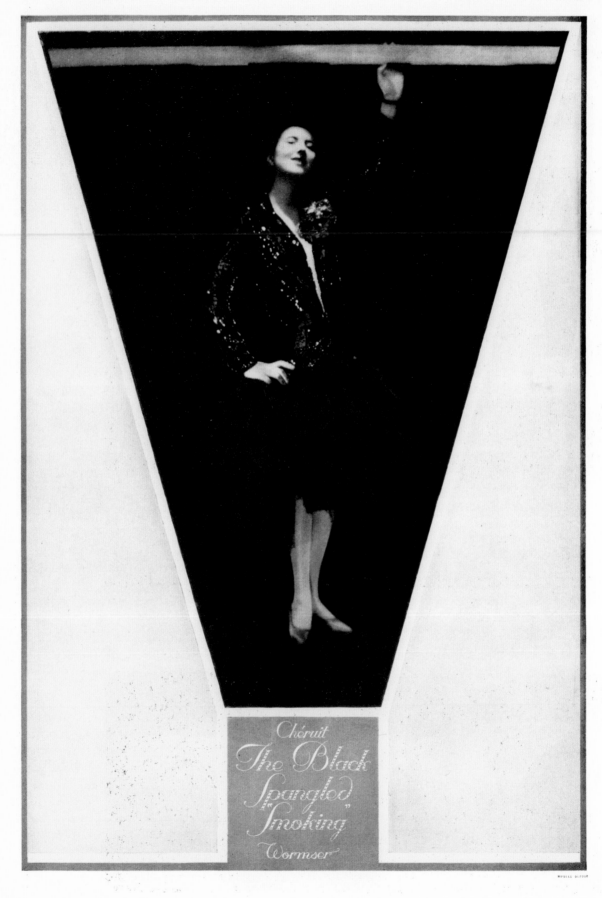

HARPER'S BAZAR, January, 1927.

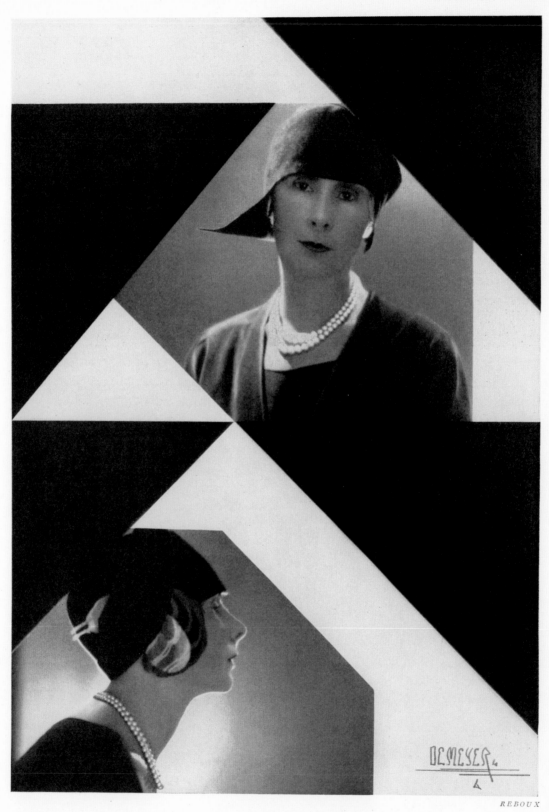

REBOUX

Baroness de Meyer in a new Reboux hat of
Black Felt, with Red and Beige feathers

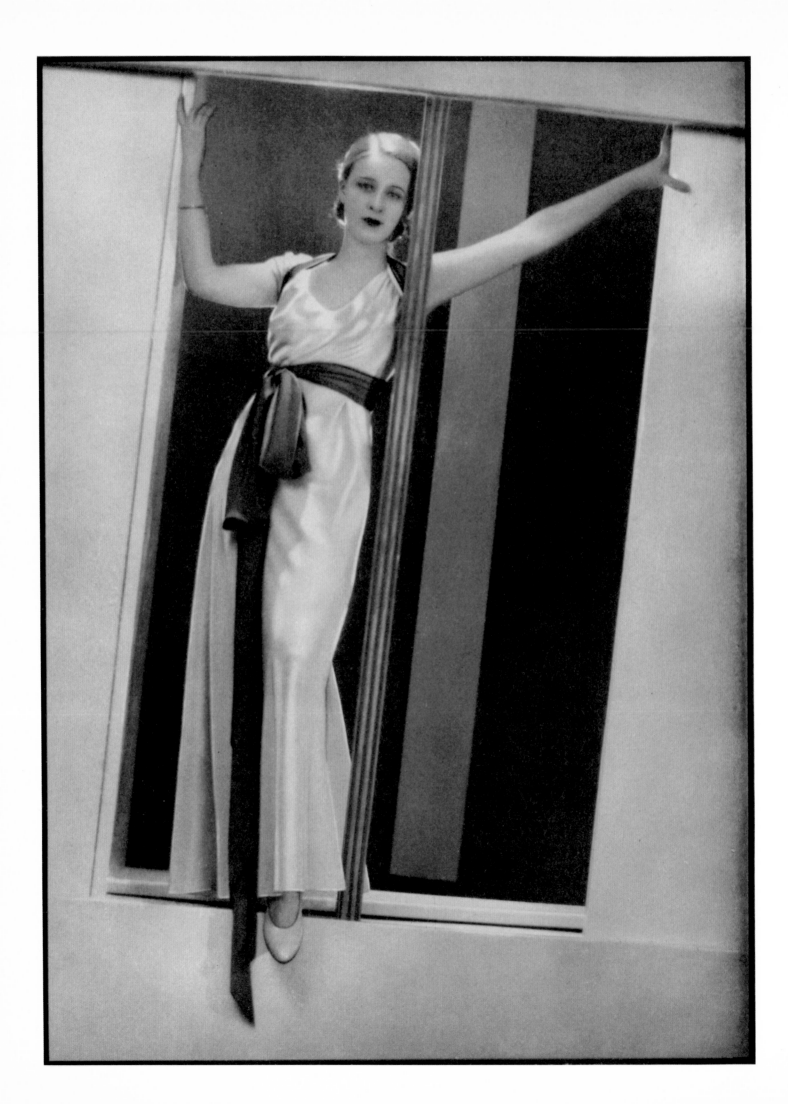

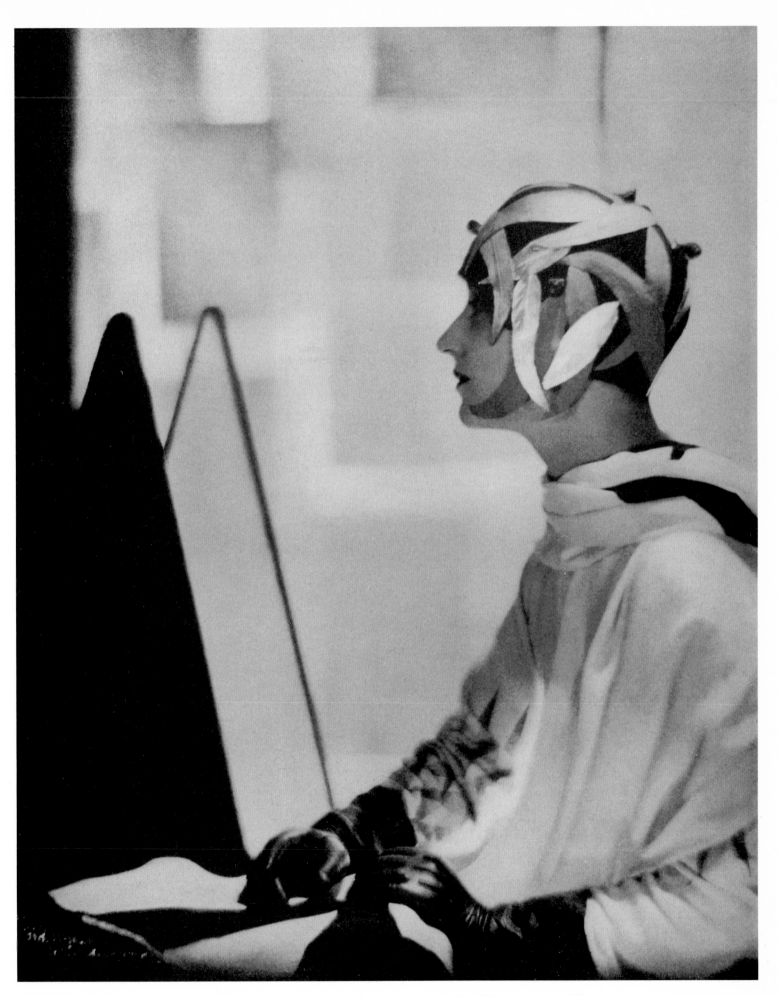

Left, HARPER'S BAZAAR, May, 1932. Above, HARPER'S BAZAR, August, 1925.

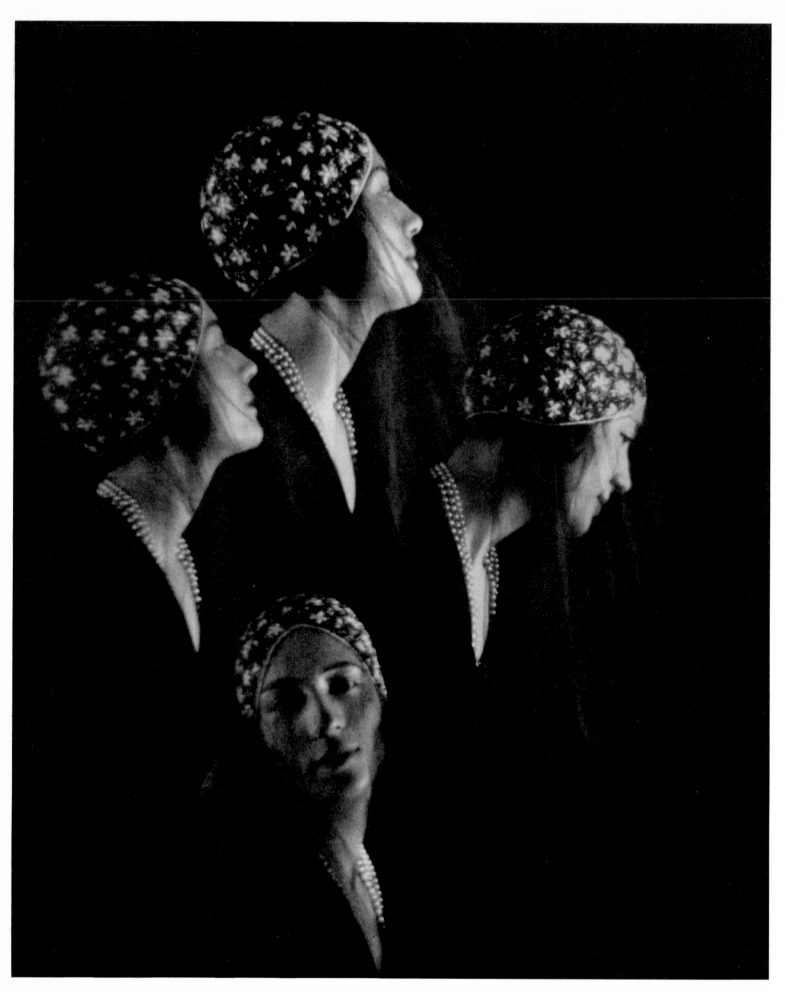

Above, HARPER'S BAZAR, May, 1928. Right, HARPER'S BAZAR, June, 1928.

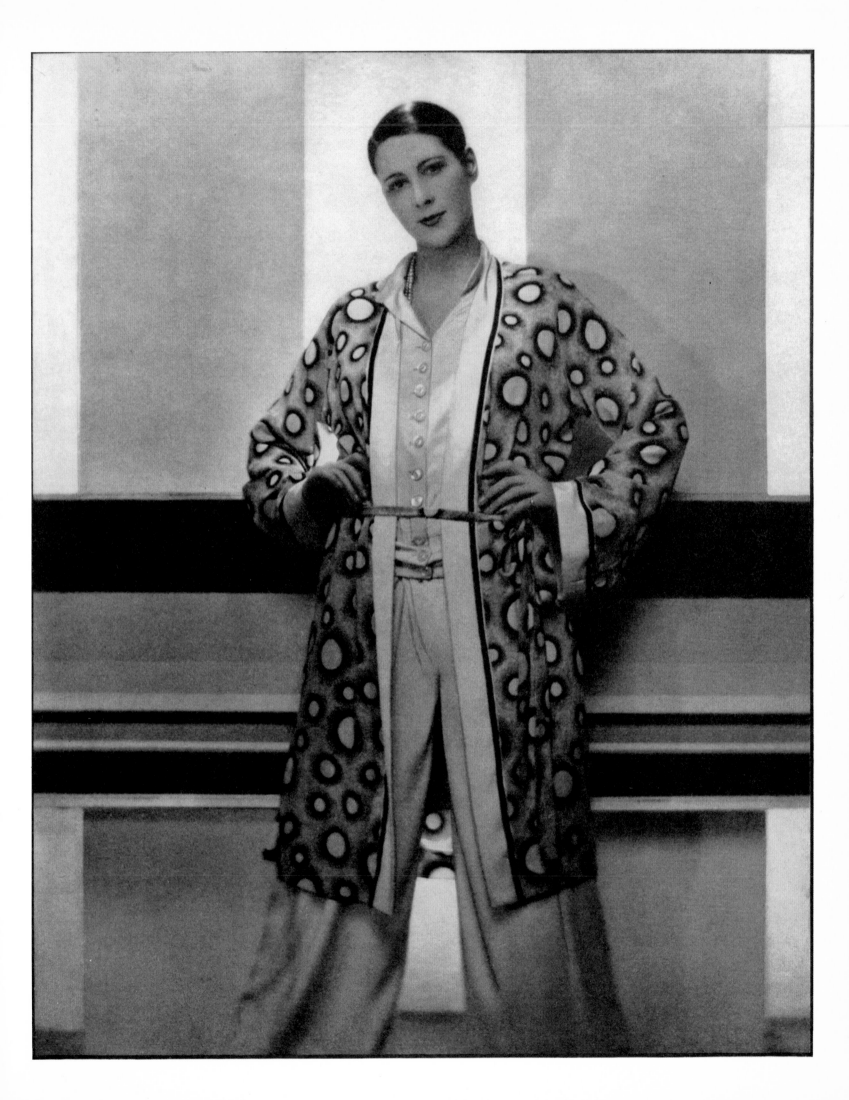

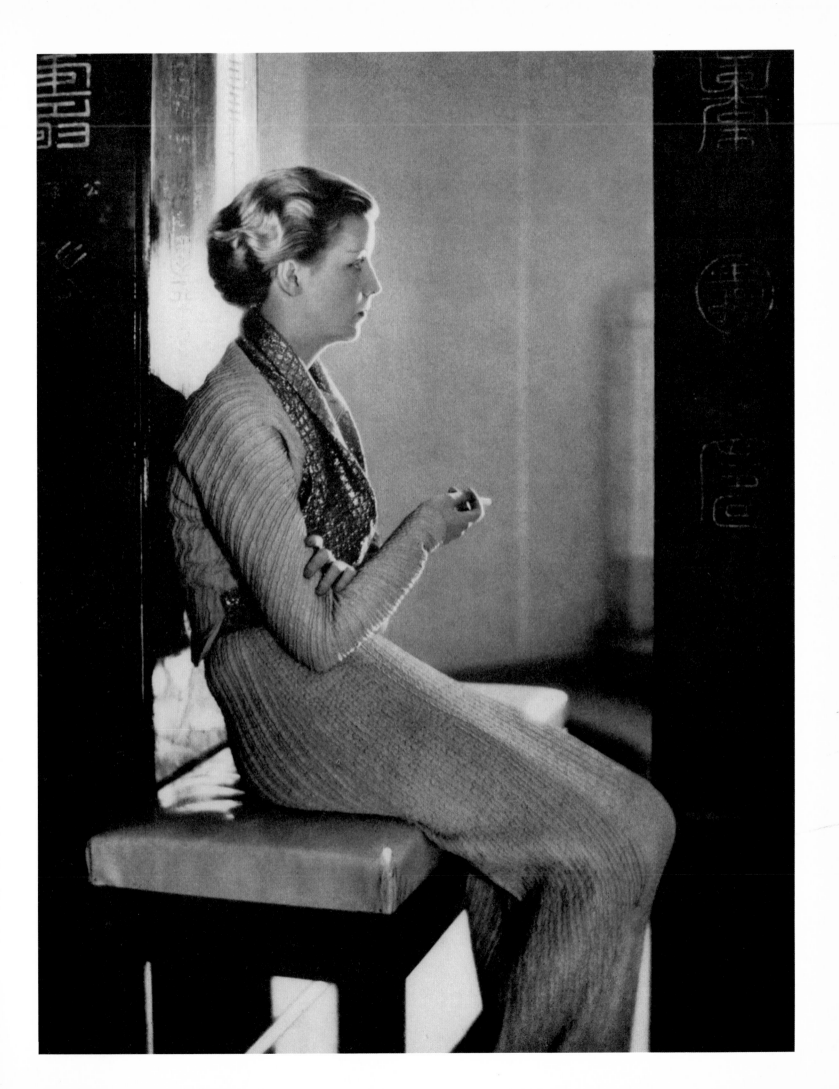

CHRONOLOGY

Note: Adolph de Meyer's history is at best difficult to assemble with any certainty. Many of the reference materials are open to question—particularly those that come from de Meyer's own hand: it is clear that he fabricated many of the "facts" of his own life. There are numerous possible reasons for this. He was a homosexual living in a culture that abhorred and prohibited homosexuality; as a German, he was subject to suspicion as to his patriotic affinities during both world wars; and finally, he was not above glamorizing the elements of his life for the interest of readers of the magazines in which his work appeared. For the scholar, these fabrications present a problematic set of sources.

1868: Born to Adele Watson and Adolphus Meyer, probably in Paris or Germany. Initially, Adolph's family name is given as either "Meyer" or "Meyer-Watson." The title "Baron" will not appear in his name until after 1898.

1870s–1880s: De Meyer's childhood is spent in Paris and Germany.

1894–1895: De Meyer enters the international photographic world as a respected and talented amateur. (In this period, the word "amateur" signifies artistic and intellectual—as opposed to commercial—practice.) His photographs are exhibited in New York, London, Brussels, and Paris. Exhibition catalogues list him as "Adolf Meyer, 8 Parkstrasse, Dresden."

1896: De Meyer moves to London, but continues to be listed in catalogues with a Dresden address. He joins the London Camera Club, and his works appear at the Royal Photographic Society and the London Salon. He introduces himself into the fashionable social circles of London.

1896 or 1897: De Meyer marries Olga Alberta Caracciolo, reputedly the illegitimate daughter of the Prince of Wales (later Edward VII) and Blanche, Duchesse de Caracciolo. De Meyer's portrait of Olga is published in *The Photographic Times*, an illustrated monthly magazine published in New York.

1898–99: De Meyer joins the Royal Photographic Society, and is elected in the fall to the Linked Ring Brotherhood, an important British artistic photography group; his name in their roll appears as "Baron Adolph de Meyer (Watson)." He is listed in the London Salon catalogue at the address 1 Cadogan Gardens, London. His work is exhibited in London and Berlin.

1900: Photographs by de Meyer are included in the exhibition "New School of American Photography," organized by F. Holland Day; the show opens in London and will travel to Paris in the following year. De Meyer takes a trip around the world: Olga accompanies him to Japan; he continues by himself to China, India, and Ceylon.

1901: Edward VII succeeds to the throne of England, augmenting the de Meyers' social position considerably, as the King publicly displays his affection for Olga.

1903: De Meyer purchases an English Pinkerton-Smith lens, ground specifically to combine sharp focus at the center with gradual diffusion at the edges. The special properties of this lens, together with de Meyer's characteristic technique of backlighting, create the extraordinary luminosity for which his photographs are known. In December he sends Stieglitz a check for a subscription to *Camera Work*, initiating a friendly correspondence that will continue until 1912. De Meyer visits

America, and spends time with Gertrude Käsebier in Newport, Rhode Island, where she makes several portrait studies of him.

1905: Käsebier and Frances Benjamin Johnston visit the de Meyers in Venice at their villa, the Palazzo Balbi-Valier; Johnston describes the visit in letters to her mother. De Meyer gives Käsebier a letter of introduction to Auguste Rodin.

1906: De Meyer writes to Stieglitz from the Palazzo Balbi-Valier, saying that he is "grateful for what you say about my work...and hope to steadily improve." He asks Stieglitz to have Käsebier lend eighteen platinum prints of still lifes for an exhibition.

1907: An exhibition of photographs by "Baron de Meyer of Germany and George Seeley of Massachusetts" runs from January 25 to February 12 at Stieglitz's Photo-Secession Galleries in New York. De Meyer organizes a show of contemporary photography with Alvin Langdon Coburn at London's New English Art Galleries, and corresponds extensively with Stieglitz about the exhibition. From the brothers Auguste and Louis Lumière in Paris, de Meyer learns the autochrome process, a method of photographing in color. Charles Holme publishes several of his autochromes in the book *Colour Photography and Other Recent Developments of the Art of the Camera*.

1908: Stieglitz devotes the entire issue of *Camera Work* 24 to de Meyer's work, publishing seven photogravures. In a letter, de Meyer complains to Stieglitz that the proofs he has seen are not luminous enough. Coburn brings twenty-five prints by de Meyer to Stieglitz in New York, where they are exhibited at the Photo-Secession Galleries. De Meyer is still listed with London and Dresden addresses. He exhibits with Coburn at the Photo-Club de Paris. In a letter to Stieglitz, de Meyer writes that he is working on autochromes.

The first productions of Sergei Diaghilev's Ballets Russes are performed at the Théâtre du Châtelet, Paris.

1909: De Meyer corresponds with Heinrich Kühn about exhibiting work in Dresden. He resigns from the Linked Ring Brotherhood in May 1909, and becomes a Fellow of Stieglitz's organization, the Council of the Photo-Secession in New York. The "Exhibition of Photographs in Monochrome and Color By Baron Adolf de Meyer of London and Dresden" is held at the Photo-Secession Galleries in February. In Germany, de Meyer meets Stieglitz in person for the first time, and writes to him in September that it "seemed to me like the reunion of old friends."

1910: Stieglitz's show, "An International Exhibition of Pictorial Photography," is held in Buffalo at the Albright Art Gallery, and includes twenty-five photographs by de Meyer. The catalogue lists him as residing in London and Dresden, and notes that "Baron De Meyer's affiliations place him in the Austrian-German section, although his sympathies are with the American workers." De Meyer also exhibits at the Goupil Gallery in London. Edward VII dies, and the de Meyers' social and financial situation changes abruptly. They take a villa on the Asiatic side of the Bosphorus.

1911: "Modern Photography," an exhibition organized by Max Weber and Clarence White, is held at the Newark Museum in April. The show includes work by Americans and Europeans; de Meyer exhibits his autochromes.

1912: De Meyer photographs Vaslav Nijinsky in the Ballets Russes

production of *Prélude à l'Après-midi d'un Faune* in Paris. Stieglitz exhibits de Meyer's photographs at the Photo-Secession Galleries in New York, December 18 to January 15; the Dresden affiliation has been dropped in the catalogue listing. The October issue of *Camera Work*, number 40, is devoted exclusively to de Meyer's work: fourteen photogravures are published in the issue. Europe is uneasy with the oncoming war; de Meyer travels to America, and writes to Stieglitz that he is in desperate need of work.

1913: De Meyer's portrait of Mrs. Harry Payne Whitney (Gertude Vanderbilt Whitney) is published in *Vogue* magazine's January 15 issue.

1914: Condé Nast hires de Meyer as *Vogue*'s first full-time photographer, beginning with the January 1 issue of the magazine. De Meyer signs a contract for $100 per week; it stipulates that he work only for *Vogue* and *Vanity Fair*.

Paul Iribe publishes the album *Sur le Prélude à l'Après-midi d'un Faune* in Paris; in it, de Meyer's photographs of Nijinsky and other dancers in the ballet accompany Stéphane Mallarmé's poem. There are also contributions from Jean Cocteau, Jacques-Émile Blanche, and Auguste Rodin.

1915: *Vogue*'s July issue carries de Meyer's first editorial on entertaining, which includes a quasi-fictionalized personal memoir. *Vanity Fair* publishes a rotogravure supplement of de Meyer's photographs of Geraldine Farrar as Carmen. The June issue of *Vanity Fair* includes a profile of the de Meyers.

1916: De Meyer writes a description of the Palazzo Balbi-Valier for the February issue of *Vogue*. His photographs appear in the Condé Nast publications with a regularity that is unmatched by any other photographer.

Nijinsky performs with the Ballets Russes in New York; de Meyer photographs him as the Favorite Slave in *Schéhérazade*.

Following the advice of an astrologer, Adolph and Olga change their names to Gayne and Mhahra.

1917: De Meyer begins designing clothes, and takes up interior decorating for fashionable homes in New York and Newport.

1918: "The Bride's Yearbook" is published in *Vogue*'s May issue, with eighteen photographs by de Meyer. The magazine's August issue announces his new couture line, Gayne House, with the address 59 East 52nd Street.

1920: In the January issue of *Vogue*, entitled "On the Trail of the Sun," de Meyer introduces a new quality to his work, showing his models in outdoor vacation settings. For *Vanity Fair*, he photographs theatrical personalities, among them John Barrymore, Mary Pickford, Charlie Chaplin, and Lillian and Dorothy Gish. In Paris, de Meyer photographs and reports on the French collections. He begins to spend a good deal of time in France, and indicates to *Vogue*'s editor, Edna Woolman Chase, that he is happier there than in New York.

1921: Accepting William Randolph Hearst's offer of an increased salary, a Paris apartment, and greater editorial responsibility, de Meyer begins work for Hearst's *Harper's Bazar*, starting with the magazine's May issue. The July issue features his portrait of Mrs. William Randolph Hearst. De Meyer's photographs continue to appear in *Vogue* during this year.

1922: De Meyer signs a ten-year contract with the Hearst Corporation and is accepted as the preeminent fashion presence at *Harper's Bazar*. In the June table of contents, the lead reads, "Fashion Compositions Photographed by Baron de Meyer." The September issue introduces a series of fashion editorials under the heading "Baron de Meyer Observes and Writes From Paris."

1923: *Harper's Bazar* opens the year with an issue that includes "The New Mode in Paris: A Fashion Letter by Baron de Meyer." He reviews and photographs all the great French houses, including Chanel, Lanvin, Molyneux, Patou, and Poiret. The February issue features his interview with Gabrielle (Coco) Chanel. In a fashion editorial in the August issue, de Meyer writes of his Parisian childhood, claiming (probably speciously) that he was born in Paris.

1924: Editorials in *Harper's Bazar* announce, "Baron de Meyer Attends the Openings." The style of his photographs begins to reflect the spirit of Modernism that is pervading Europe: tonal contrasts are more marked, layouts incorporate a new, graphic geometry and constructed balance.

1925–26: De Meyer's photographic layouts become more and more stylized. The models are often posed in profile, and look increasingly like mannequins. De Meyer makes creative use of collage and geometric graphics, in photographic layouts that now regularly cover several pages of each issue of *Harper's Bazar*. He continues writing editorials prodigiously. He photographs the American entertainer Josephine Baker.

1927: Elizabeth Arden advertisements, with photographs by de Meyer, first appear in *Harper's Bazar*.

1928: De Meyer's photographs continue to cover multiple-page layouts, but other photographers—Edward Steichen, Paul Outerbridge, Anton Brühl—are appearing more regularly at *Harper's Bazar*.

1929: De Meyer's last great creative year at *Harper's Bazar*: his photographs are shot in fantastic sets, and his models are more ethereal and stylized than ever. The magazine changes its name to *Harper's Bazaar*.

ca. 1931: Olga de Meyer dies.

1932–34: Carmel Snow becomes Fashion Editor at *Harper's Bazaar*, her mission is to redefine the look of the magazine; within two years, she is named Editor in Chief, and hires Alexey Brodovitch to be Art Director. When de Meyer's contract with Hearst comes up, it is not renewed. New photographers—notably Martin Munkacsi—set a new pace for fashion photography at the beginning of the thirties.

De Meyer, newly dependent on drugs, travels in Europe, and has a succession of homosexual lovers. He develops a lasting attachment to a younger man named Ernest.

Stieglitz donates his archive—including many of de Meyer's photographs—to The Metropolitan Museum of Art.

1938–39: With the threat of Hitler's advance through Austria, de Meyer arranges to sell his possessions in Paris, Vienna, and Venice, and to adopt Ernest as his son. They travel to the United States, and take up residence in Hollywood.

1939: In February de Meyer gives an elaborate party in Hollywood for the stars of the Ballets Russes: Alicia Markova, Léonide Massine, Alexandra Danilova. *The New Yorker* reports that de Meyer's guest list includes Prince Thurn und Taxis, Mary Pickford, and other celebrities.

1940: Mr. and Mrs. Edward G. Robinson mount an exhibition of de Meyer's prints at their home. De Meyer writes Stieglitz to ask to borrow work, explaining that he destroyed most of his own possessions in 1935. De Meyer is unable to locate sufficient vintage work for the exhibition, and reprints older material on large sheets of Eastman Kodak paper.

1941–1945: De Meyer's final years are neither happy nor successful. He writes a screenplay, an autobiography, and a number of romantic novels—none are published. He lectures occasionally, and makes a few society portraits.

1946: De Meyer dies of coronary thrombosis in Los Angeles. His obituary in the *Los Angeles Times* does not mention his photography.

1980: Material left to Ernest, de Meyer's lover and adopted son, is auctioned at Sotheby's, New York.

NOTES

1. Adolph de Meyer, "Fetes of Unsurpassed Elegance," *Harper's Bazar* (September 1923), p. 39.
2. The magazine's title was spelled this way until 1929, when the extra *a* was added, changing it to *Harper's Bazaar*. See John Tebbel and Mary Ellen Zuckerman, *The Magazine in America: 1741–1990* (New York: Oxford University Press, 1991), p. 103.
3. Adolph de Meyer and Alfred Stieglitz Correspondence. Alfred Stieglitz Archive, Collection of American Literature, Beinecke Rare Book Room and Manuscript Library at Yale University, New Haven, Conn. Unless otherwise noted, all de Meyer/Stieglitz correspondence in this book is taken from this source. (Dates follow quotes in text.) Another very important research source is Weston Naef's *The Collection of Alfred Stieglitz* (New York: The Metropolitan Museum of Art, 1978).
4. De Meyer, "Arts and Crafts of Entertaining," *Vogue* (July 15, 1915), p. 20. De Meyer wrote several articles on entertaining, travel, flower arranging, and decorating for *Vogue*. Later, for *Harper's Bazar*, he wrote a fashion editorial for almost every issue during the years between 1922 and 1932. Unfortunately there is very little useful biographical information in his articles.
5. Emily Burbank, "Baron and Baroness de Meyer," *Vanity Fair* 4 (June 1915), p. 42.
6. Edna Woolman Chase and Ilka Chase, *Always In Vogue* (New York: Doubleday and Company, Inc., 1954), p. 165. Chase's memories of de Meyer are somewhat jaundiced: she was angered by his defection to *Harper's Bazar*, and refused to rehire him when Carmel Snow fired him from *Harper's Bazar* in 1932.
7. Jacques-Émile Blanche, *Portraits of a Lifetime: The Late Victorian Era, The Edwardian Pageant 1870–1914* (New York: Coward-McCann, 1938), p. 171.
8. See Philippe Jullian, *De Meyer*, ed. Robert Brandau (New York: Alfred A. Knopf, 1976), p. 14.
9. For purposes of consistency, in this text we have followed the spelling as it appears in the *Index to American Photographic Collections*, 2nd edition, ed. Andrew H. Eskind and Greg Drake (Boston: G. K. Hall & Co., with the International Museum of Photography at George Eastman House, 1990).
10. See William Innes Homer, *Alfred Stieglitz and the Photo-Secession* (Boston: A New York Graphic Society Book, Little Brown and Company, 1983), p. 6.
11. Ibid., p. 10.
12. Cecil Beaton, *The Glass of Fashion* (Garden City, N.Y.: Arno Press, 1973), p. 345.
13. See Linda Gertner Zatlin, *Aubrey Beardsley and Victorian Sexual Politics* (Oxford: Clarendon Press, 1990), pp. 11–13.
14. Ibid., p. 13.
15. Blanche, p. 52.
16. Andrew McLaren Young, et al., *The Paintings of James McNeill Whistler* (New Haven and London: Yale University Press, 1980), p. 158.
17. Peter C. Bunnell, ed., *A Photographic Vision, Pictorial Photography 1889–1923* (Salt Lake City: Peregrine Smith, Inc., 1980), p. 24.
18. Cecil Beaton and Gail Buckland, *The Magic Image: The Genius of Photography from 1839 to the Present* (Boston and Toronto: Little, Brown & Co., 1975), p. 106.
19. Charles H. Caffin, "Exhibition of Prints by Baron Ad. de Meyer," *Camera Work* 37 (January 1912), pp. 33–35.
20. Barbara Michaels, *Gertrude Käsebier, The Photographer and Her Photographs* (New York: Harry N. Abrams, Inc., 1992), p. 98.
21. Helmut and Alison Gernsheim, *Alvin Langdon Coburn, Photographer, An Autobiography* (New York: Dover Publications, Inc., 1978), p. 14.
22. Ibid., p. 20.
23. Maurice Maeterlinck, *The Intelligence of the Flowers* (New York: Dodd, Mead, and Company, 1907), pp. 10–11.
24. Caffin, "The De Meyer and Coburn Exhibitions," *Camera Work* 27 (July 1909), p. 29.
25. De Meyer wrote about his travels in his article "Concerning One's Setting: Baron de Meyer Describes Houses He Has Lived In": "I've wandered about the world for a great many years. . . . I've lived in England, in Italy, in New York, in Paris and have had a house on the Bosphorus and another on the hillside in Japan." In *Harper's Bazar* (March 1927), p. 77.
26. Stieglitz, "Plates: Baron A. de Meyer," *Camera Work* 24 (October 1908), p. 37.
27. Ibid.
28. De Meyer, "The Substance of a Venetian Dream," *Vogue* (February 15, 1916), pp. 41–43, 108.
29. Beaton, *Glass of Fashion*, pp. 104–106.
30. According to the memoirs of Bronislava Nijinska (Nijinsky's sister), Nijinsky paid £1,000 for the project. See Jean-Michel Nectoux, et al., *Afternoon of a Faun: Mallarmé, Debussy, Nijinsky* (New York and Paris: Vendome Press, 1989), p. 63, footnote 6.
31. Nectoux, *L'Après-midi d'un Faune* (Paris: Éditions de la Réunion des Musées Nationaux, 1989), p. 22.
32. See Caroline Seebohm, *The Man Who Was Vogue: The Life and Times of Condé Nast* (New York: The Viking Press, 1982), p. 192.
33. *Vogue* (December 17, 1892).
34. De Meyer, "Arts and Crafts of Entertaining," pp. 19–20.
35. *Vogue* (November 1, 1914), p. 34.
36. De Meyer, "'The Great American Atmosphere': They Would Not Recognize It in Europe; Most People Deny Its Existence in New York, But Here It Is, Define It Who Can," *Vogue* (December 15, 1916), p. 55.
37. John Savage, "Baron de Meyer: His Influence on American Taste in Three Different Branches of Art," *Vanity Fair* (November 1920), p. 73.
38. *Harper's Bazar* (May 1921), p. 84.
39. De Meyer, "Baron de Meyer Observes and Writes: Paris Gossip by a Mere Man," *Harper's Bazar* (September 1922), p. 39.
40. De Meyer, "A Conversation About Clothes: Baron de Meyer, Unblushing, Eavesdrops at the Ritz and Records Interesting Conversation Held by Three Smart Women," *Harper's Bazar* (January 1924), p. 31.
41. See Willis Hartshorn and Merry Foresta's introduction, in *Man Ray in Fashion*, exhibition catalogue (New York: International Center of Photography, 1990), p. 17.

ACKNOWLEDGMENTS

Sam Wagstaff thought that Adolph de Meyer was a photographer of genius, and that his work was underappreciated in our hyperintellectual time. It was his idea that a book and an exhibition of de Meyer's photography might rectify this. Willis Hartshorn, Director at the International Center of Photography, helped to make this idea a reality, and chose photographs with me from de Meyer's vast production with unfailing curatorial skill. Without Scott Hyde's superb reproductions of de Meyer's magazine work, this book and the exhibition would not have been possible. Particular thanks also to Paula Curtz, Exhibitions Associate at ICP, whose extraordinary administrative talents in assembling rare prints from institutions were invaluable. Diana Stoll edited the text with remarkable patience and insight. De Meyer's pictures were brought to life again on the printed page by Yolanda Cuomo's thoughtful design. I am very grateful for the guidance of Carol Armstrong at the Graduate Center of the City University of New York, and for the wonderfully intelligent perspective of Peter Galassi, Chief Curator of Photography at The Museum of Modern Art. Beth Gates-Warren of Sotheby's produced a catalogue for the 1980 sale of de Meyer's work, which continues to be a very valuable source in the study of his work and life. Gil Maurer, Chief Operating Officer of The Hearst Corporation, once said that "magazines are about ephemera"; his support has permitted ICP to shape this ephemera into tangible form. Finally, thanks to Joel Ehrenkranz, for his wisdom and infinite kindness make all things possible.

—Anne Ehrenkranz

The preparation of the book *A Singular Elegance: The Photographs of Baron Adolph de Meyer*, and the organization of the companion exhibition have been complicated by the fact that accounts of de Meyer's life are vague and often contradictory and so few original prints have survived, particularly of his fashion work. To complete this book we have had to rely on the generous assistance of numerous individuals and institutions.

ICP is particularly grateful to: Maria Morris Hambourg, The Metropolitan Museum of Art, New York; Peter Galassi, The Museum of Modern Art, New York; Weston Naef, The J. Paul Getty Museum, Malibu; Beth Gates-Warren, Sotheby's, New York; Diana Edkins, Condé Nast Publications, New York; Anne Tucker, The Museum of Fine Arts, Houston; Pam Roberts, The Royal Photographic Society, Bath, England; Etheleen Staley, Staley-Wise Gallery, New York; G. Ray Hawkins and Marla Hamburg Kennedy, G. Ray Hawkins Gallery, Santa Monica; The Eakins Press Foundation, New York; and Zabriskie Gallery, New York.

Other institutions which have provided material for the book include: International Museum of Photography at George Eastman House, Rochester, New York; The Theater Museum, Victoria & Albert Museum, London; The New York Public Library for the Performing Arts, New York; The Baltimore Museum of Art, Maryland; Australian National Gallery, Canberra; and the Museum of Art, Rhode Island School of Design, Providence.

Private lenders who have made images available from their collections include: Robin Symes, London; Flora Miller Biddle, New York; Pamela LeBoutillier, New York; and Ira Resnick, New York.

I want to thank the staff of the International Center of Photography, particularly Steve Rooney, Deputy Director for Administration, and Ann Doherty, Deputy Director for Development. I am especially grateful to Paula Curtz, Exhibitions Associate, without whom this book would not be a reality.

ICP is grateful to *Harper's BAZAAR* and the National Endowment for the Arts, whose support has assisted in the preparation of this book, the exhibition, and its tour.

—Willis Hartshorn, Director, International Center of Photography